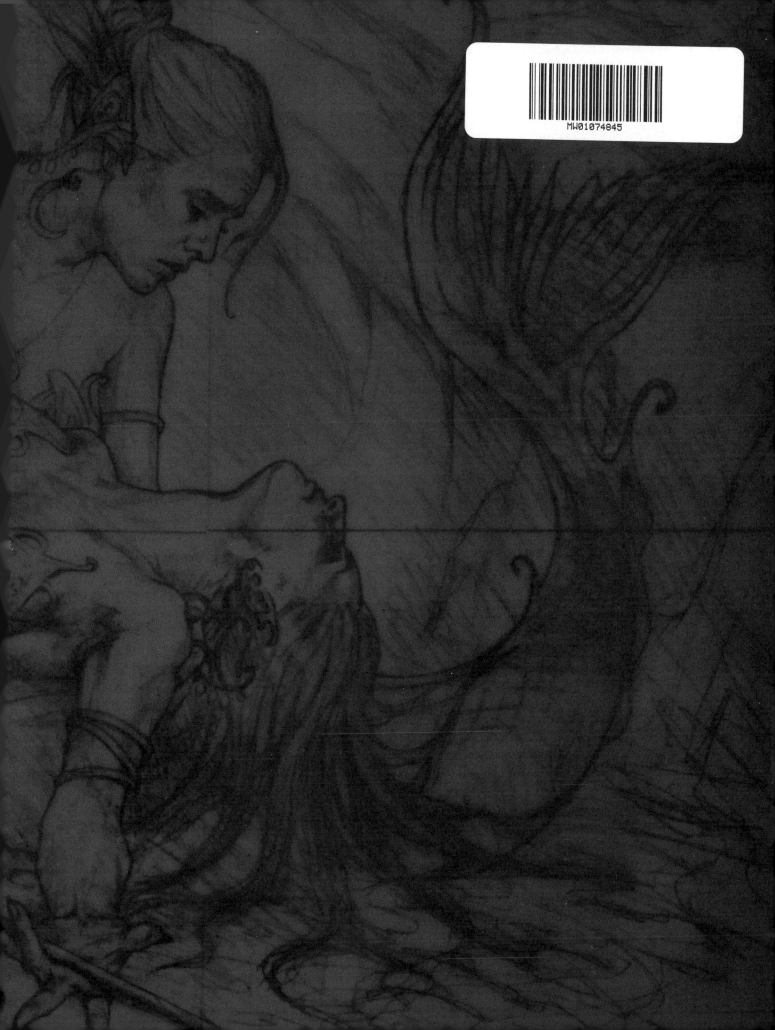

MW01074845

THE SCI-FI & FANTASY ART OF
Patrick J. Jones

This book is dedicated to
Boris Vallejo, for igniting the flame.

Korero Press Ltd,
157 Mornington Road, London, E11 3DT, UK
www.koreropress.com
First published in 2016 © Korero Press Limited
ISBN-13: 9780957664999
Images copyright: Patrick J. Jones
A CIP catalogue record for this book is available from the British Library

All rights reserved. With the exception of quoting brief passages for the purposes of review, no part of this publication may be reproduced, stored in a retrieval system, or transmitted in any way or by any means, electronic, mechanical, photocopying, recording or otherwise, without the prior written permission of Korero Press Ltd.

The information in this book is true and complete to the best of our knowledge. All recommendations are made without any guarantee on the part of the author or Publisher, who also disclaim any liability incurred in connection with the use of this data or specific details. This publication has been prepared solely by The Publisher and is not approved or licensed by any other entity. We recognize that some words and designations mentioned herein are the property of the trademark holder. We use them for identification purposes only. This is not an official publication. All images in this book have been reproduced with the knowledge and prior consent of the artist concerned and no responsibility is accepted by the producer, publisher or printer for any infringement of copyright, or otherwise, arising from the contents of this publication. Every effort has been made to ensure that credits accurately comply with information supplied. CONAN and CONAN THE BARBARIAN are trademarks or registered trademarks of Conan Properties International LLC. All rights reserved.
Printed in China

THE SCI-FI & FANTASY ART OF
Patrick J. Jones

foreword by Donato Giancola

KORERO PRESS

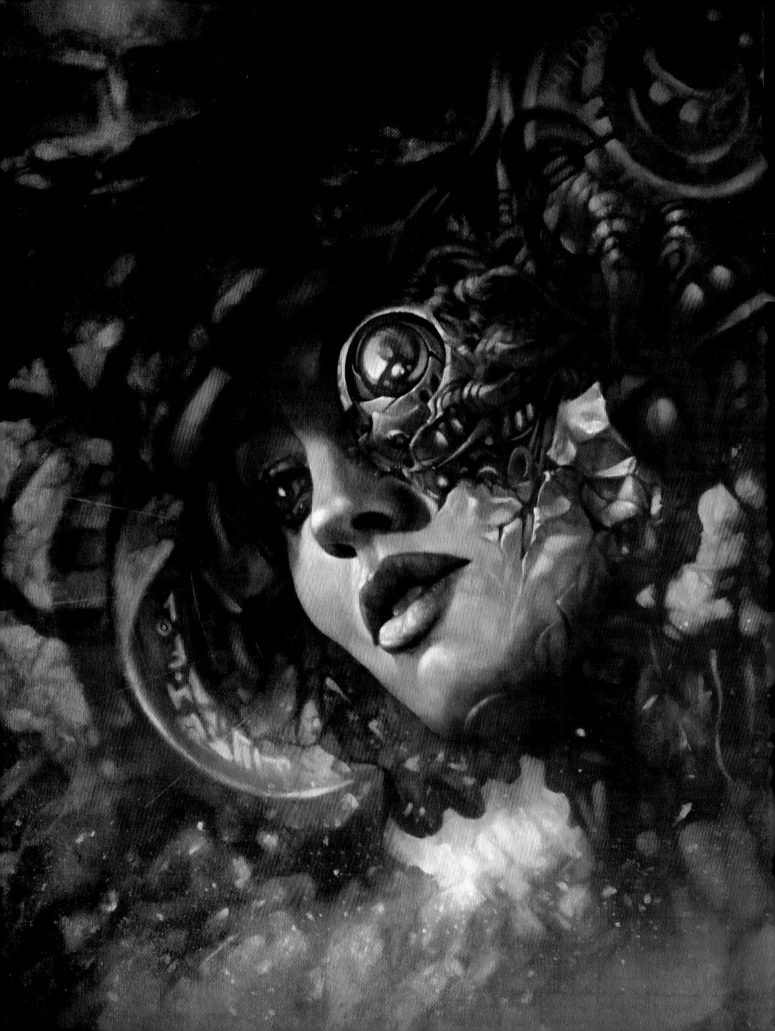

Contents

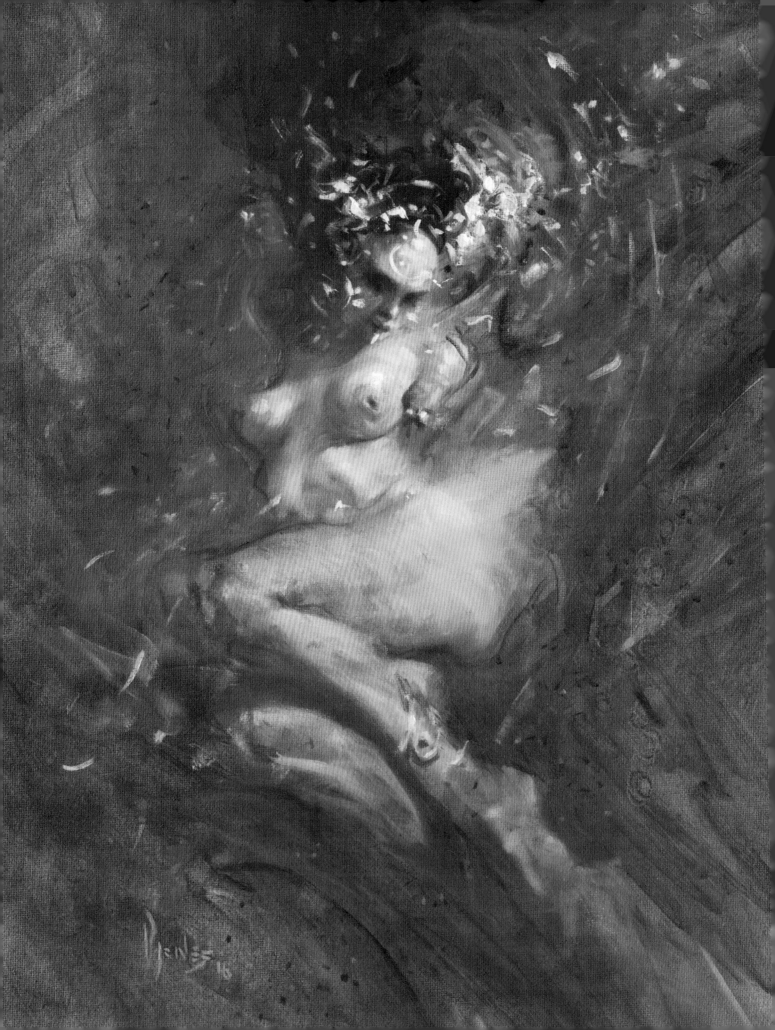

If you hear a voice within you say you cannot paint, then by all means paint, and that voice will be silenced.

Vincent van Gogh (1853–1890)

Foreword

Patrick Jones's work radiates light. Standing in front of one of his large canvases, you are bathed in the luminosity emanating from all areas of its surface. Flesh glows with an internal light, shadows are steeped in layered, translucent colours, and highlights are opaque and brilliant. All these seductive visual effects invite you to reach out and touch the surface of the painting, checking to see whether your body feels what your mind implies. This action is one of the greatest compliments to a painter.

Stepping back for a second look, you become aware of Patrick's other mastery – that of the anatomy of the human figure. You are drawn into the sublime rendering and dynamic movement of his characters. The sensuality of his figures is a driving force in much of his work, built on his appreciation and understanding of the human body. Countless hours in the studio and work with live models gives expression and emotion to Patrick's figures which cannot be transmitted by symbolic language alone. We feel his characters' pain, their desire for physical embrace, and the caress of their touch – forgetting that

they are merely golems created from graphite, pigment, and oils (or pixels in the case of his digital works). Patrick's interplay with characters and his love of story weaves together flesh and form to take you on a ride through historical, mythological, and fantastic narratives. Whether the work is for a science-fiction novel cover or a private commission, passion is not hidden away here, but placed front and centre – passion for technique and the passion his figures reveal in their quests and challenges, and in the tense moments they share with one another. It is evident that the artist cares as much about technical rendering as he does about communicating the living soul of his characters – and for that I am grateful.

The dynamic colours and design brought to bear in every image are a testament to the conceptual and visual maturity Patrick has achieved in his work. A wonderful payday is in store for those of you lucky enough to view his canvases, where the beauty of the surface and its complex colour arrangements can be more fully realized and celebrated. Without a doubt, Patrick is a master of his craft.

Donato Giancola
www.donatoart.com

Left: *Transfiguration;*
20 x 14 inches;
oil on canvas

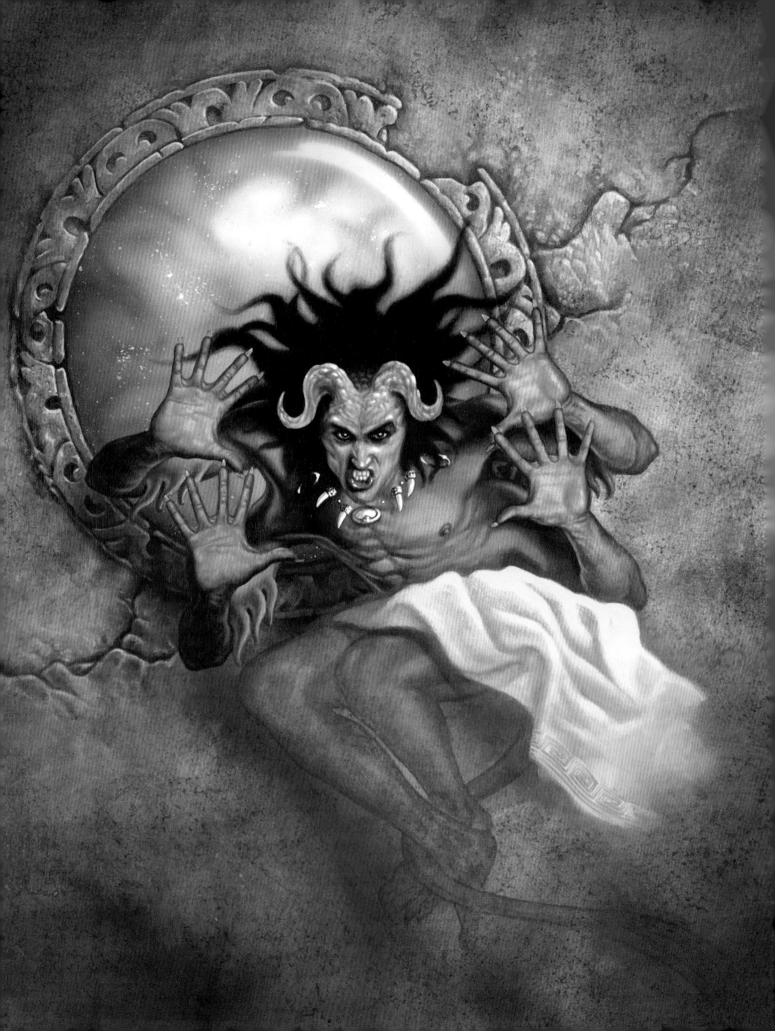

The canvas is the door to another dimension. The paintbrush is the key.

Michelangelo (1475–1564)

Interview

Patrick speaks with Mike Cody

Although the influence of modern artists such as Frank Frazetta and Boris Vallejo are present in Patrick's body of work, one cannot discount the "studied" look of his paintings, which harks back to the work of the traditionalists of the French Academy in the 19th century, among them Pierre-Paul Prud'hon and William-Adolphe Bouguereau. Frequently, Patrick's work communicates a sense of allegory, such as a symbolic theme or emotion. Often dark, tonally lush, and with a Classical sense of broken or muddy color, the lighting in his paintings is intense and dramatic.

Patrick's instructional drawings show a thorough understanding of human anatomy, and the knowledge of how to render form. Respected as a professional, he has worked for the publishing industry as well as Hollywood. His work is in a class that amazes the artist as well as the layman because of the obvious skill and talent behind it. So, let's now meet Patrick J. Jones.

Patrick, you are originally from Ireland: can you tell us a bit about your background?
I was born in Belfast and grew up in the Ardoyne district at the height of The Troubles in Northern Ireland. It was a depressed and violent republican area filled with dangerous characters, but the sense of community was so strong. I felt safe, despite the gunfire in the streets. Although there was a lot of

horror in my early years, I consider myself lucky to have grown up in a place where everyone knew each other and exchanged greetings as they passed by; a place where people left their front doors open to welcome visitors.

I had little interest in the street riots going on around me, and took refuge on the rooftops of the local shops, where I could read my comics in peace, and draw all day long. There were virtually no other distractions in the area, so it was a great time for study.

You now live in Australia; what brought you here?
Australia was the third place I called home after a decade of living in England. I met my future wife, Cathy, in London and after we had travelled across Europe and the Middle East together, we resettled in her home town of Brisbane.

Where did you learn to paint in oils?
I am self taught, if there is such a thing. Belfast has a magnificent library, a legacy from the industrial age when shipbuilding made the city prestigious. I spent every spare moment I had in those hallowed halls, educating myself about art; I studied the work of centuries of artists and their techniques. Later I discovered Boris Vallejo's book *Fantasy Art Techniques* and I carried it with me wherever I went.

Left: An early oil painting, circa 1990s.

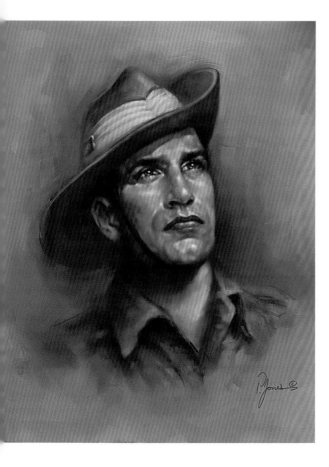

Left: Avertising art for the Australian RSL (Return Servicemen's League)

fantasy book jackets, and after a bout of homelessness I fell in with a bunch of hippies and ended up painting greeting cards from a communal house. Within six months, however, I was painting fantasy and sci-fi book jackets for one of London's leading fantasy and sci-fi publishers, Orbit Books.

Then I found my own place to live and for a few years my dreams were being realized. However, a sudden economic recession decimated my book jacket work and so I rode out the storm doing advertising work. That storm lasted fifteen years, and to be honest I should have jumped ship sooner, but I had a family by then and bills to pay. Once advertising sucks you in, it's hard to justify going back to much lower-paid publishing work. It almost seemed a selfish indulgence.

I was sharing a studio with great artists back then, and painted everything under the sun. The local supermarket looked like my private art exhibition; I created artwork for the packaging of steamed puddings, custard pies, dancing vegetables – all kinds of food – plus illustrations of handsome business men and women. Thousands of little artworks, millions of cartoons. The cartoons kept me sane, and I won awards and praise along the way, but I was always aware I had traded in my dreams of being a fantasy artist.

Where has your work appeared in print?
Although I now work almost exclusively as a fantasy artist, 99 per cent of my past printed work was advertising, such as billboards, posters, and packaging. I remember once seeing my billboards all over LA during the Oscars on TV, and on the side of buses in Brisbane. Although it's briefly exciting, that stuff is here and gone within a week or a month. I cartooned some children's books for Disney and Reader Rabbit that are still around, and I still see my book jacket art when I'm in the US. The millennium edition of the board game Trivial Pursuit was memorable, as I illustrated the little icons while travelling around Europe, which paid for all my travel costs, room and board.

Have you produced work for the movie industry?
Not much. Movies are like the circus: they come to town and you must drop everything for a few months, then they're gone again. I have teaching commitments now and that keeps me in a stable pay cheque situation. You need to be commitment-free to work on a movie. The last movies I worked on were the 2003 live-action version of *Peter Pan,* and *The Great Raid* in 2005.

Who were your early influences?
To begin with, Walt Disney. We didn't have a local cinema but I remember, when I was about six years old, the British soldiers screening *Pinocchio* at a girl's school one Saturday afternoon, to win over the natives. From the opening pan-in scene of Pinocchio's village, I was forever hooked on fantastic art. Although Belfast was in ruins, we were still able to read the magazines and watch the TV shows that the rest of the English-speaking world enjoyed. I traded Marvel comics with other kids and watched *Star Trek* on TV. The BBC screened movies such as *The Time Machine* and *Forbidden Planet* without ads; those were marvellous times! I remember copying Steve Ditko's Spider-Man, and was enthralled by Jack Kirby's work on the Fantastic Four. We got the 1960s run of Marvel comics during the 1970s, reprinted as if they were hot off the press! I was reading the best of the 1960s (Marvel) and the 1970s (Warren) in the same period.

I understand you started out in advertising. What sort of work did you do?
Advertising art was not what I had in mind as a young artist. I first moved to London in the 1980s, to paint

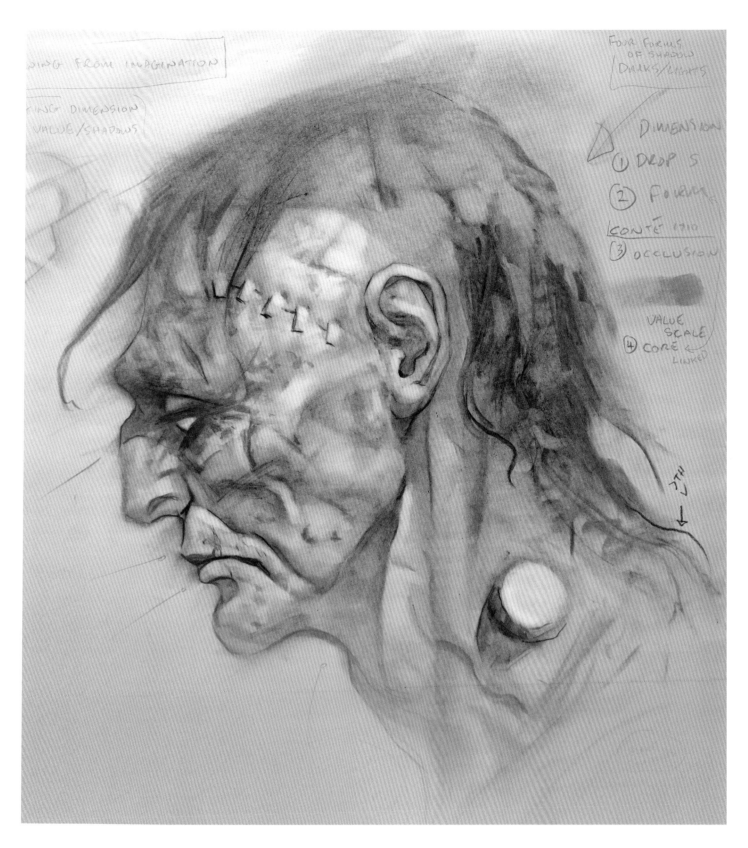

Above: *The Monster;*
16 x 32 inches; charcoal
sticks and charcoal pencil
on butcher's paper.

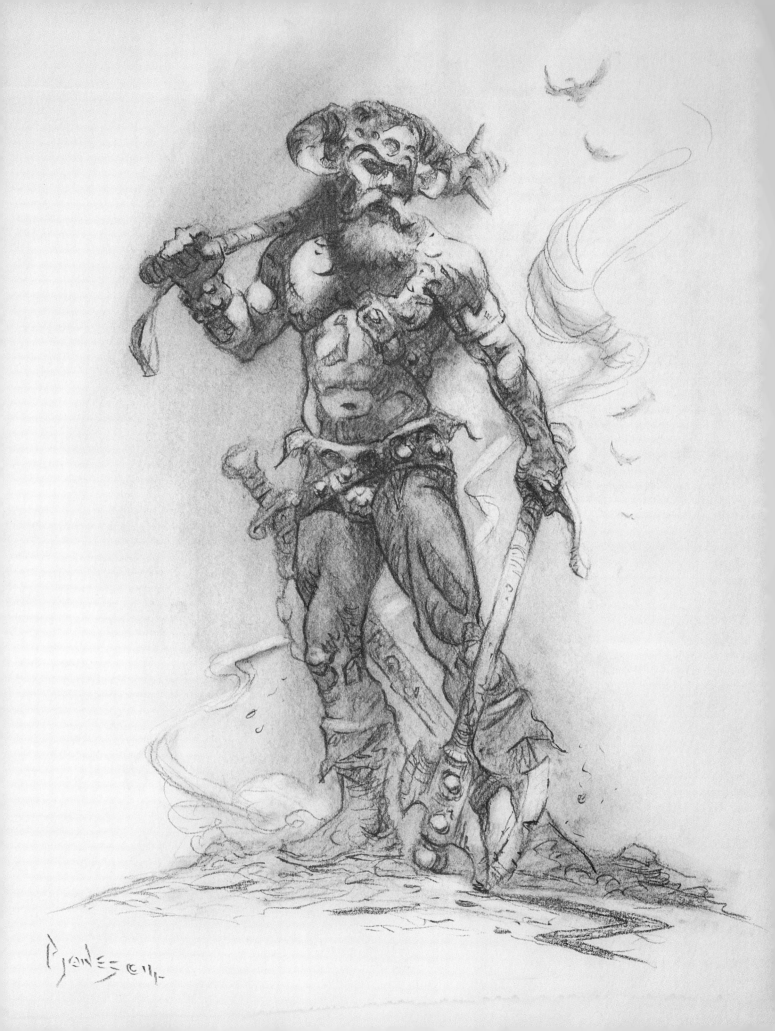

Who are your fantasy art heroes?

The easiest of all questions to answer: Boris Vallejo and Frank Frazetta. When I was thirteen years old my uncle Jim sent me to the store to buy *The Savage Sword of Conan #4* – he was a comic fan and would pass the comics on to me – whose cover was by Boris Vallejo. That cover changed my life: I knew right then, with complete clarity, what path to take in art. Soon afterwards, I discovered Frank Frazetta, and there was no going back. Those were the Warren years and everyone was on fire: Sanjulian, Jeff Jones, Bernie Wrightson, Mike Kaluta, Richard Corben... an amazing generation of artists all pulling out the stops. My eyes were out on stalks!

Do you have any fine art heroes?

Sure, as I grow as an artist I appreciate the old masters more and more. But it wasn't always the case. Belfast didn't have an art gallery with traditional paintings, and it wasn't until I moved to London that I had the chance to see the great works of artists such as Rembrandt and Caravaggio. Among my favourite artists today are John William Waterhouse, Lord Leighton, Solomon J. Solomon and Herbert Draper; I guess the Romantic classicists are where I'm at.

Two paintings that will always stay with me are *Hylas and the Nymphs* by Waterhouse and *Lament for Icarus* by Draper; those works were the fine-art benchmark to me, in the way that Frazetta's *Conan the Destroyer* and Boris's *Vampire's Kiss* were the benchmark of fantasy art. Today I also admire my fellow artists at Illuxcon (a fine-art symposium dedicated to sci-fi and fantasy art), who tend to raise the bar with each show – much as the salon artists of Paris and London did during the 19th century.

Do you use live models when painting?

Yes, I work in the style and technique of the old masters and therefore use models. The difference is I cannot afford to have a model pose for the 100 hours or so I need to paint a canvas, and so I photograph them as reference. Much as I admire artists who don't use models, I also admire those who do – as long as the finish is not photographic or stiff-looking. Artists like Donato Giancola show that modern masters can use photographs as inspiration, in much the same way that Caravaggio used live models. I use the same models for my figure drawing classes and paintings and have come to know them quite well, which helps. I could,

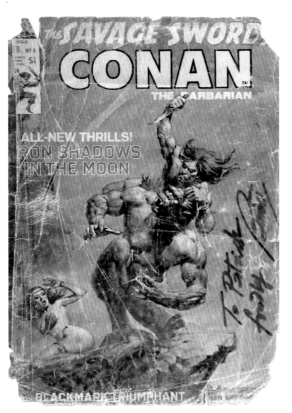

Left: Patrick's copy of *Savage Sword of Conan #4*, signed by Boris Vallejo and showing decades of wear. "This was always packed before I moved to a new home," Patrick says. "It has been a constant source of inspiration, through the best of times and the worst, and has travelled the world with me."

Far left: *The Sentry* colour comp; oil on canvas

of course, make use of some of the millions of images available on the internet and cobble them together, but I want my art to be 100 per cent my own vision (obvious influences aside).

I give my models motivation and a backstory, and will act out the emotion for them to mirror. What I hope gives my art its own voice is my unwavering hold on the original emotion, from the sketch stage through the modelling session and onwards to final art, coupled with my determination to better each painting.

How did you get started in teaching?

When I first arrived in Australia, the advertising agencies were asking for digital art on disc, and so I had no choice but to go back to school and enrol on a digital arts course. Within a month or two I was painting digital commissions in class. Peter Keown, the teacher, threw out the task sheet and graded me on my commissioned work instead. Afterwards, he asked me to teach figure drawing to fashion students. Driving to work through the Sunshine Coast Hinterland had a great freedom to it, and I decided it would be a nice way to break up the studio-bound week. I mostly teach figure drawing now, which is a win-win as I attend figure drawing classes anyhow.

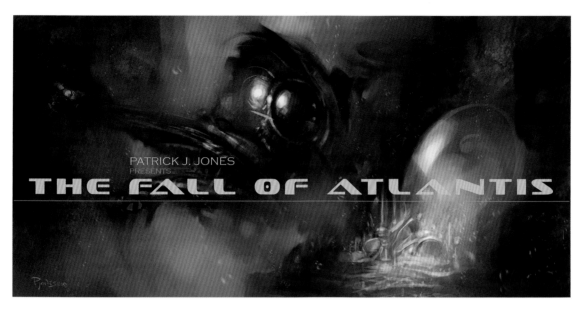

Left: Introduction to *The Fall of Atlantis,* one of the step-by-step digital art movies downloadable from Patrick's online store: www.pjartworks.com.

Right: Patrick is seen here art directing artist's model Alana Brekelmans for *Attack of the Harpies* and future paintings. "Finding a model as expressive as Alana elevates my work to a higher level," he says. "I consider my models to be an essential part of a creative collaboration, and when a stand-out model appears I treasure him or her like gold."

I've heard that you are also quite involved in digital techniques. Can you tell us about that?

The digital stuff was full throttle for the first ten years I worked as an illustrator in Australia. If I wasn't painting digital commissions, I was doing demos for students and conferences. The birth of IX in 2008 brought me back to painting almost exclusively in oils.

I still use digital tools to paint the colour rough stage of an oil painting, and to compose my photographed models. I've rarely used Photoshop for painting, so my digital working method isn't much different to my traditional one. When I paint digitally I use the software Corel Painter, which I find mimics traditional media very well.

I like your dark-toned works, like *The Captive, Valley of the Serpent* and *Palace of Medusa:* what's your vision on these types of dark paintings?

Those paintings are where I was always heading, before life threw up roadblocks. I want to paint pictures that have a sense of otherworldliness that the viewer can escape into, and therefore I call on my own inner demons and emotions to make it the best work I can.

Your beautiful cover for the book *Death's Head Max* mixes your contemporary Classical approach with a retro look from the 1930s; why retro?

When I got that commission, from the publisher Easton Press, I simply decided on a retro look as every other cover was hard-edged sci-fi at the time. If there is no romance in art it leaves me cold. I also wanted to pay a final homage to Frazetta before leaving the nest.

Where does your inspiration come from?

From other artists mostly, but also literature and the movies. The 1960 movie *The Time Machine* for instance, is a constant inspiration. I don't need to see it again to feel the wonder I felt watching it as a kid. If I could paint a picture that would leave such an indelible impression, it would be an incredible thing.

With your skills and experience you could pursue a number of directions; is fantasy your main interest?

Yes, and it always will be. I've painted in many styles and genres over the years and have never felt the same depth of passion that comes with painting the art of the fantastic. I have no doubts about my artistic direction.

Where do you see your art going in the future?

Bigger, bolder paintings – much in the style of the Victorian Romantics. If there is a timeless painting in me – something that's truly mine – I'm determined to find it. I would like to leave the kind of echo Frank Frazetta left behind.

Mike Cody is a fantasy artist and founder of The Frazetta Roundtable, a Facebook Group created for the purpose of sharing and discussing art influenced by Frank Frazetta.

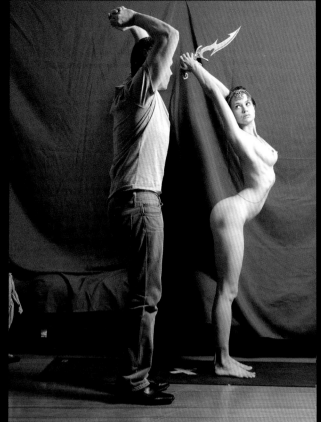
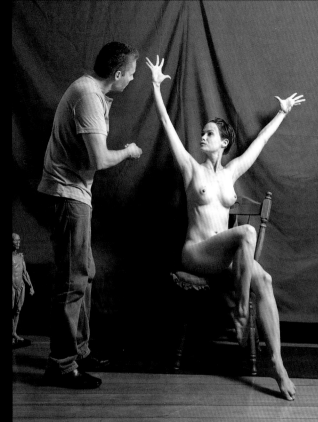
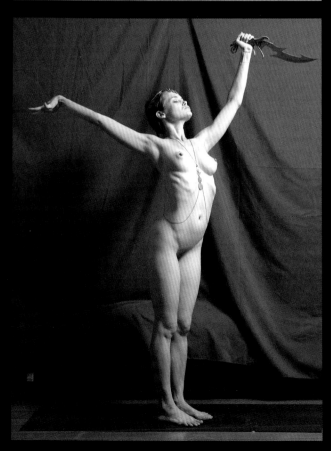
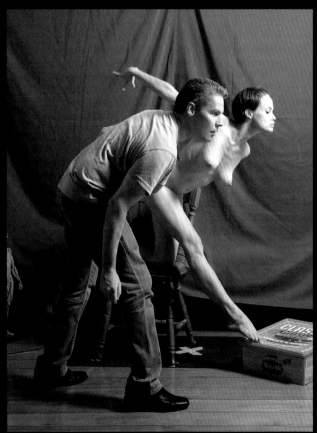

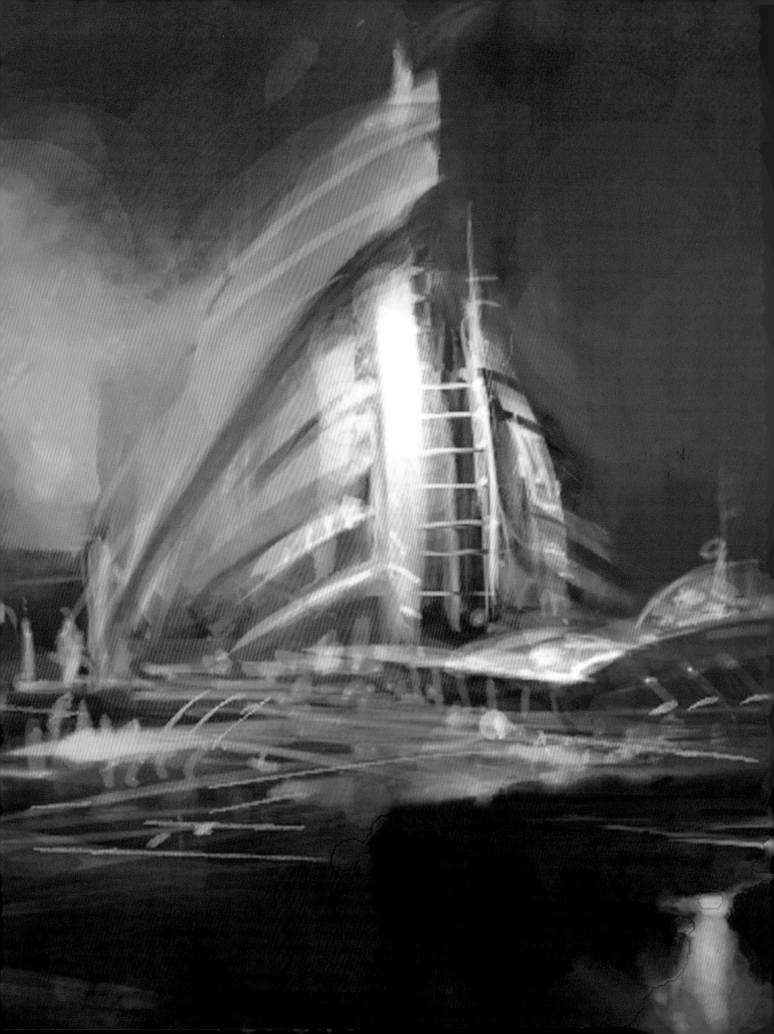

The greater danger for most of us lies not in setting our aim too high and falling short, but in setting our aim too low, and achieving our mark.

Michelangelo (1475–1564)

The Return

The Big City Publishing Years

The following chapters contain a selection of my fantasy and SF work completed from 2005–15. Each artwork contains a story. To begin, in answer to the frequently asked question, "How did you get your start as an artist?", here is a short story on the subject...

When I arrived in London as a young artist in the grim winter of 1984 I had very little money. I slaved on building sites for a pauper's wage and would sleep on the site or in abandoned council flats. Had I known the road would be so difficult, I might have stayed in Ireland, but sometimes ignorance is not only bliss, it can be a force. I gambled a week's wages on promotional postcards and sent them out cold to all the publishing houses, simply addressed to "the art director". Back then there was no internet, just phone books; everything was difficult. I didn't have a clue. Finding freelance work in the Fantasy & SF book publishing market was like trying to grab smoke. Work was commissioned, I discovered, via artist's agents. I was delivered that death blow by a world-weary artist I met, who added, "and... it's impossible to get an agent, as they only take on established artists".

Against all the odds, Janette Diamond, art director at Orbit Books, gave me my first break. She contacted me when I'd all but given up hope. By then I was living in a bedsit (a room with a bed and sink). These were the days before mobile phones, and I shared a coin pay-phone on the stairwell. The little Italian lady down the hall, who spoke almost no English, handed me a crumpled message she'd written, with the words "Orbit Books" scrawled on it, and we both smiled in delight.

I remember staring at my first commissioned work, in awe at what I'd achieved, which was not the painting itself, but the fact I'd bent the pitiless world to my will. Mindful it might be a one-off commission, which would leave me scratching around in the dirt again, I hit on a plan and rang the London agent I desperately wanted: The Sarah Brown Agency. As expected, they told me their books were full, but before they could hang up I played my trump card, saying: "I'd like to show you a piece I've just finished for Orbit Books… I can pop by on the way." It took great composure to sound casual, as my future hung in the balance. The line went silent before they replied: "Sure, we'd love to see it." That day I delivered my first fantasy artwork to a major publisher, and also signed on the books of London's foremost fantasy artist's agent. It was the first summer day in London after an eternal winter, and I strode down Oxford Street like the king of the world.

Those early artworks are long gone, with only fading book jackets as memories. A recession decimated the publishing market, and I bunkered down in advertising art. In 2005 I raised my weary head. After securing publishing agents in New York and LA, I got to work…

Left: *Future Vegas*; 16 x 9 inches; digital

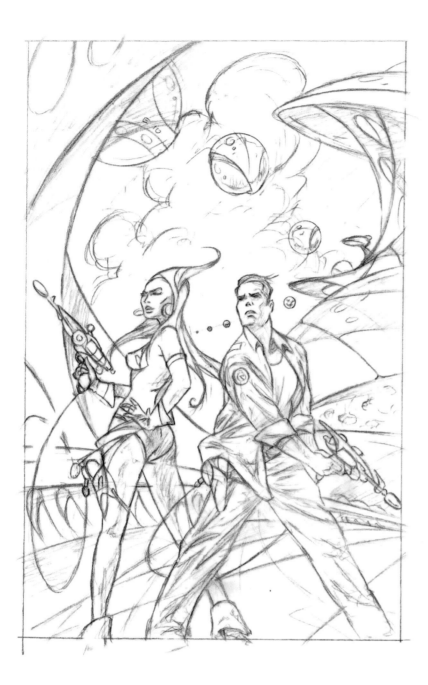

Seen here is my first commission from New York publishing giant Roc Books – the riotous comic novel *Bikini Planet*! The year was 2005, I was living in my newly adopted country of Australia, and I had also enrolled as a mature student on a digital arts course at my local college. Today this strange, early digital art looks further from the work I do now than the work I did ten years previous to it. The problem was I painted it in Photoshop using airbrushes and masks, which create hard edges on the outsides and soft edges on the inside. I was excited to be painting book jackets again but frustrated by my inexperience with digital tools. My original pencil idea, shown left, was rejected as "too serious", and I sadly resigned myself to painting parody. However, it was an incredible beginning and I was well aware of my good fortune.

So there I was, working on the most important commission of my career while also studying as a full-time student. In class one day, I asked a fellow student if she'd pose as the heroine for *Bikini Planet*. She recoiled like a serpent – I guess she considered it a corny pick-up line – and I shuffled off back to my lonely chair, the rebuff compounding the alienation I felt in my new country. I shared my tale of woe with the studious fellow next to me, who happened to be the girl's best friend. Tim, who would become a great friend to me, declared my art "incredible" and vowed to reprimand the girl. He called her over, and with a flamboyant display of diplomacy, sat her down to see my work. When she discovered I was a professional illustrator, she was thrilled. I invited Tim and the class to the shoot and was hailed as a "real artist", which completely reversed my lonely campus experience.

Above: *Bikini Planet*; 12 x 9 inches; pencil rough

Right: *Bikini Planet*; 6 x 4 inches; digital

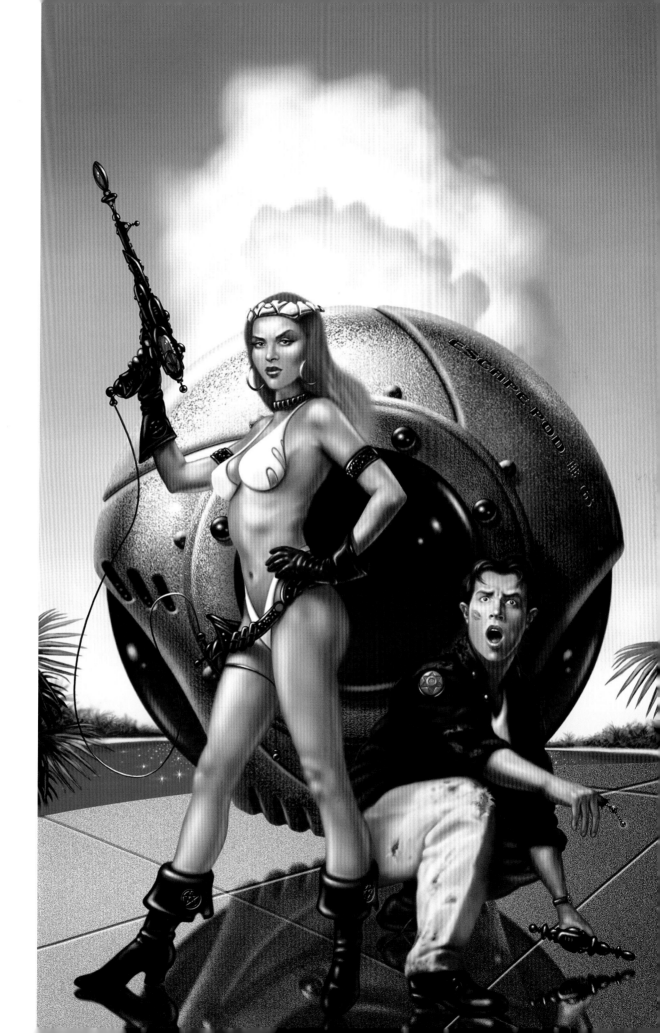

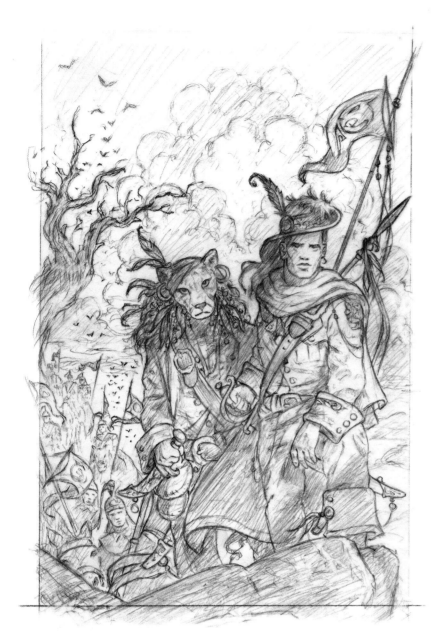

Although *Bikini Planet* got my foot in the door, and was well received, I felt it took a few more book jackets before I hit my stride with Roc Books. *Covenants* was a big improvement on the first cover, but I can see now the residue of fifteen years working in advertising. If I painted this today I would kill most of the brighter hues; everything is colour-saturated, like the "wham-bam!" of the advertising billboards I was used to painting. At the time, though, I remember thinking I had done a pretty good job.

I began *Covenants* in Photoshop, using airbrushes, but the employment of masking tools killed one of the most beautiful aspects of working with traditional oils: the atmosphere inherent in lost and found edges. If every edge shares the same crispness, all essence of depth is lost, along with – most importantly – the sense of wonder found in viewing an oil painting.

The freedom I had felt on giving up traditional airbrush masking techniques years before, inspired me to try the software Corel Painter. Working with just a few basic painting tools, I eased into this strange new digital arena. Lo and behold, I discovered the bridge between traditional art and digital art. Corel Painter – the wonder of the digital age!

My digital arts course was drawing to a close in this period, and one day the class met for a tour of Platypus Graphics, Brisbane's major print company. During the tour my teacher, Peter, drew my attention to a large poster the tour guide had peeled off the press to show the group. "That's a lovely piece of art, Pat," he remarked to me. "Thanks, Peter, it's one of mine," I replied. This revelation was not surprising, as I had illustrated for every ad agency in the city. Peter took great pride in declaring to the company man that the job he held in his hands was, in fact, "One of ours!".

Above: *Covenants*; 9 x 12 inches;
black and white pencil rough

Right: *Covenants*; 18 x 24 inches; digital

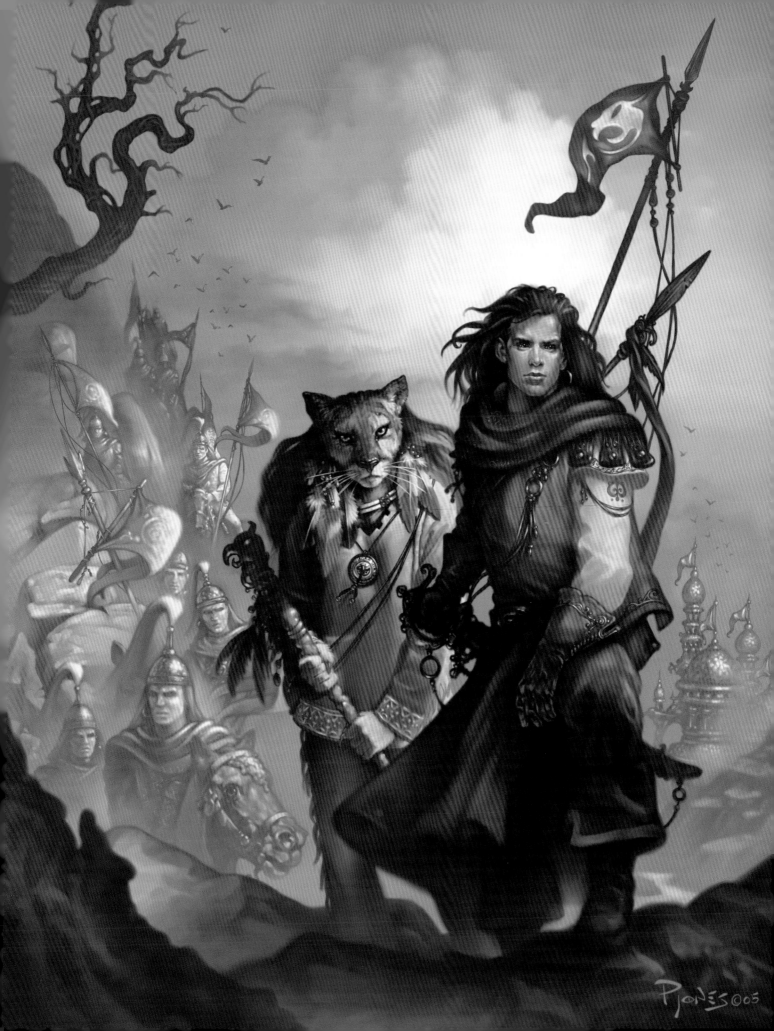

When my digital arts course finished, the anxiety I had felt on my first day as a mature student, eighteen months previously, was a dim memory. Life felt great as I walked through the sun-drenched campus grounds with my diploma in my hand. It was a stark contrast to the day I had left school in Belfast as a young lad; on that occasion we were greeted by a convoy of double-decker buses that drove us directly to the social security office, where we were instructed in how to "sign on" as unemployed. A dismal true story that seems more bizarre with every year that passes.

Once I'd graduated, I had more time to work, and I decided to explore Corel Painter further. I used mostly oil pastels, as the oil brushes still looked too digital to me. Eureka! The oil pastels were more realistic than the oil brushes, and faster too. I customized everything until I had a palette of blenders, papers, and brushes that I saved as "Patrick's Classic Palette". From that point onwards, I was in control of the machine rather than the other way around.

During this period I was also producing romantic "photo-artworks" for another NYC publisher. The photoshoots were fun, but within this genre lurked a particular evil: art direction by committee! This means a committee comprised of marketing staff, alongside the humbled art director, gather to tick off a list of changes your art needs in order to please everyone.

Hollywood goes a step further by herding the general public into free screenings and then asking for their learned opinions. People gibbering in the limelight to justify the free movie, or just to get the hell out of there, have the power to change artistic direction. Art direction by committee eventually forced me to create my online store, where I am now my own art director and gallery owner. The cartoon pirate "Morgo" seen here was a promo for my movie tutorial on creating characters using digital tools.

Above: *Space Pirates: Morgo*;
16 x 4 inches; digital

Right: *Treasure Island: The Pirate*;
18 x 24 inches; digital

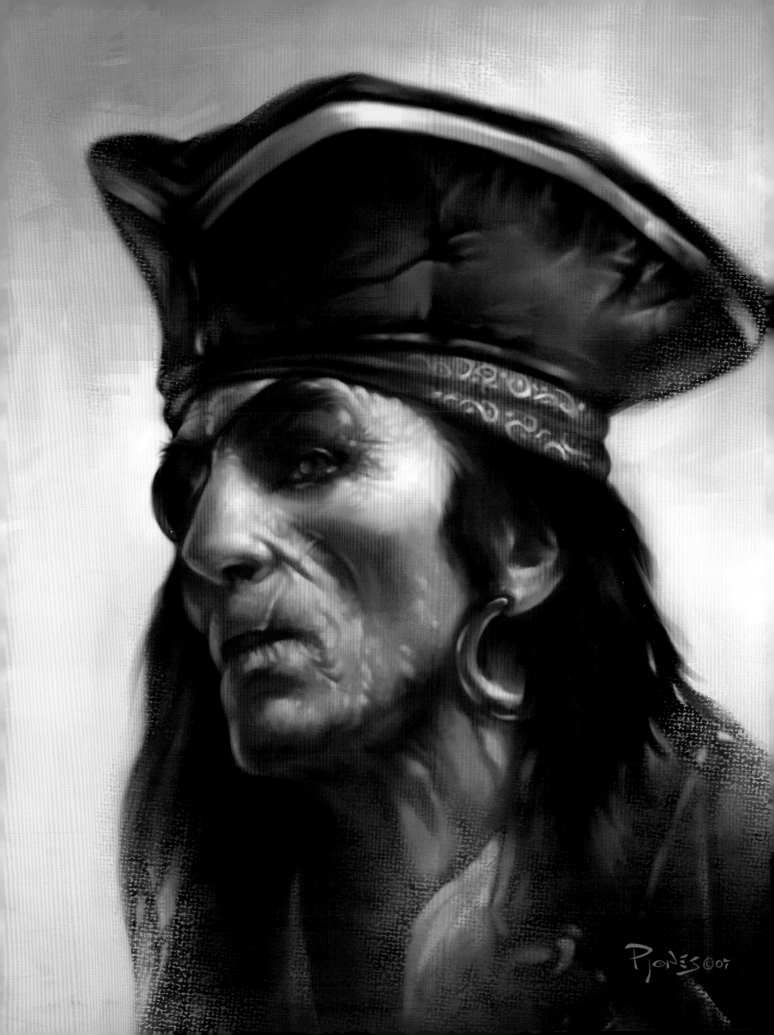

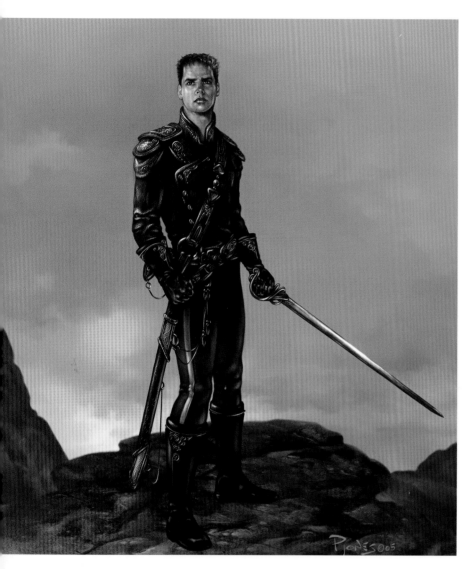

Roc Books then commissioned a series of paintings from me for their bestselling title *Deathstalker*. This time the pressure was tenfold, for I was to follow in the footsteps of one of the greatest fantasy artists in history: the mighty Donato Giancola! Donato had painted the covers for the first printings, and they were intimidating to say the least. Pictured left is my first study of Deathstalker. He has dark hair, as described in the book (although, regardless of that fact, the publisher preferred a blonde-haired hero!).

Let me pause for a moment to offer a cautionary tale to young artists regarding the importance of meeting deadlines. One of my big breaks was a referral to Pan Books when I was in my early twenties. As the secretary walked me in to meet the art director, I spotted an incredible painting leaning against his desk. When the art director told me I was taking over from the artist who had painted this wonder, I gulped and then gushed with admiration for it. To my surprise, the director's eyes bulged with rage: "What, this crap!?" he roared, lifting his foot to smash the artwork before regaining his composure. "This @#$! has missed every deadline I've given him. I don't care how great he is, I've got too many @*$%&!# things to worry about without his constant excuses!"

I stood in silence, as he was clearly at his wits' end. Finally, he looked at me through the floppy hair fallen over his eyes and said: "I hear you are good with deadlines. Can you paint me a picture within a week so we can get back on schedule?" I knew there was no way I could match that level of expertise – I was simply too young – but that wasn't the question. "Yes," I said. A week later I handed in finished art to a relieved art director, and picked up another commission to take home. I may have been a generation behind the other artist, but ultimately, I was more professional.

Above: *Deathstalker* study; 9 x 12 inches; digital

Right: *Deathstalker*; 18 x 24 inches; digital

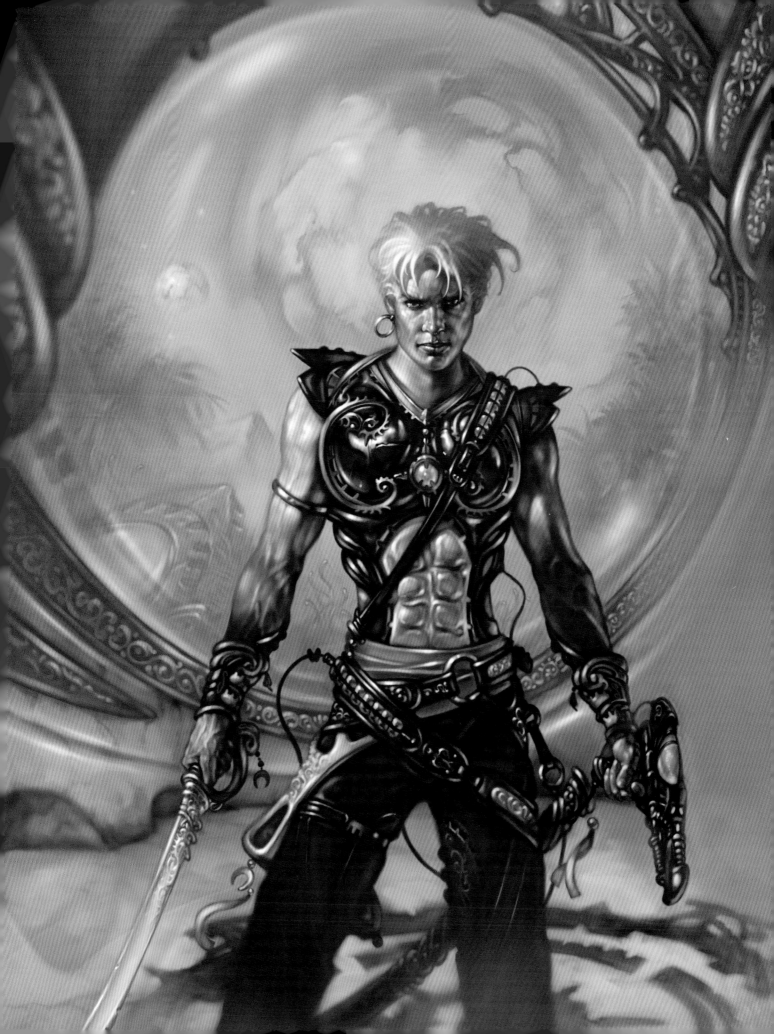

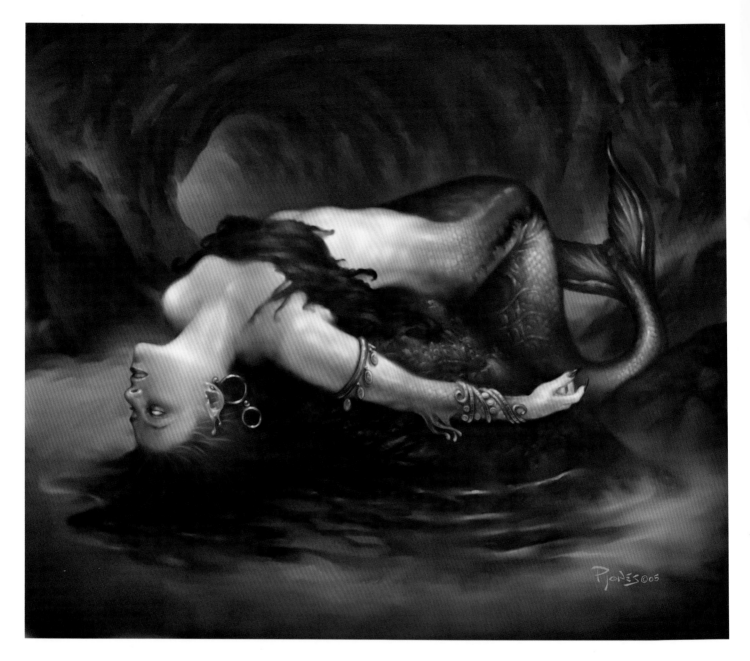

When my LA agent called with a commission to paint a book of mermaids, I needed a model to convey the drama and emotion in my sketches. I set my hopes high and after a few false starts my wife, Cathy, introduced me to her top drama student, Tora Hylands. Although I illustrated the mermaids book, I have never seen it, despite the fact that complimentary copies were part of the contract (this kind of huckster promise is, unfortunately, common).

Tora became the bedrock of my digital work, and my early traditional paintings, too. She modelled for the two artworks seen here, and although very young at the time, she not only understood my sketches and

notes, she added further depth with her acting skills. I had found the perfect model. *Darkdreamer* was rejected by the publisher as "too erotic" (although the pencil sketch had been approved). Apparently, they had not expected the finished work to be so realistically rendered. (Three years later, I produced an oil-painted version of *Darkdreamer* for the first IX show; *see pages 100–101*). The digital version was my first ever work selected for inclusion in the Spectrum Art Contest, which is considered the premium fantasy art collection in book form. *Darkdreamer* will always be one of my favourite paintings, both for the time period it evokes, and for the personal artistic milestone that it was.

Above: *Darkdreamer;* 18 x 24 inches; digital

Right: *Amazon Queen;* 18 x 24 inches; digital

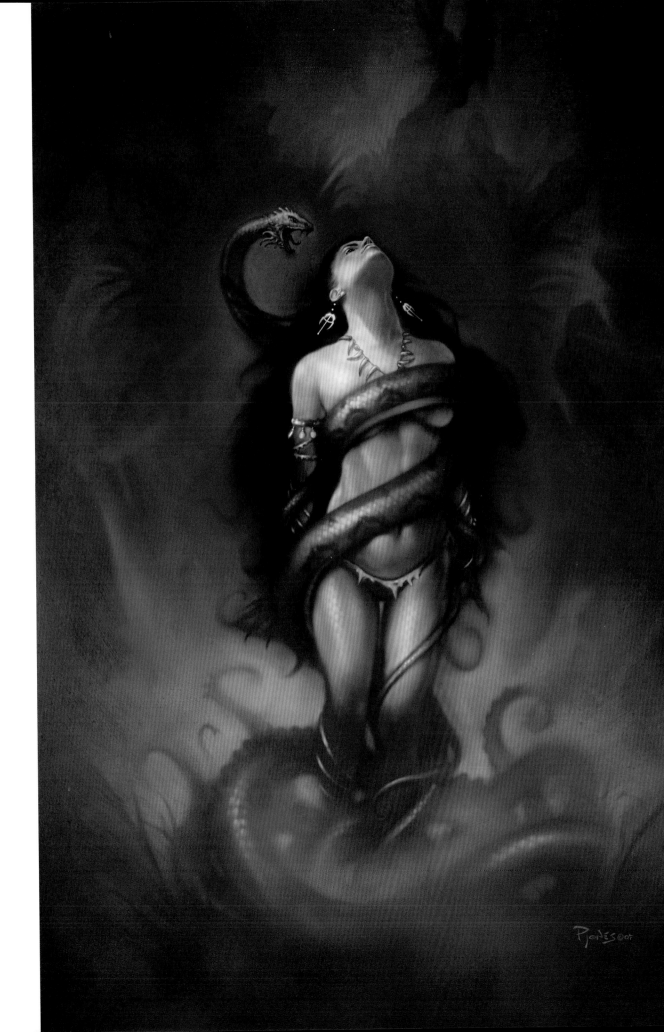

Forest Sprite; 18 x 24
inches; digital

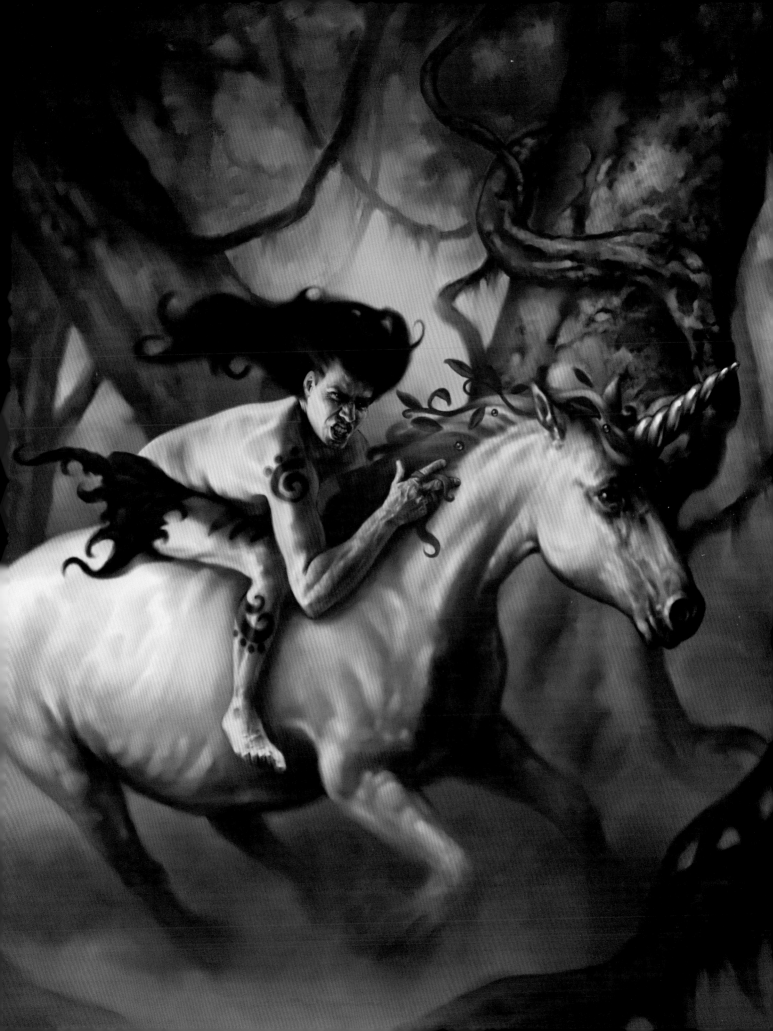

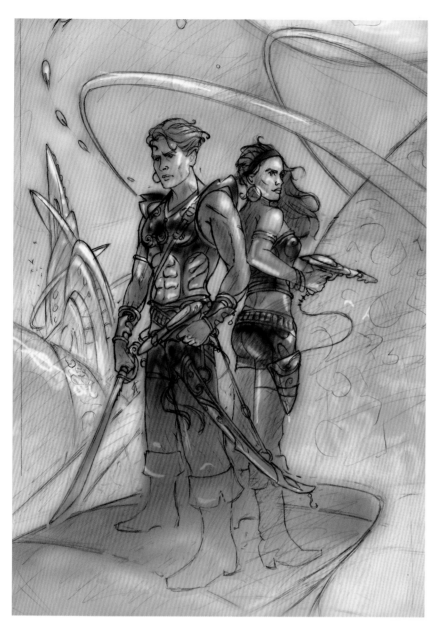

With *Deathstalker War*, I was probably still over-blending – a hangover effect from learning digital art in Photoshop – but my constant experimenting in Corel Painter was paying off. By this time, I was working round the clock with my New York and LA agents: a feat made possible by internet broadband and FTP sites that enabled me to send large files. My digital arts course had taught me useful stuff about file handling and delivery that just months earlier had been as alien to me as linear algebra.

I was working so much that I had almost forgotten to appreciate my good fortune. By taking a leap of faith I had fixed my derailed art career and was once again following in the footsteps of my art heroes, Frank Frazetta and Boris Vallejo. It was also at this point that I realized how prudish book cover art had become since the days of Frazetta, when book jackets commonly featured full nudity.

My model for Deathstalker was Max Oberoi – the living embodiment of the character, and despite his Hollywood looks, not a professional model. If I had found asking a girl to pose difficult, approaching Max was fraught with danger. Fortunately, Max was one of those rare beasts: a fellow totally unaffected by macho hang-ups, and one of the nicest guys I ever met.

This was also my first *Deathstalker* using Tora Hylands as a model. The relative innocence of the heroine's leather shorts in this artwork caused a storm in the art director's teacup. "Why is her ass naked?" my agent complained. It was decreed there and then that the offending buttocks be obliterated from sight. Shown here is the art before I reluctantly airbrushed a contemporary mini skirt on top by request.

Above: *Deathstalker War* comp;
9 x 12 inches; scanned pencil and digital colour

Right: *Deathstalker War;* **18 x 24 inches; digital**

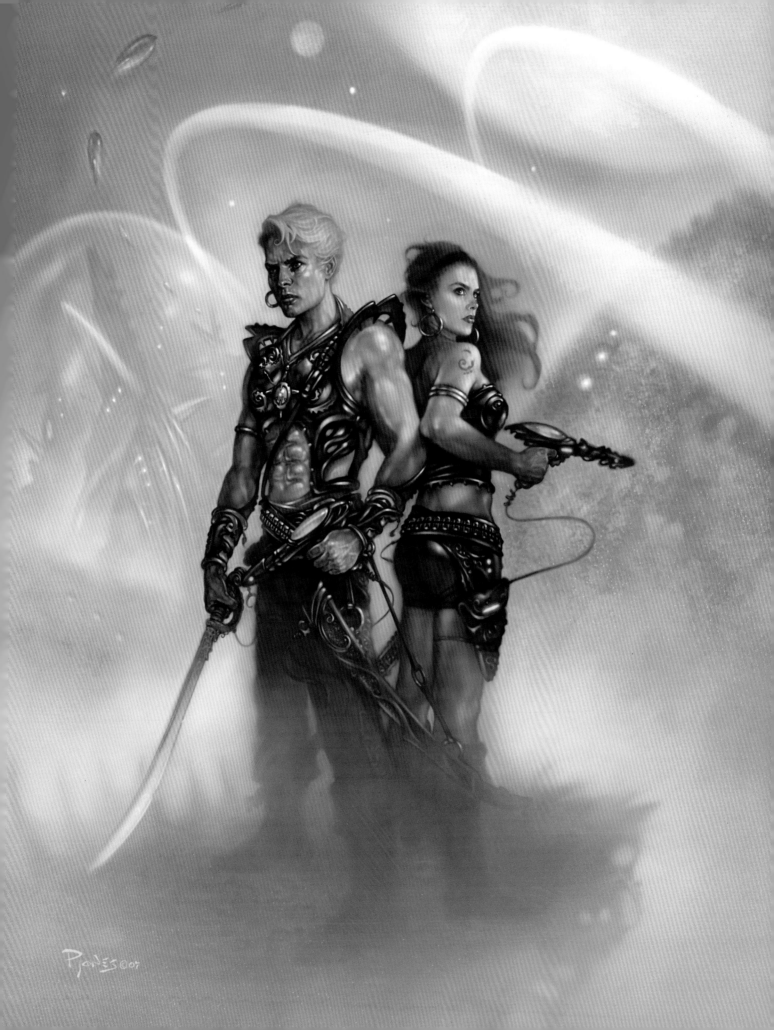

While producing *Deathstalker Destiny* I was barely aware of the digital tools any longer, as I was too busy painting on screen to notice the method. Although this is exactly what I had hoped would happen, I was surprised at how quickly it came about. During this period I was also using another digital programme, Adobe Illustrator, to draw hundreds of cartoons for children's publishing. Apart from the sketching side of things, my total professional output was now digital art, with only Corel Painter – with its traditional feel – retaining the ghosts of my past.

The art director initially rejected the sketch idea for *Deathstalker Destiny* as it gave away the possible death of the hero. I rarely fought for one sketch over another – after all, they should all be equally good enough to finish – but feeling this one had the most iconic potential, I pointed out that superhero comics featuring the hero's death on their covers sent sales through the roof, as they brought back readers who had long since given up on the title. Everyone wants to know how it all ends, right? Being a smart egg, he had a re-think, a head scratch, a chin rub, and then gave the go-ahead.

Above: *Deathstalker Destiny* roughs; 9 x 12 inches; digital

Right: *Deathstalker Destiny*, 18 x 24 inches; digital

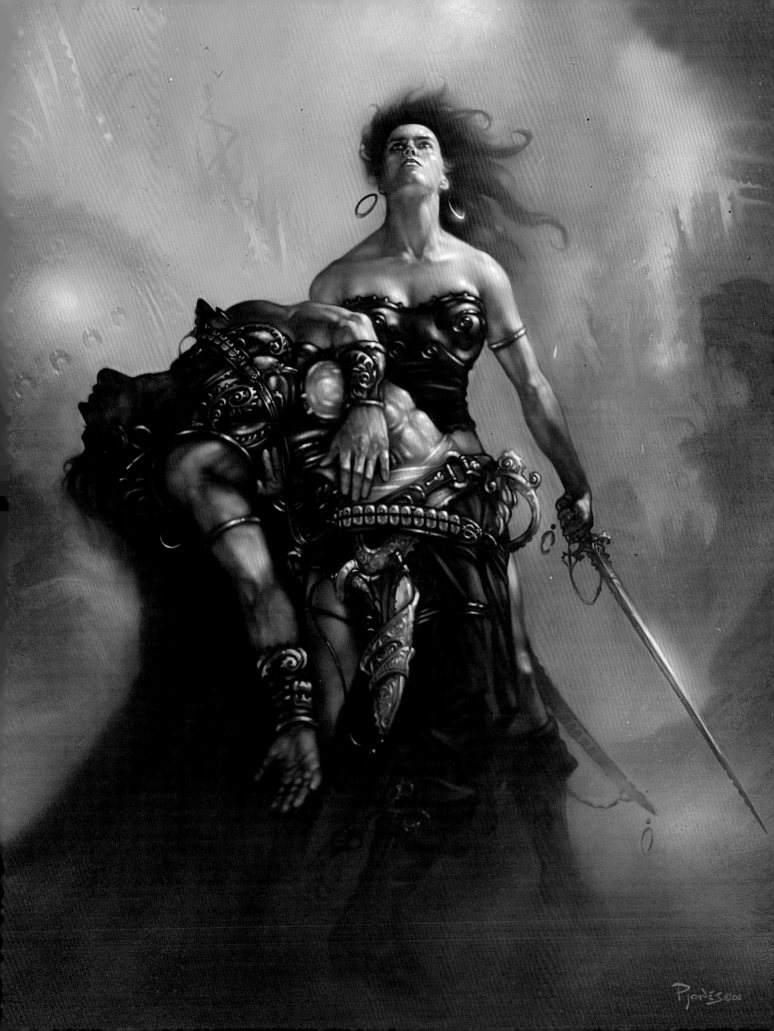

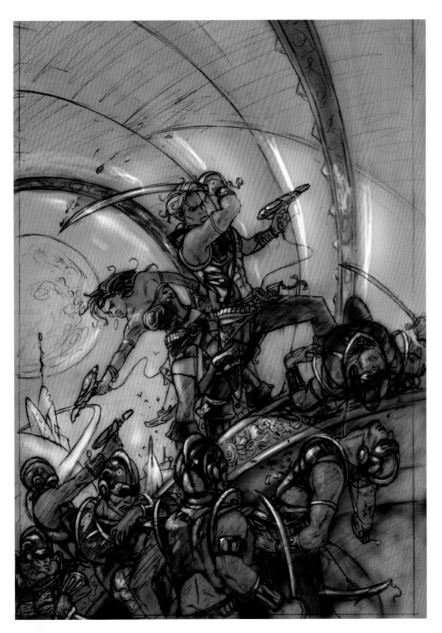

With *Deathstalker Rebellion* I wanted to make a big impression. Everything was falling into place. Tora was bringing my sketches to vivid life with her emotional drama, and I was gaining recognition for my work in the genre. Max posed here, not only for Deathstalker, but also for the other soldiers. I clearly remember that the photoshoot – held on my back verandah – was great fun, with toy guns and swords strewn everywhere. It was basically three grown-ups playing at being kids again. What a time that was!

The energy that went into those posing sessions was incredible. After the *Deathstalker* shoot, we headed to a well-known sandwich shop franchise and feasted like wild beasts on bread and meat. Even the ever elegant and stylish Tora devastated a foot-long crusty loaf in minutes, pausing only to exclaim how much she loved food, before going back in for the kill. There weren't enough napkins provided to clean up that war scene.

Above: *Deathstalker Rebellion;*
9 x 12 inches; pencil and digital

Right: *Deathstalker Rebellion;*
18 x 24 inches; digital

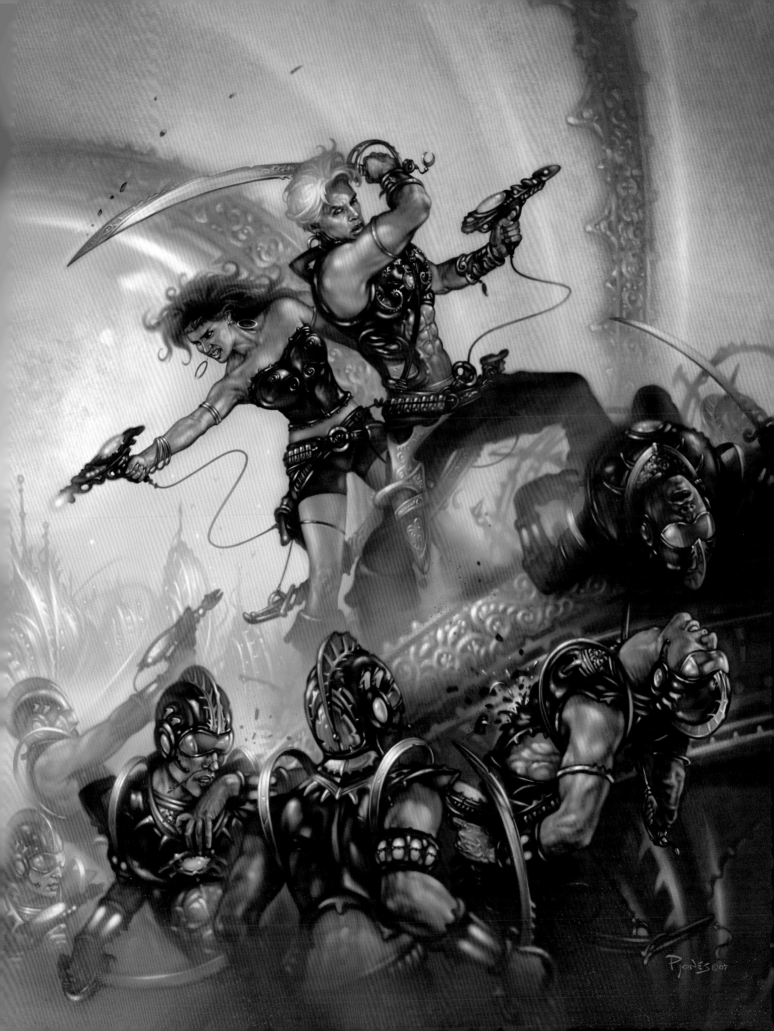

By 2007, I was having a most unexpected full-blown love affair with digital art, but there was one thing that drained my enthusiasm – the constant requests to paint on separate layers for the art director to play with. Defiantly, I painted *Deathstalker Honor* on a single layer, and Ray, the art director, immediately squashed my flaccid protest by asking me to separate the background from the foreground. This meant painting a full background, just like an animated movie cell, with cut-out figures that could be moved around, either on purpose or by accident, thus threatening the foundation of my carefully thought-out composition.

This erosion of my artistic integrity was compounded by the merciless art director of the romantic photo-art jobs I was doing, who was beating me up concurrently. Both she and Ray worked for huge corporate publishing houses with big money on the line, which meant every brushstroke and blob of colour came under close scrutiny. The relentless changes demanded by the photo-art director had me painting like a feverish puppet on a string, until I did whatever she asked to end the mental torture.

I had reached the place I had fought tooth and claw to get to, only to discover I was in a trap. This kind of brutal art direction was not a new phenomenon:

at some point all artists will fall into the orbit of that mercurial force. However, I learned early on that sometimes art directors cannot see the difference between artwork before and after it is altered: during my early years, an art director asked me to brighten a colour in an artwork – an amendment that would have killed the very soul of the work. I tried to argue the case for not changing it, but his ears were barricaded by ego. He was convinced that the colour needed to be ablaze! Early the next day he came into the studio before I had conjured up the strength to even start the alteration. He picked up the artwork, which hadn't been changed in any way, and said, "See: much better!"

For all these artistic hurdles, I was grateful to Ray at Roc Books for giving me the chance to learn on the job, and I did my best work for him as the *Deathstalker* series neared its end. Afterwards, I flew to New York City to meet my agent, Betty, for the first time, and also to see Ray. I had been to Manhattan on a previous trip, and it had left a huge impression on me – with its wailing police sirens and the palpable energy of the neighbourhoods and streets – but this time I arrived as an artist rather than as a tourist. As I sat in the sun outside an Italian restaurant on the Lower West Side, talking with Ray, the city felt like home.

Deathstalker Honor;
18 x 24 inches; digital

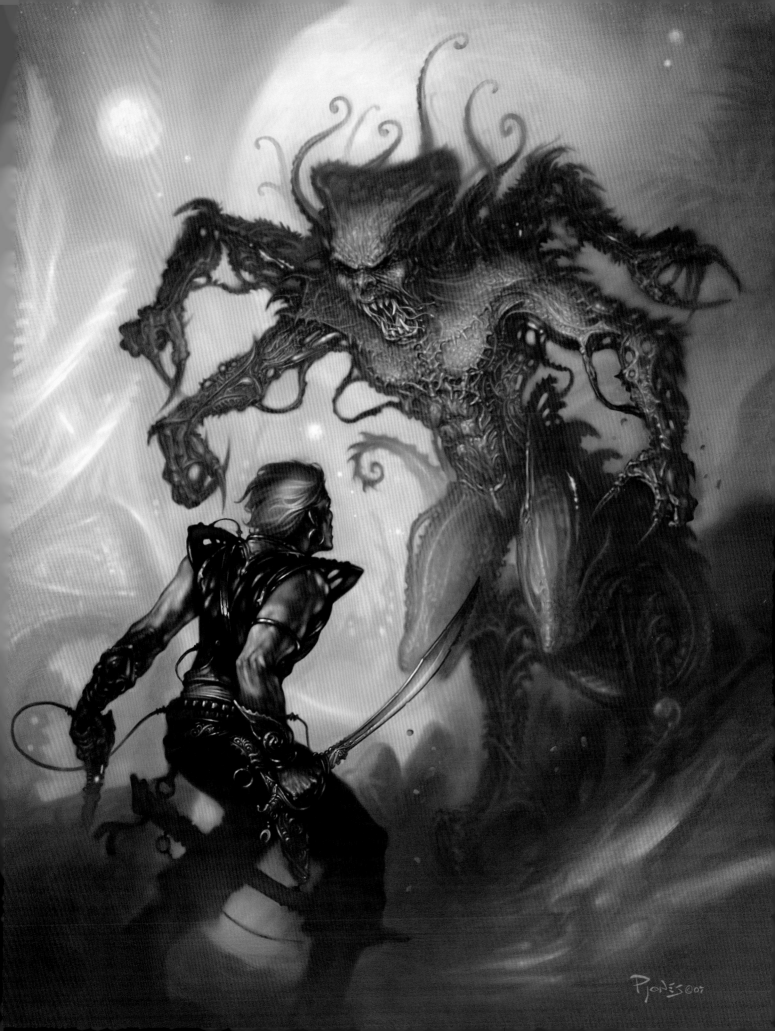

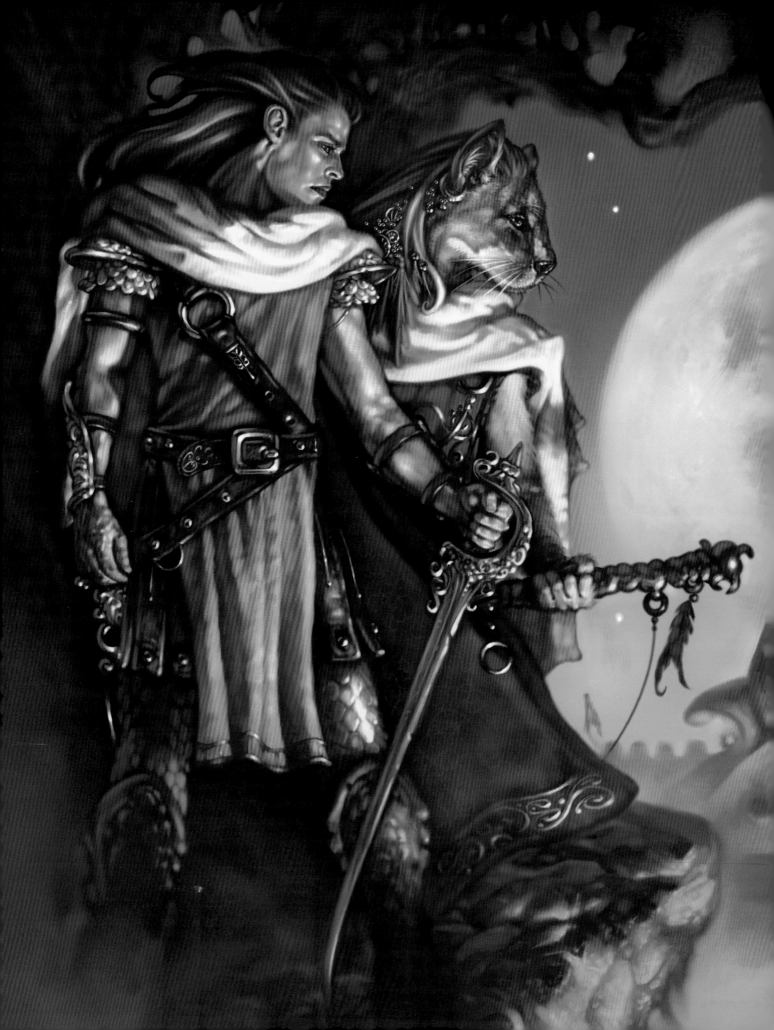

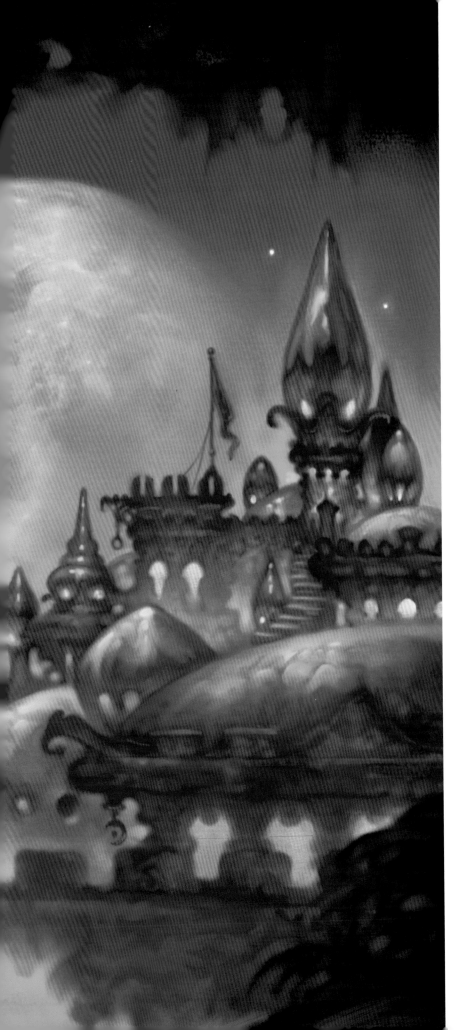

This is one of the final book jacket illustrations I did for Roc Books. Ray gave me almost total freedom to paint *The King's Own* as I pleased, making this my favourite work from that period. I posed for both characters – wrapped in blankets and holding a broomstick. The self-timer remote control for my camera was one of my best early investments – it saved me a lot of money when I couldn't afford models.

During this time I also worked at Warner Bros., on the Gold Coast of Australia. I got my break as a concept artist there after hearing about a wrap party for the movie *Inspector Gadget 2*, held at a swish riverside venue called The Powerhouse. Aware that the building was open-plan, I took a punt that I could stroll right in there, and sure enough, I breezed in undetected; grabbing some hors d'oeuvres and a drink completed my disguise. I ended up schmoozing with movie producers and handed out my business cards.

The following Monday I arrived at Warner Bros. Studios for an interview and strolled through the back lot with my pass and portfolio in hand. I remember the magic of it: walking by a full-scale ghost ship and dockside in the early morning sunshine; saying hello to some extras dressed as cowboys; passing trailers with famous actors' names written on simple placards. It was a marvellous moment for a lifelong movie fan.

With a contract signed, I turned up the next day for work in my old, beat-up car, which I planned to hide behind a bush. Unfortunately, parking was designated facing the wide studio windows. Every other car was showroom new and made my pile of junk look like an impounded derelict. When I asked the other artists where they had parked they said, "Out the front." I asked why it was they all had the same car model. They looked bewildered when I admitted I hadn't negotiated a company car as part of my contract. "You mean, you're paying for your own petrol, too?", asked one fellow, highlighting the fact that I was a rookie. "Did you get your per diems?" asked another, sounding like a giant bag of coins as he walked past. I hadn't. (I later discovered these were a daily cash allowance handed out in a little brown bag under the cover of shadows). I stood there like a hayseed.

Thankfully I was able to earn their respect when I sat down to draw, but, boy, did I learn a lot about negotiation from those guys for my next movie gig.

The King's Own; 18 x 24 inches; digital

While I was busy working on mass-market book jackets, I got a call from Betty in New York with a commission she felt was important. It was for the prestigious independent publisher Easton Press, which republished literary classics in high-quality, leather-bound books with interior art. I did the work, delivered a single-layered file to them – flat as a pancake with no chance of the artwork being changed or figures moved around – and then waited for the fireworks. Instead, their art director thanked me, saying it was great to see traditional work again. To my amazement, he believed it was an oil painting!

Although this close-up of *On the Beach* seems clumsy by my traditional standards today, you can see how painterly Corel Painter brushes can look, due to the varying degrees of hard and soft edges possible with their blending properties. This artwork represented a huge turning point and prepared me for my return to real oil painting: almost like a flight simulator pilot preparing to fly for real.

If you ever wonder why artists and actors take a pay cut to work for independent companies, it can be summed up in two words: artistic freedom. In the years between 2005 and 2009, I worked with Easton Press on and off, and I don't recall any art directorial interference of any kind. This of course would result in some of my finest work, which reached a milestone peak with my Frankenstein piece – featured in the Horrorworks section of this book (*pages 66–67*)

On the Beach was an apocalyptic tale set in Australia, and it resonated with me at the time as I had just become an Australian citizen, and the country still felt huge, exotic, and strange. The novel proposed that, in the aftermath of an atomic war, Australia would become humanity's last refuge: a notion that gave me a somewhat selfish feeling of comfort.

Looking back at the other artwork featured here, *Cusp*, I can clearly recognize the period before my digital art looked more traditional. A bit like the 1960s before The Beatles grew beards and created a whole different sound to their music.

Above: *On the Beach* close-up; digital

Right: *Cusp*; 18 x 24 inches; digital

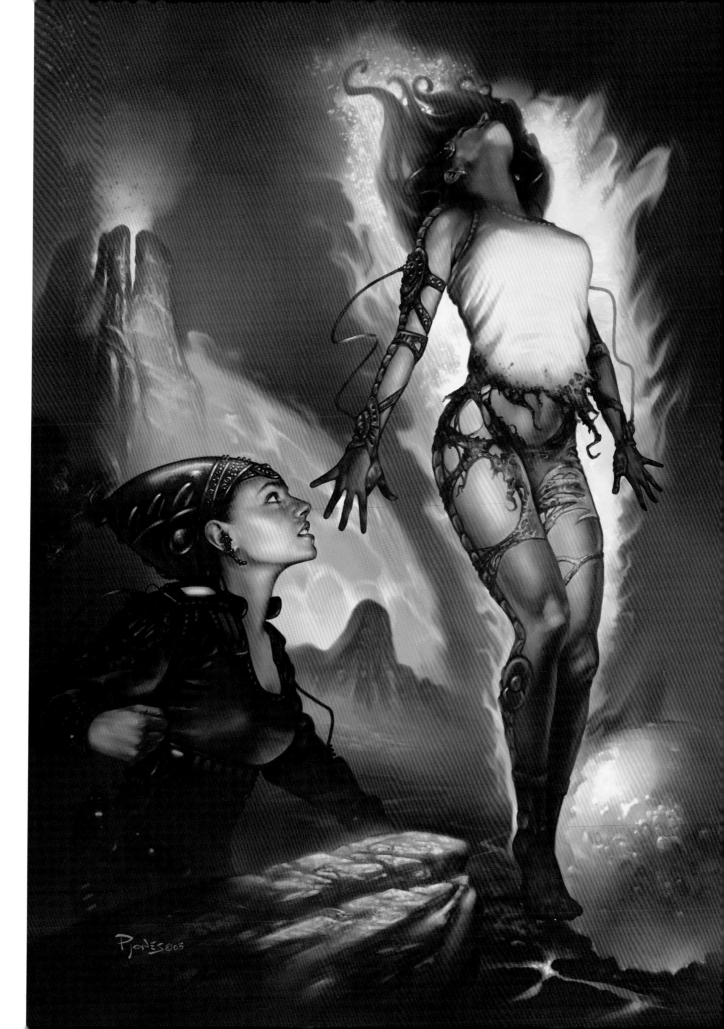

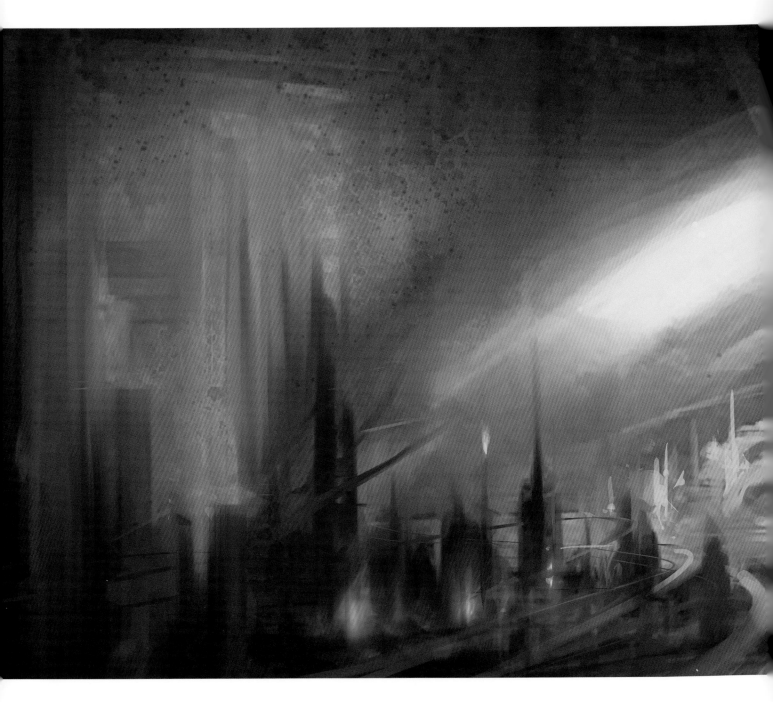

With my publishing work keeping me chained to my desk for long periods of time, I was in serious danger of becoming a hermit; luckily, I was rescued by my old digital arts teacher, Peter Keowen, who dragged me out of my cave to teach fashion students how to draw the human figure. And so began my teaching career.

At first I thought that two days a week spent in the classroom would be too much time spent away from painting, but in fact, it not only got me into a more organized work pattern, it made me a better

artist! I discovered that having to demonstrate *how* art is produced is a learning experience all in itself. Although it left me exhausted, the two teaching days added to my work schedule hardly made a dent in my professional output.

Becoming a teacher made me realize how much more I needed to learn myself. The more I expanded on drawing and painting techniques, the more research I needed to do to fill in the gaps in my knowledge. It was incredible how much I thought I knew, and how much more I discovered there was to know. Today,

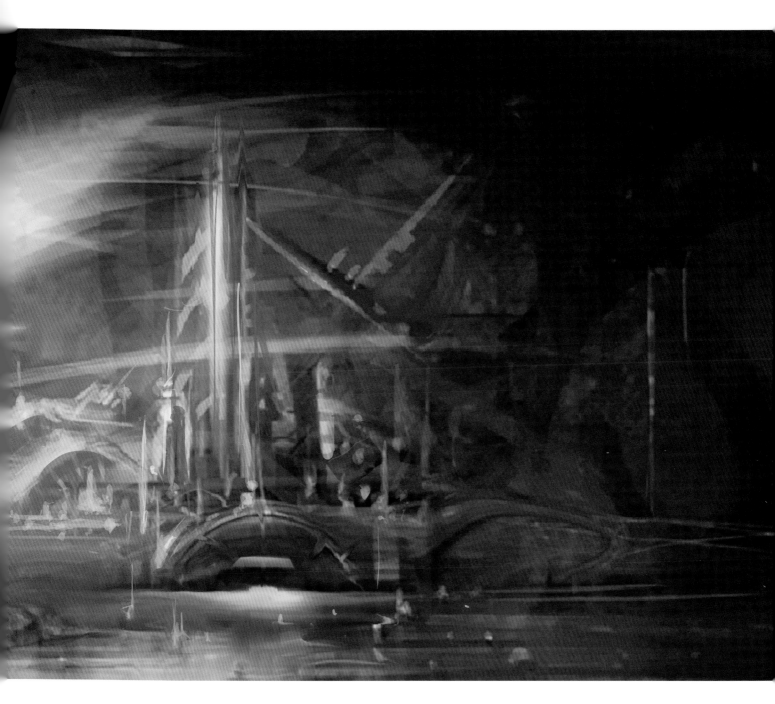

when I tell my students, "You don't yet know how much you don't know," I see bewilderment in the eyes of those as yet unsure of their future direction, and a sense of wonder in the eyes of those who are totally committed to becoming artists.

Featured on the following pages are a series of demonstrations I painted during my teaching classes, and at various expos during question and answer sessions with the audience. I always advise my students to create a backstory for their artworks, for I find that without such a structure, their art tends to become

shambling and they grow bored and frustrated. As I grew the art shown above, *The Ghosts of Brooklyn,* out of random strokes, I held in my mind the idea of a future New York City that had become a gated community for the rich and powerful. As the painting progressed, I imagined that the rich had destroyed Manhattan's bridges and tunnels, leaving only the Holland Tunnel, which now served as a gateway only accessible by yacht. In the foreground of the painting is an ancient and run-down Brooklyn, where the poor remain in the shadow of Manhattan's golden glory.

The Ghosts of Brooklyn;
16 x 9 inches; 90-minute live demonstration; digital

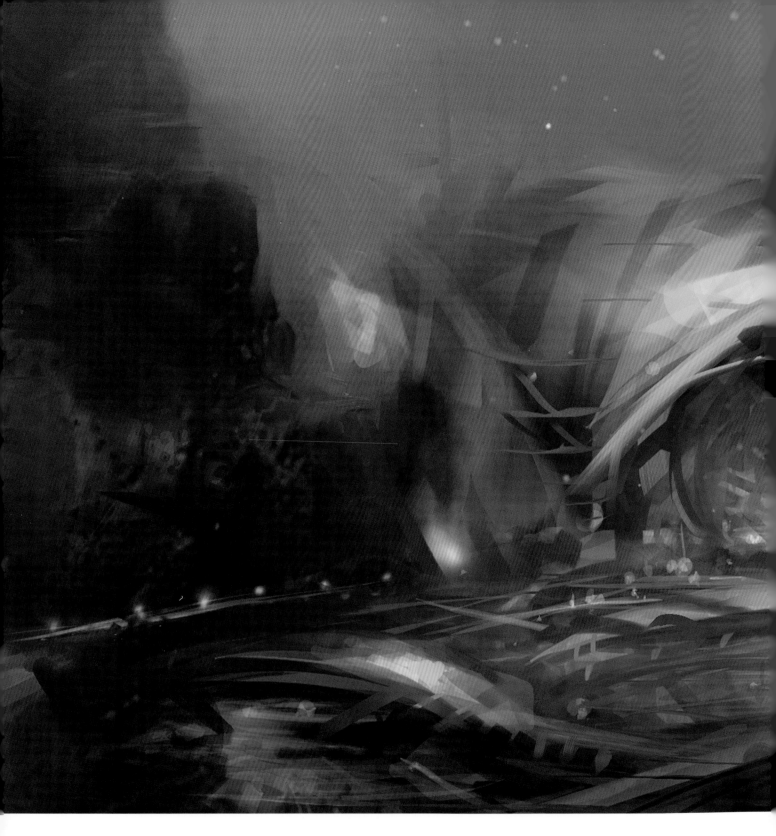

Carnival 3000 AD evolved as it was being created. Shortly after arriving in Australia I went with my new wife to Sydney Harbour to celebrate New Year's Eve, 1999/2000, and it obviously left a subliminal impression on me. This demonstration was recorded as a movie and is available as a download on my online store. In it, I'm working from my imagination, changing ideas as I go until I find what I'm looking for, all the time voicing my thoughts. I look forward to revisiting these demo movies in my old age, to witness a true reflection of myself as a young artist, rather than relying on a faded memory.

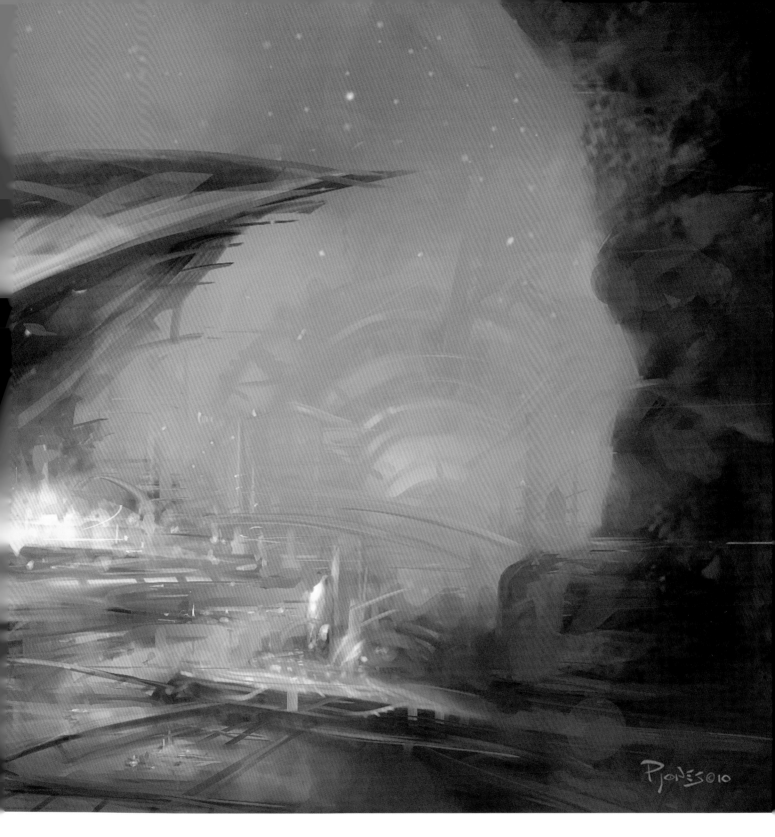

Carnival 3000 AD;
16 x 9 inches; 3-hour live
demonstration; digital

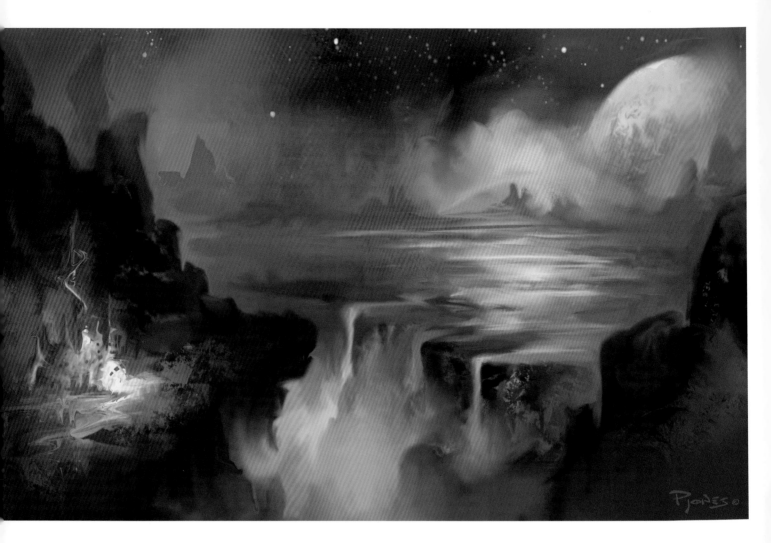

Teaching provided me with the opportunity to experiment with digital media more than I might have done during my normal workflow, and ironically, it afforded me the chance to be a student again. I remember painting *Broken Android* while teaching Photoshop. The image started out as a lesson in photobashing, which is basically cobbling together photo-reference, skewing and transforming objects, and painting on top – a method commonly used by concept artists in the movie business. It was only when I brought the image into Corel Painter, and worked with that program's traditional media brushes, that I felt some emotion coming through.

Broken Android was one of my first digital images mistaken for traditional oil-painted art. Years after it was completed, collector Paul Lizotte asked to buy it and so I painted him a traditional version, *Born to Die*, which is shown on the contents page of this book. *Alien Landscape* is another painting I produced for my online store as a movie, this time working exclusively in Corel Painter without photo-reference of any kind. This was one of the digital paintings that helped me find my way back to traditional painting.

Another advantage to teaching was that I was basically getting a free training course in public speaking – something that would become a great asset later in my career. I distinctly remember the first time I stood in front of a class and tried to speak. I was genuinely surprised to find myself frozen with doubt and fear; it was like a living anxiety dream.

What also surprised me was just how exhausting teaching was. All the preparation, demonstration, and grading; the huge classes; the one-on-one student help (with another student's hand always raised in the background); the occasional violence; and most draining of all, dealing with human emotions. I always raise an eyebrow when someone remarks on how easy teachers have it – teaching, rewarding as it is, remains the toughest job I have ever done: and I used to pick-axe frozen tarmac on the streets of London.

Above: *Alien Landscape;* **16 x 9 inches; 90-minute movie demo; digital**

Right: *Broken Android;* **18 x 24 inches; digital**

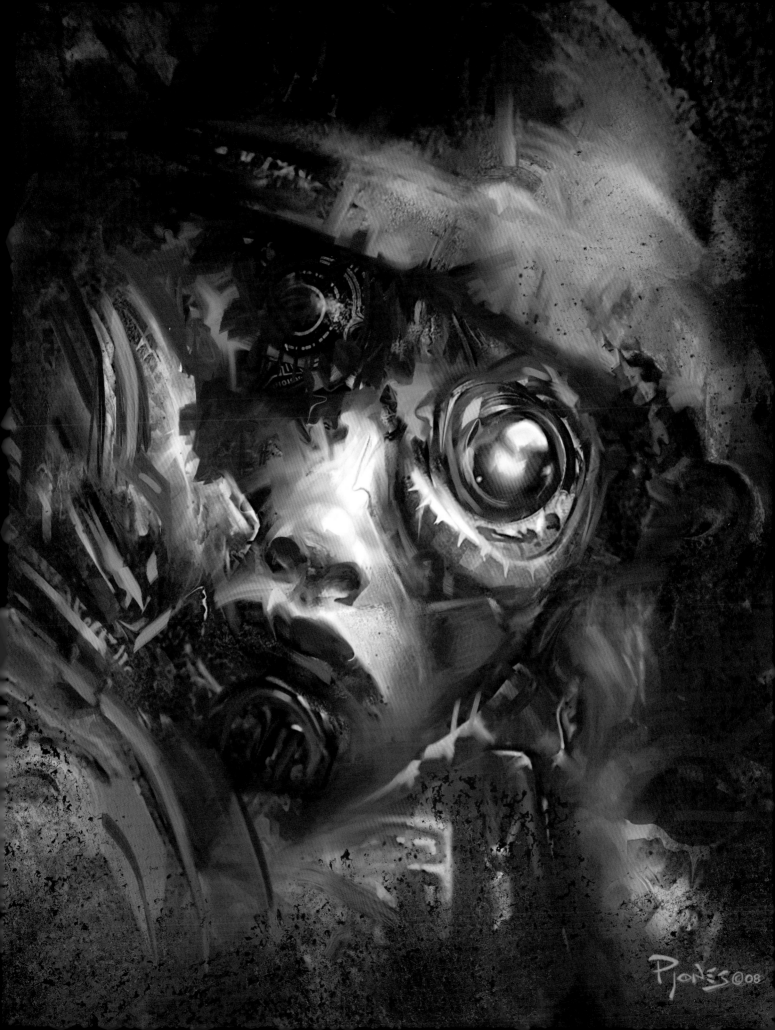

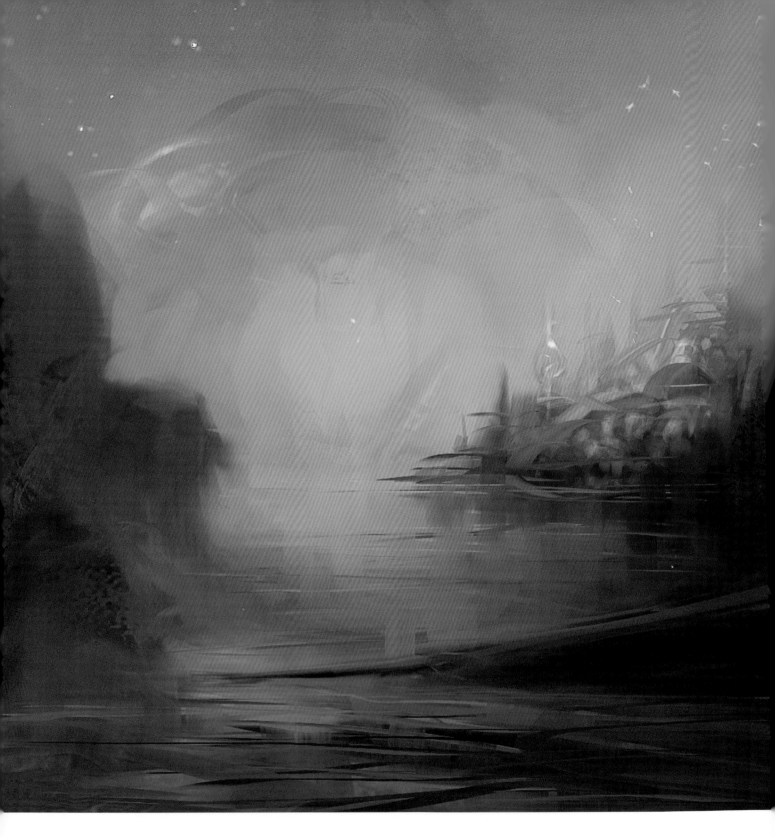

Future Babylon was another demo I documented, this time with screen shots for my downloadable online book, *Digital Painting Techniques*. There is not a lot of scope for random effects in digital art, but some exceptions are the distortion tools in Corel Painter. I used a lot of "bloat" and "pinch" tools here to create distortions to the underlying art that I then worked on top of; this gave me lots of shapes and new ideas I might not have thought of. Even though the media used is worlds apart, I felt a very strong connection with the Romantic landscape work of the English artist J.M.W. Turner (1775–1851) when painting this.

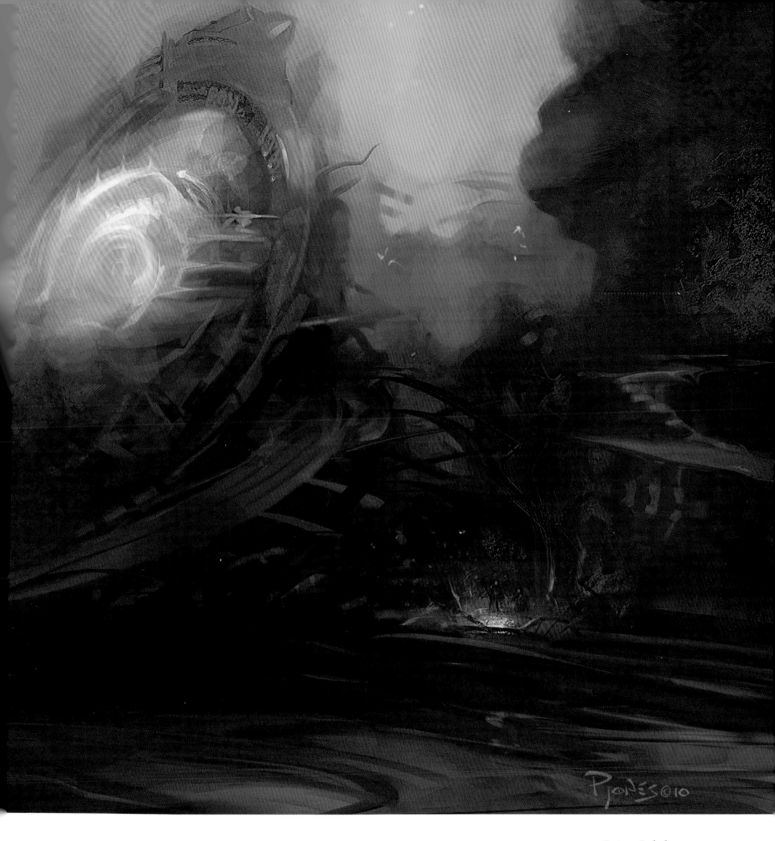

Future Babylon;
20 x 12 inches; 3-hour
live demonstration;
digital

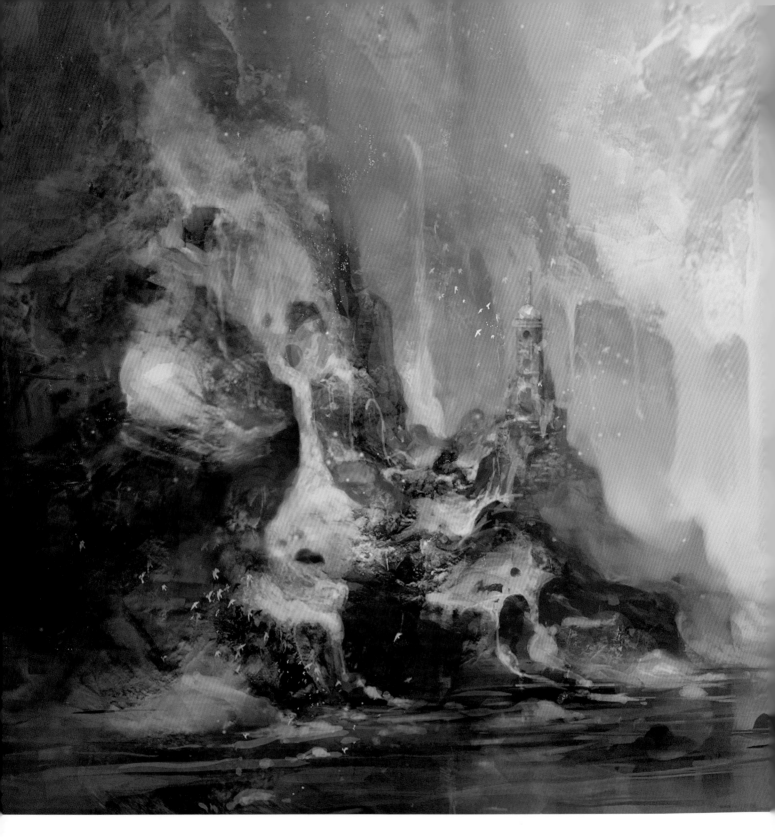

It is hard to be in "the zone" when painting live, as the question and answer session with the audience, and subsequent clowning around – mostly instigated by me – break the spell. As *The Final Refuge* was a class demo in front of my advanced students, the first hour was spent demonstrating method, thought process, and technique, and in the following two hours the students worked on their "final assessment" masterpieces, stopping here and there to see where I was going on the big screen. During the periods in which we all knuckled down in the creative quiet of the classroom, I found myself truly lost in this piece.

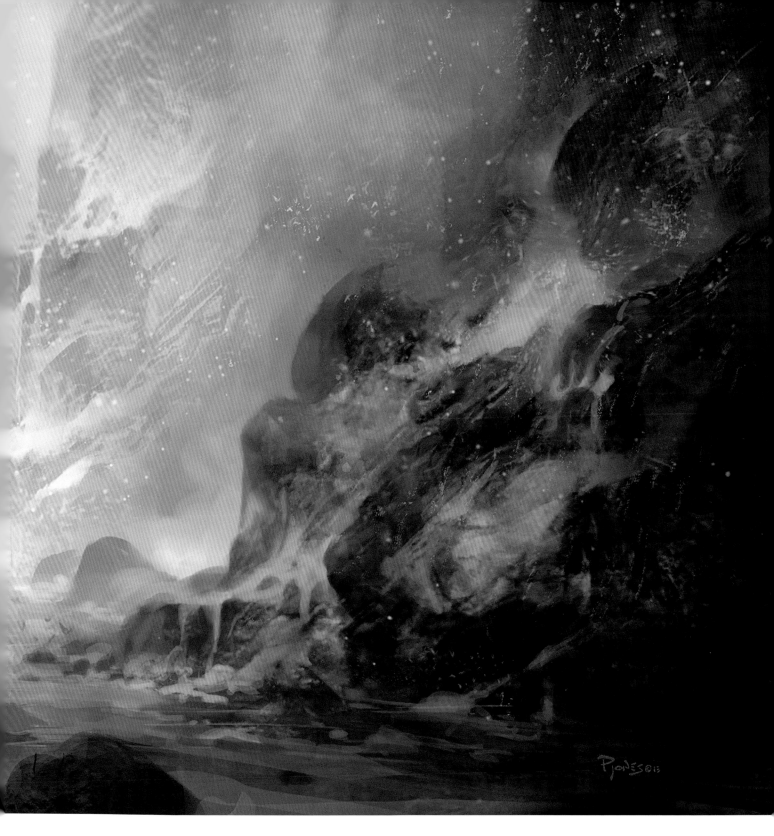

As it was painted entirely from imagination, without any reference, I had all the freedom in the world to create. Getting lost in the nooks and crannies of a world evolving out of abstract shapes was totally absorbing. I now consider *The Final Refuge* the peak of my live demos: my own "final assessment" piece.

The Final Refuge;
16 x 12 inches; 3-hour
live demonstration;
digital

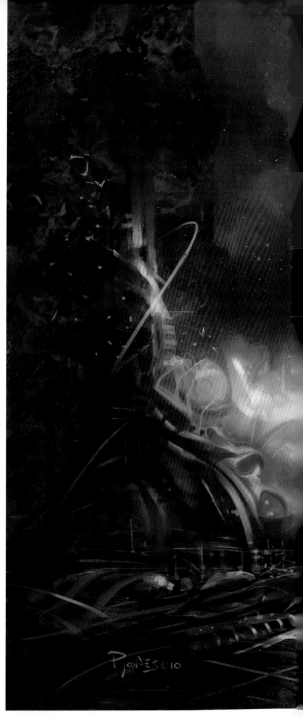

When the art director at *ImagineFX* magazine offered me a six-page, step-by-step tutorial article showcasing my digital techniques, it gave me the opportunity to let my creative spirit roam free. I decided on an epic "invasion from outer space"-type piece, and shown here are the concepts I submitted.

Back when I was starting out, I would submit very rough ideas of the comps I *least* wanted to paint, along with one comp finished to a higher degree (the one I *wanted* to paint), thinking the art director would pick the most finished comp. They nearly always didn't. I know now that a vague concept stirs the imagination

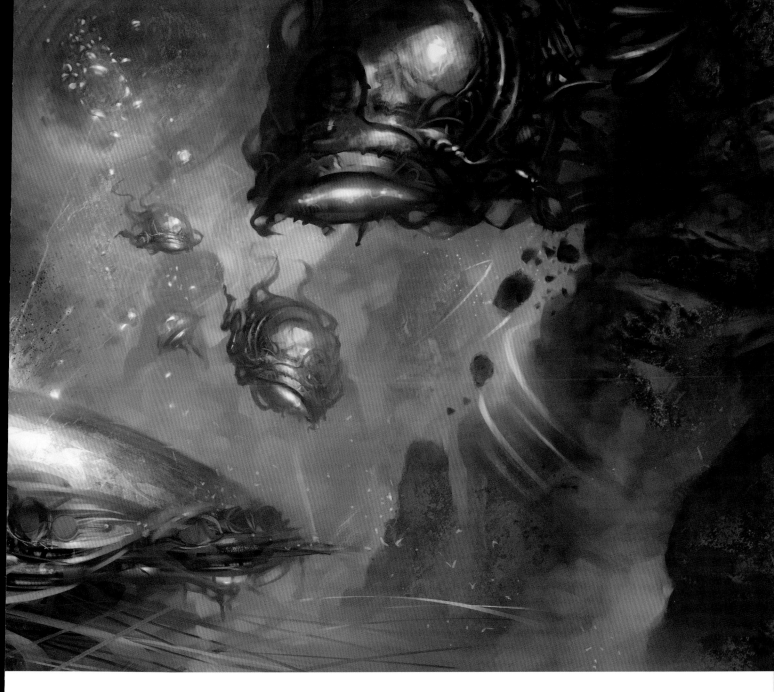

more than one where everything is spelt out. Today I always ensure I only submit ideas of equal finish, all of which I would be equally happy to develop further. That said, I still hoped *ImagineFX*'s art director would pick the concept shown bottom left, which was my favourite by a long shot. Instead he choose the top left version.

That's the way the cookie crumbles much of the time in commercial art, but I remained in a good place to deal with the disappointment, as all the comps were strong enough to keep me creatively fuelled to spend the many hours needed to take the idea to finished art.

The fantastic thing about digital art is how fast you can get an idea down in full colour and value. Gone are all the lengthy preparations, such as canvas priming, colour mixing and drying times. This, in turn, lends the hand towards energetic mark-making. Here, as with a lot of traditional art, I prefer the energy and mystery of the "unfinished" quick concepts over the "tighter" final art.

As I grow as an artist, I'm also tending towards a looser style in my personal work, as can be seen in the oil paintings *Transfiguration* and *Singularity* shown on the foreword and epilogue pages of this book.

Above: *The Infestation;*
18 x 24 inches; digital

Left: *The Infestation*
thumbnail comps;
6 x 4 inches; digital

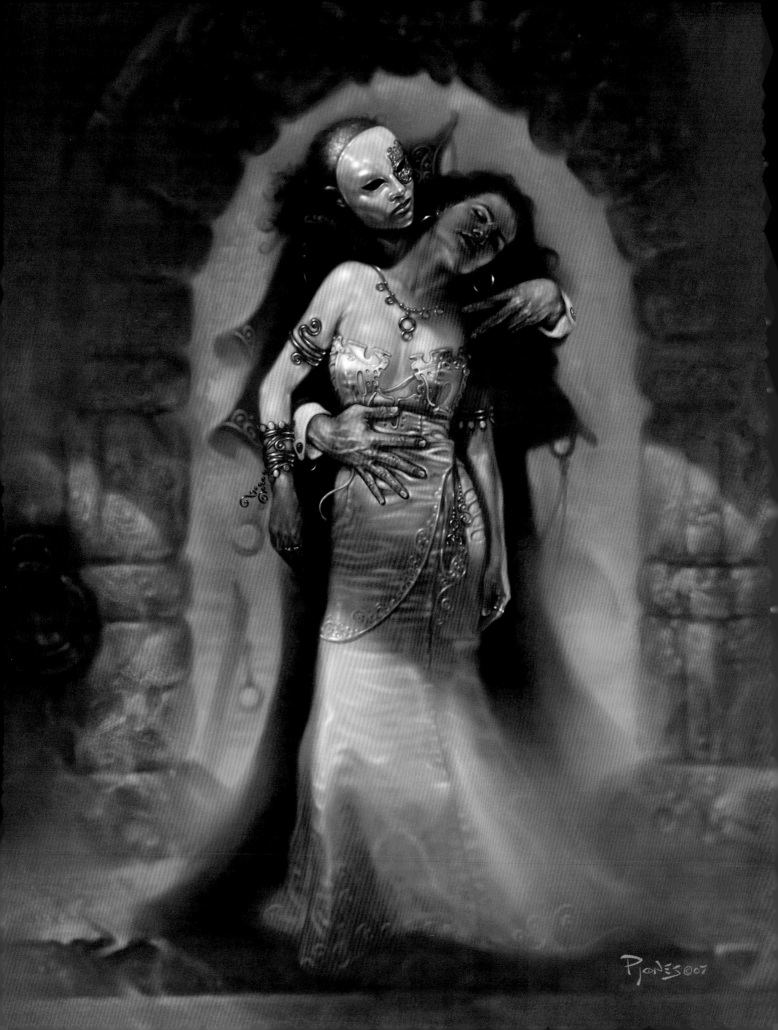

Deep into that darkness peering, long I stood there, wondering, fearing, doubting, dreaming dreams no mortal ever dared to dream before.

Edgar Allan Poe (1809–1849)

The Classics

Horrorworks

Few artists are given the honour of illustrating a classic of horror literature, so when the chance to paint a whole series of them came along in 2005, I salivated like a werewolf. In this section I have chosen my favourites from this period, concluding with my version of Frankenstein. I always surround myself with inspirational art while working, and top of the inspirational list during this period was American comic-book artist and horror illustrator Bernie Wrightson, whose inked drawings for Marvel's illustrated version of the *Frankenstein* novel are, in my opinion, the best visualisations of the characters and story. With the bar set so high, I did a lot of research into the gruesome medical instruments used in Victorian times, and then added some wicked barbs and blades of my own to the doctor's medical kit.

My own, painted version of *Frankenstein* took the prize for best digital, concept artist in the Asia Pacific region in ConceptArt.Org's "Newborn" contest. The standard of professional art on display from all corners of the world was truly stunning, so I was genuinely surprised to win. "The best artist out of 4 billion people" was my outrageous running joke at the time.

The Phantom of the Opera, based on the novel by French writer Gaston Leroux, was another landmark digital painting for me. I remember spending an extra day on it even after I thought I could do no more. I revisited it a year later when artists and authors Ally Fell and Jonny Duddlebug asked me to contribute to their art book *Erotic Fantasy Art.* I hadn't created any erotic art, and I had no real interest in the genre, so I simply painted on top of the original art of *Phantom of the Opera.* It was an easy thing to undo the bodice of the female figure to suggest a level of supernatural sensuality, rather than get involved in anything tawdry.

For *Frankenstein* (*see pages 66–67*) I painted everything from scratch, as I would with a traditional painting, but I still used photographs for visual reference. I posed for both the monster and the doctor in that work, and it took a lot of energy. As the painting was an overhead view, I had to place the camera over my verandah balcony on a 10-second timer then gallop downstairs and pose for the shot. After around 50 shots I was exhausted. My next-door neighbour, peering through his dusty window, thought I was quite mad, especially in my half-naked state as the monster!

Left: *The Phantom of the Opera,* revised version; 18 x 24 inches; digital

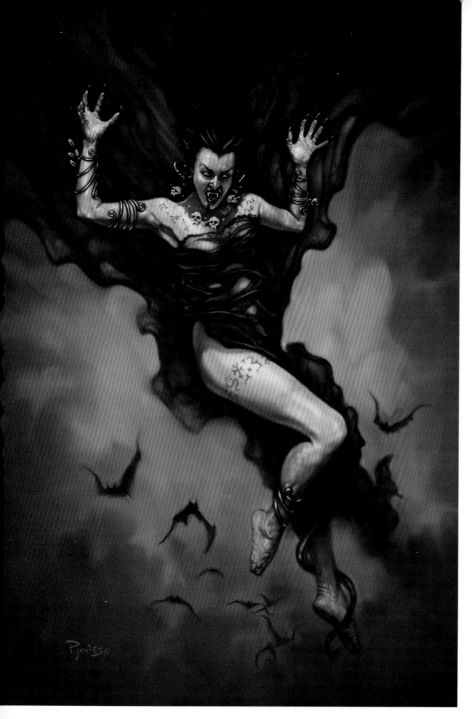

First out of the box of horror classics was what is widely considered the original vampire story, *Camilla* by Sheridan Le Fanu. I tried to imagine what would put the shivering fear of shadows in me, and after a few sketches I hit on the idea of creepy Camilla descending from a stormy sky.

I hired Tora Hylands and bought an outlandishly large swathe of chiffon from the haberdashery store. To capture the flying effect, Tora posed lying down and I took some shots from overhead on a step ladder.

Frank Frazetta was famous for re-working his paintings until they were sometimes completely different artworks. Two years after *Camilla* was completed, I felt that my digital painting skills had progressed to the point where I could work on top of the old artwork and create something better. While many bemoan the fact that Frank no longer had his earlier versions, I was able to keep both as I had done them digitally.

Above: *Camilla,* 18 x 24 inches; digital

Right: *Vampyre Planet,* 18 x 24 inches; digital

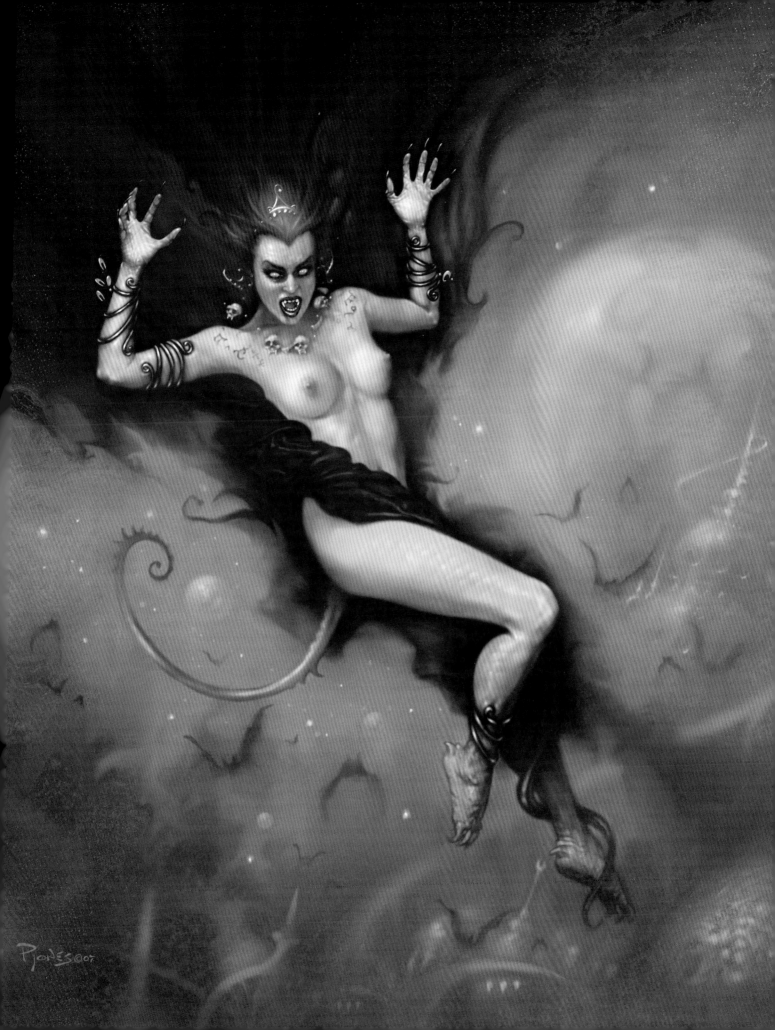

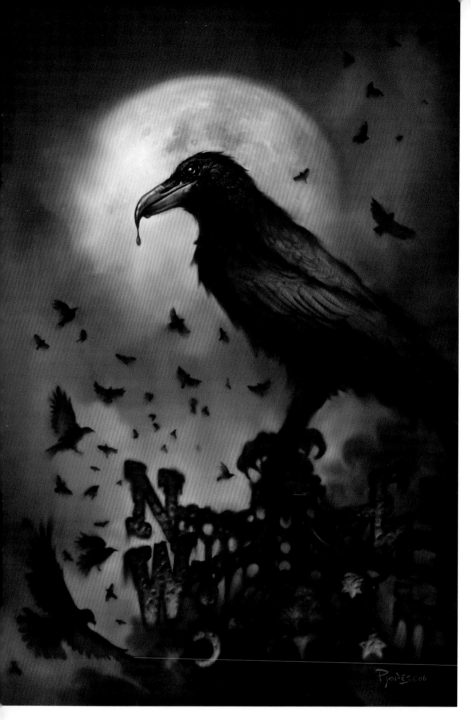

Dr. Jekyll and Mr. Hyde brings back fond memories of my fledgeling teaching years. Although the administration and grading parts of teaching are grim beyond all human endurance, the relative autonomy of life as a freelance teacher almost makes up for it. As a gun for hire I designed and taught a Fantasy & Sci-Fi Masterclass on Australia's Gold Coast for a few years, which included a cosplay photoshoot class.

My students would turn up on the day with trollies full of dressing-up clothes, and I would meet them on the sprawling campus grounds with my SUV full of camera equipment and my collection of costumes. Each student would bring their sketches and take turns at being art director, actor, photographer, etc. I would also pose students for my own real-world projects and take them through the stages of actual commissioned artwork. The photoshoot for *Dr. Jekyll and Mr. Hyde* took place under the tropical shade of two Australian gum trees, and it took some great acting skills to create a mood of drizzly Victorian London while kookaburras squawked in the background, but my students had fantastic fun trying.

Above: *The Birds*; 18 x 24 inches; digital

Right: *Dr. Jekyll and Mr. Hyde*;
18 x 24 inches; digital

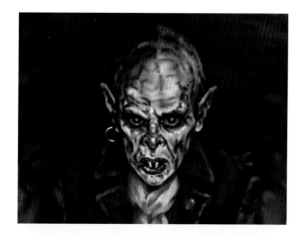

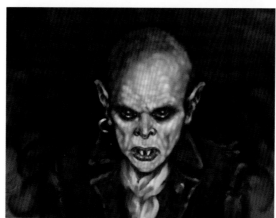

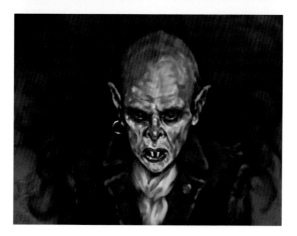

The story of Dracula has been told and parodied so often that it is easy to forget how well written and eerie the original novel by Bram Stoker was. For creating sinister vibes in my version, I was inspired more by the silent movie *Nosferatu* (1922) than by more recent movies, and also by a superb floating vampire painted by the great fantasy artist Brom, to whom I doff my cap in appreciation. To add further creepiness to my artwork, I added some hidden faces.

The female model for Dracula's victim was one of my best art students. Most of my students are adults aged between eighteen and eighty, which means most have working lives beyond their studies. My chosen student was a professional model, so we both struck lucky – I was able to combine teaching with modelling sessions while supplementing her with occasional income as she studied.

Although these were mostly fun times, I was once tested on a more confronting aspect of teaching – potential violence. My aforementioned model student was being harassed by a fellow mature student (with whom she was entirely uninvolved, romantically); he had become fixated on her. One day, on finding she had mysteriously vanished after he had followed her to class, he went berserk, and (bizarrely) started swinging an internal hard drive over his head. What he didn't know was that I had locked the object of his attention in the unused classroom next door for her own safety, mere seconds before he turned up. I managed, with the aid of another mature student, to clear the classroom of terrified students and keep him contained until security arrived to haul him away, gibbering and grinning like a maniac. When I later asked my model if she knew what had happened to her harasser's face, which was smashed up and missing four front teeth, she told me that a burly jock had punched him in the mouth down in the school parking lot when he caught him chasing her. That was a weird day on campus.

Above: *Dracula*, progress stages; digital

Right: *Dracula*; 18 x 24 inches; digital

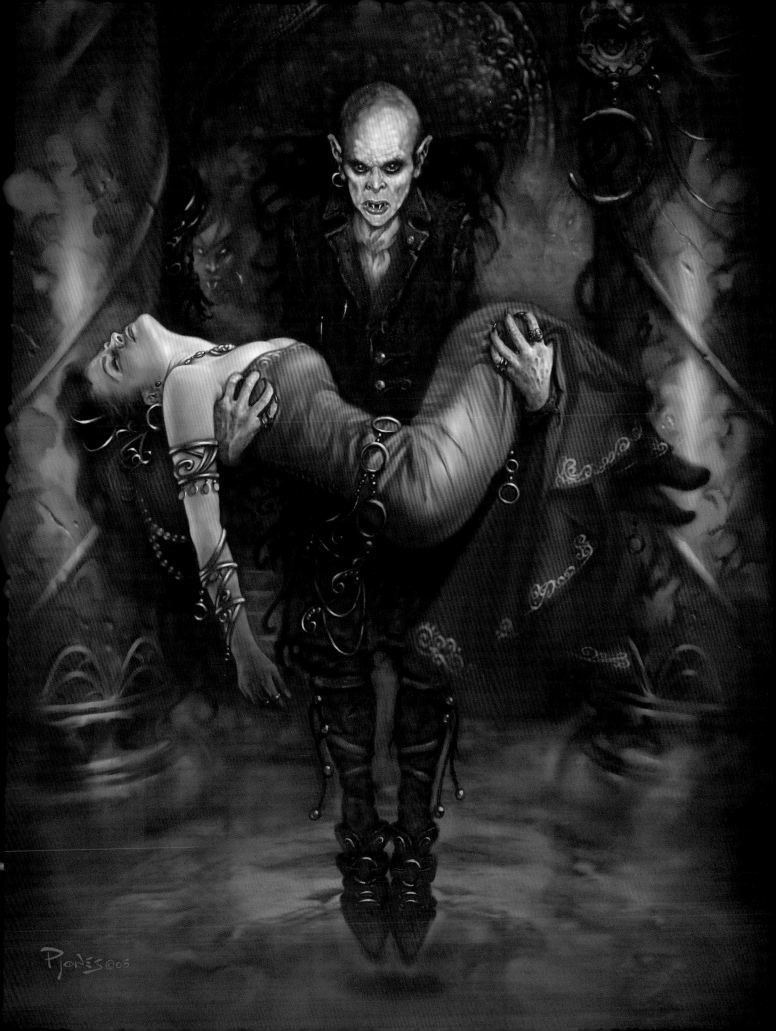

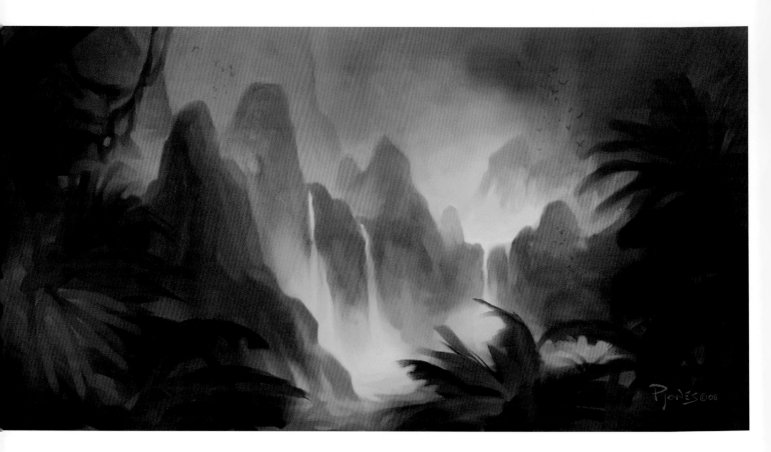

The Island of Dr. Moreau was my second selected entry into the annual Spectrum art competition – which recognizes the best in fantasy, science fiction, and horror artwork created each year. The famous sci-fi illustrator Chris Moore, whom I'd idolised as a young artist, had told me about Spectrum. The competition was tough, he said, with even seasoned professionals having five of six pieces rejected. So for me, being selected yearly since 2005 has been a continual affirmation that I am still on the right track.

I remember reading the novel in preparation for this painting, and noticed by the final chapter I was holding the book at arm's length to read it. If I was to finish the book I either had to grow a longer arm, or admit I was becoming long-sighted. And so it had come to this… Mr. Four Eyes! I never knew how good I had it before glasses. Before glasses I could read a book anywhere, with a casual air; now I had to

fumble around for my all-seeing eye machines to read anything up close. Within the first year I had sat on my glasses so many times they were bent upside my head. It seemed I needed classes to find my glasses! I was a mess. I guess I've always been a nerd, but having to constantly push up my glasses as they slowly slid down my nose, was confirmation of my nerd status.

Today I treat my glasses as part of my art materials, and try to keep them in one place where I can always find them; it's just a new kind of normal, with the occasional comic frustration when I sit on them or can't find them because they are in my shirt pocket. But boy, do I miss my younger eyes. There is a lot of *speculation* about scientific advances that may one day allow us to do away with glasses completely. I think that, to live in such a time – in which we can look back on spectacles as a device as primitive as the abacus was to computing – would be amazing.

Above: *The Island of Dr. Moreau,* **live demonstration sketch; digital**

Right: *The Island of Dr. Moreau*; **18 x 24 inches; digital**

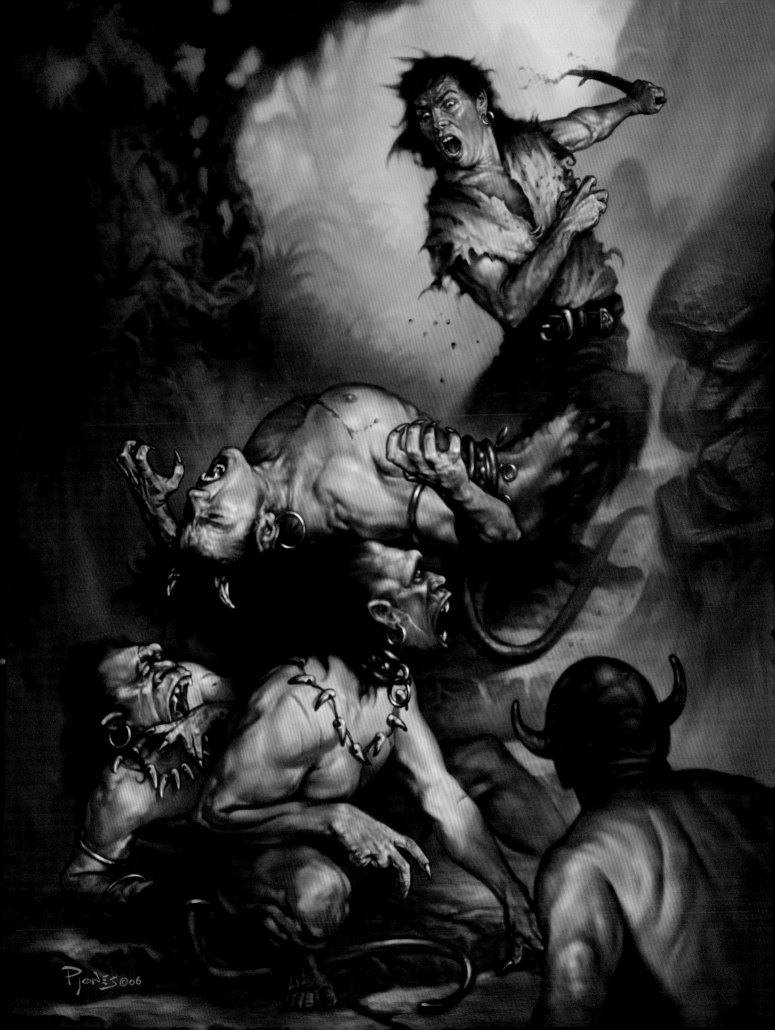

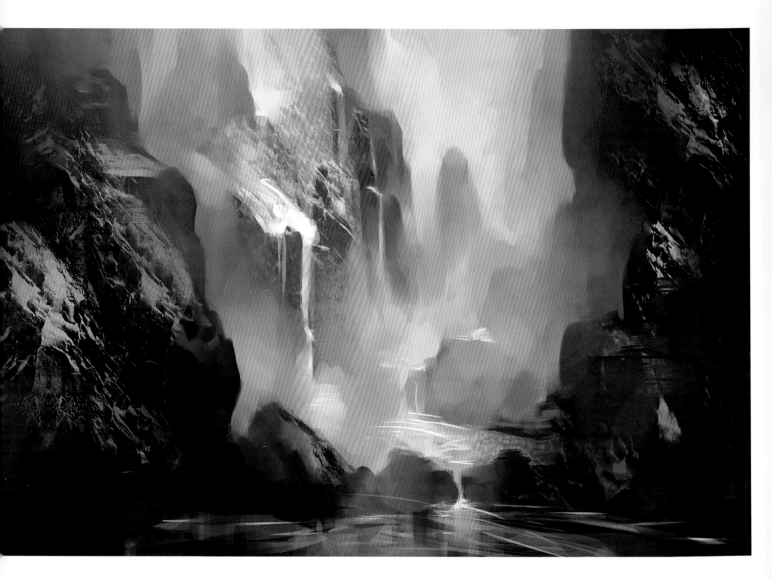

The 1931 US novel *At The Mountains of Madness*, about a disastrous expedition to Antarctica, still endures today, thanks to the creativity of its author, H. P. Lovecraft, and especially his iconic creature, Cthulhu. The author manages to create fear without resorting to blood-spattered gore, placing a sense of danger and anxiety in our minds at every turn. An incredible writer. I remember finding it tough to create deep enough facial wrinkles when posing as the hero for my painted *At the Mountains of Madness*. It didn't take too many years for that state of affairs to change.

Note the gnarled hand here. I always loved the way Frank Frazetta's heroes were wound up tighter than springs, ready to bound into action. The Facebook group "The Frazetta Round Table" once proposed that the "gnarled hand" could be its unique greeting, much like Spock's Vulcan salute, in memory of how Frank used this motif in his art. Frank taught us a lot, and it was all about the gnarled hand as I posed for this one.

Also here is one of my live demos sketches, which are great for allowing me to explore ideas for paintings without the pressure of art direction or deadlines.

Above: *The Frozen Gates*; live demonstration sketch: digital

Right: *At The Mountains of Madness*; 18 x 24 inches; digital

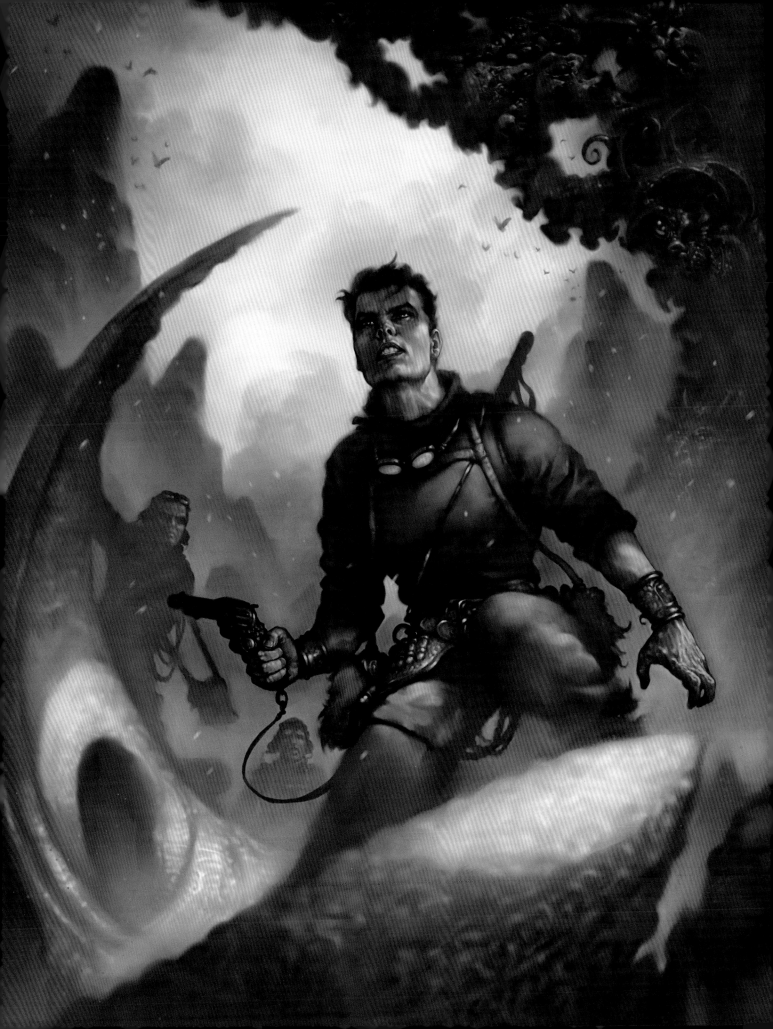

Frankenstein; 18 x 24
inches; digital

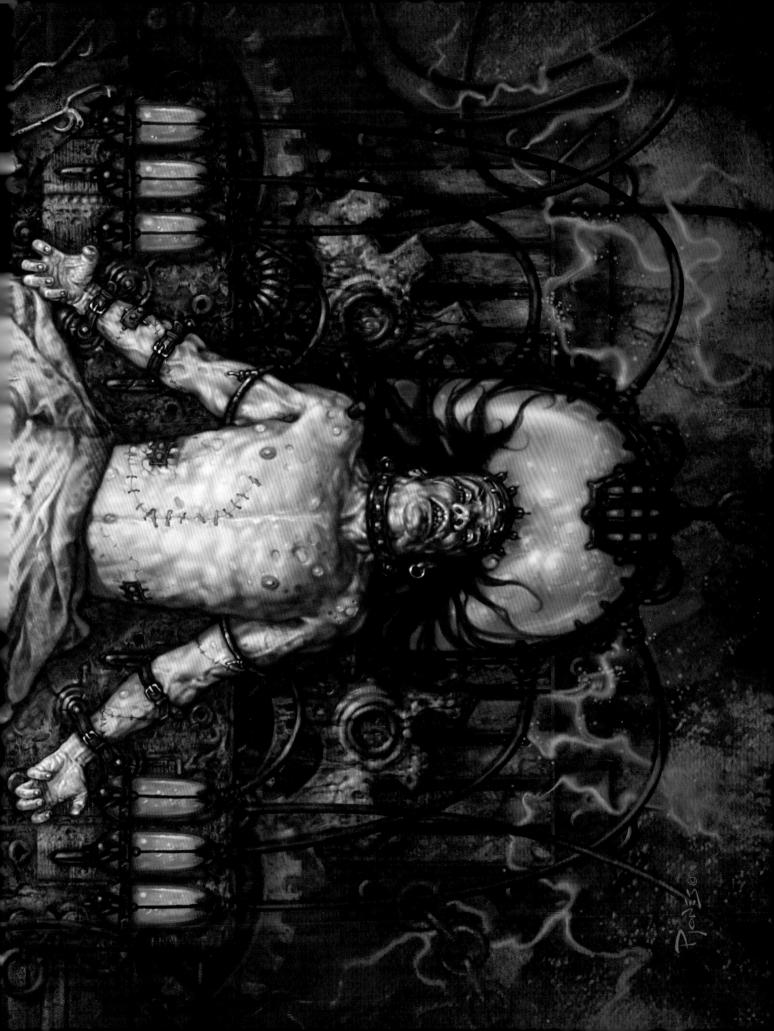

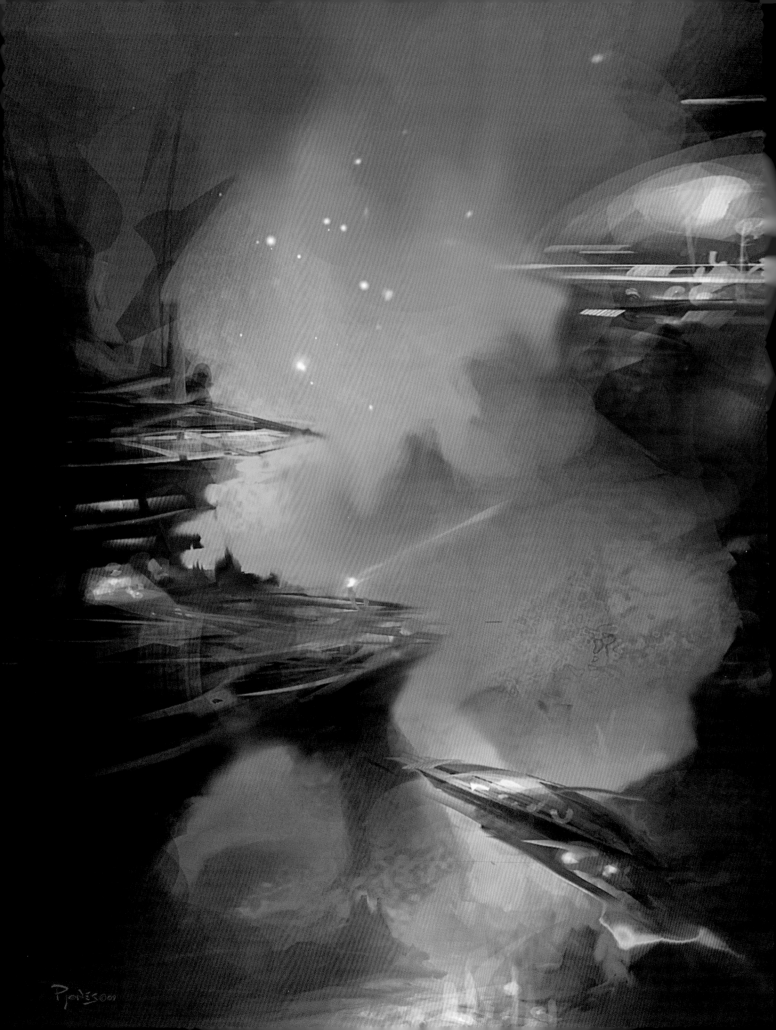

I dream of painting and then I paint my dream.

Vincent van Gogh (1853–1890)

End of an Era

The Independent Press Years

The year 2006 was one of great change for me. By the end of it I was feeling burned out due to my workload – a neutered version of the happy fellow I had been a year earlier. My wife took long-service leave from teaching and we packed our bags for a five-month trip to Ireland, England, and the USA. This was both invigorating and financial suicide, considering the travel costs ahead; therefore I planned two days a week devoted to work while on the road. I had painted while travelling before, buying materials and dropping off work at post offices across Europe and the Middle East as I went. This time I had a laptop and a Wacom Tablet and delivered digital files via wi-fi. My studio had simply shrunk to the size of a shoulder bag.

On our return I felt recharged; however, I was in danger of drifting back into advertising, and a major worldwide economic recession was being whispered about in dark corners. The latter was a truly frightening prospect for me, as I had lost everything in the previous recession when forced to sell my home at a loss. That, combined with other devastating factors in my personal life, had landed me back to square one in my early thirties: alone, penniless, and once again living in London, where I ended up working in a pub for the survival aspect of room and board. During my first stint in London, while in my early twenties, there had been a faint air of romance about a young,

starving artist new to the big city, but the second time around I felt much older, jaded, and desperate. My strength was that my earlier experience had taught me how to survive, and I managed to pull myself out of despair by working day and night as both an artist and a bartender. Eventually I left to work my way across the world towards Australia.

Looking back on what that last recession had inflicted, was painful. Yet as fear crushed me in its fist, I took a leap of faith. Most artists would have killed for the clients I was about to let go, but the simple fact was I could see my dreams fading again. The first purse string I cut was the romantic photo-art stuff: a no-brainer that immediately lifted the world off my shoulders. I held the option on my freelance teaching but dropped the children's books – the last commission had seen me illustrating six double-page spreads over 24 solid hours, which was mental agony. All-nighters were a constant evil in advertising, but enduring them on book publishing's low pay rates was insanity. All this was liberating – I was finally commanding my own workload rather than being a slave to it.

In this section is some of the independent press art I produced from 2005–2009. Painting in digital oils was inspiring me to work with traditional oils again, and my subconscious child, concerned only with art for its own sake, was shoving me towards that goal.

Left: *Return to Forever*; live demonstration; 18 x 24 inches; digital

onkey King was the first demo piece I ever created in front of an American audience. I remember sitting alone in a diner an hour before I was to perform to a packed theatre of eager faces, all waiting for me to conjure magic on screen. My hands were shaking at the thought. I should have prepared something in advance, but I hadn't, and that was a fact I had to accept and learn from. My only task now was to order breakfast; however, the waitress couldn't understand my Irish brogue, no matter how many ways I said the words. Balloon-faced with embarrassment, I pointed at a picture on the menu, like a mute monkey.

With my self-confidence now in tatters I left the diner and headed to the theatre and my inevitable fate. On stage, I created *Monkey King* on screen out of chaotic brush strokes, holding a question and answer session as I worked. The set-up was such that I faced the screen, just as the audience did, and so I spent most of the session grinning over my shoulder like a vaudeville organ player. Bizarrely, the whole thing went incredibly well – with lots of joking and laughter between myself and an audience that swelled in number to become a full house.

Did I paint *Monkey King* subliminally due to my primitive display at the diner? Maybe. Did the audience understand my Irish accent because they were more attentive than the waitress had been? I really don't know. I'm still not sure what changed between the diner and the theatre, but some kind of serendipity was at play.

Above: *Monkey King*; 16 x 9 inches; digital

Right: *Deathstalker Sidekicks*; 18 x 24 inches; digital

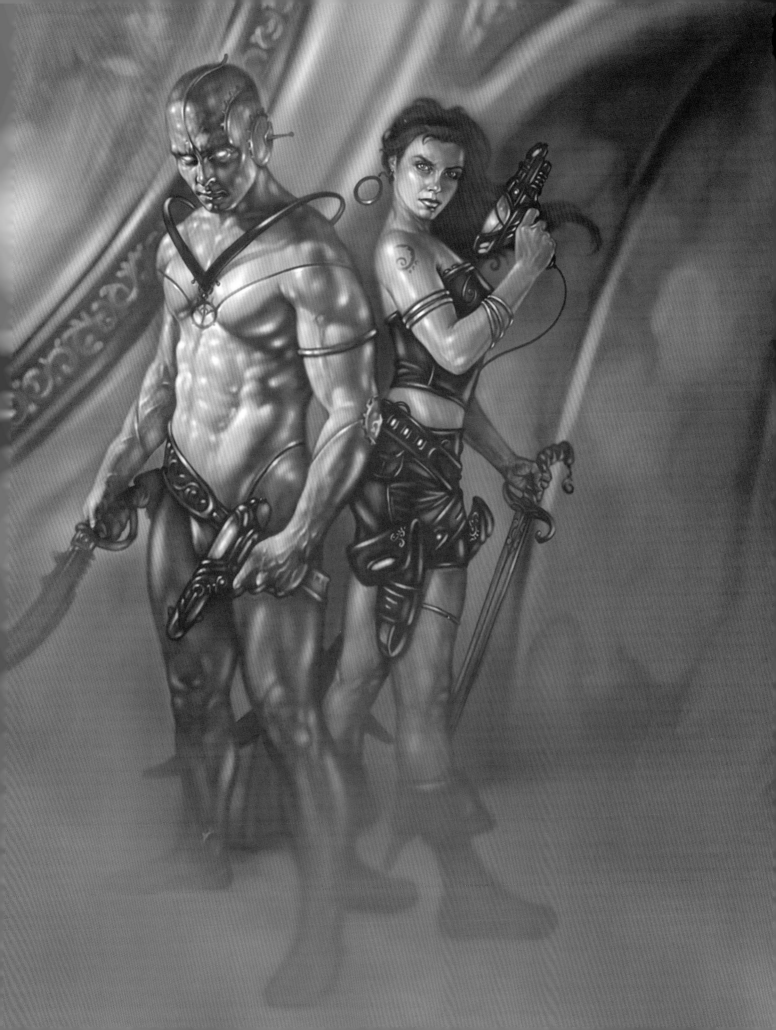

In the autumn of 2006 I hired a car in New York and headed west with Cathy, on a pilgrimage to the Frank Frazetta museum. It was early morning in the misty Poconos when we pulled up the gravel drive to the museum, but a tug on the oak doors revealed that it was closed. "Hello!", a voice cried out, and Frank's wife, Ellie, appeared from the home next door with a fistful of keys. All I could ponder while Ellie rattled with the locks to the museum was that Frank may have been watching behind one of those windows, and it took inhuman willpower not to peer back like a stalker.

Later, Ellie sat with me as I showed her my art on a laptop. She seemed impressed, especially on seeing the artwork *Camouflage*. "Ellie, was that a gasp?", I asked. She confessed it had been, before I counter-confessed that the work was digital art. "But then," she said, waving her hand around at Frank's legacy of oil paintings, "you can never have this."

Ellie's words cut deep and I couldn't shake them out of my head. This new digital toolbox had taken me out of the wilderness, but the worry seeds sown by Ellie's warning haunted me for the following two years.

Above: *The Treasure Hunters*; 8 x 4 inches; **digital**

Right: *Camouflage*; 18 x 24 inches; **digital**

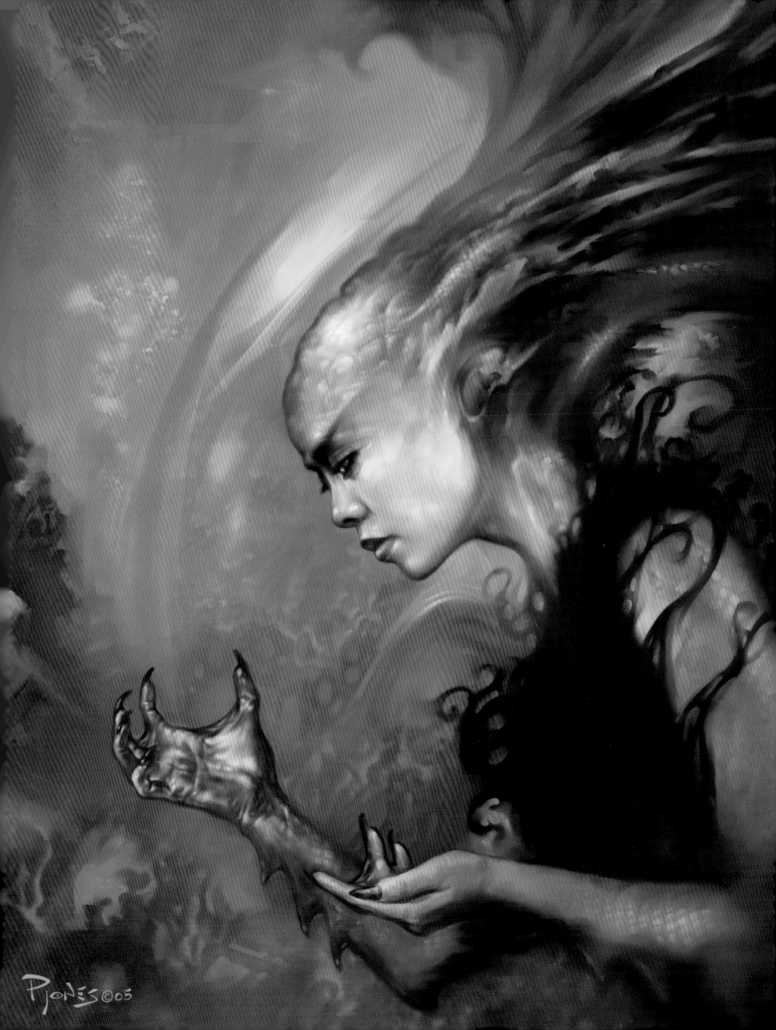

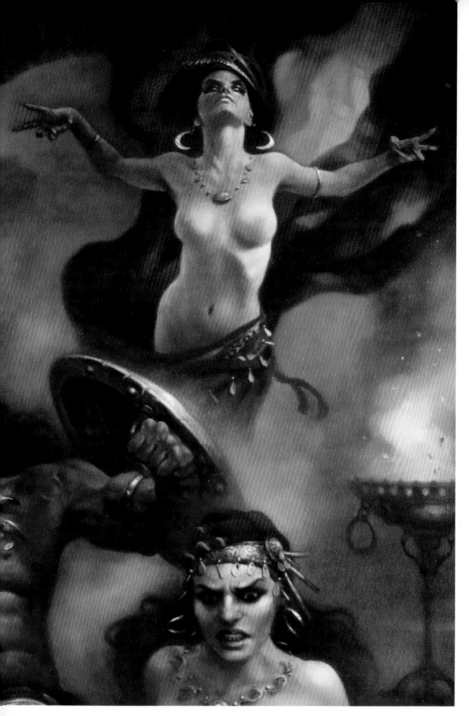

I had pre-warned Cathy that the Frazetta pilgrimage would be an all-day affair and I spent long, unbroken stares studying each of Frank's masterpieces up close, setting off the alarm more than once. After around three hours we went outside and looked over the Frazetta lake from a bench. The original art had been incredible, better than I could have hoped for. Back then Frank's art was collected almost in its entirety in that one location. I was totally overwhelmed and beguiled with renewed love for the man and his work. I told Cathy I was going back in, and although she must have been suffering, she resisted rolling her eyes. Eagerly, I eased open the museum doors for round two, pausing to hear Ellie say to the security guard, 'Have they gone yet?'. We still went in.

Ghost Stories (right) was a spooky artwork I completed during that same road trip, which had started months earlier in London. I remember working on it at the side of my bed in London late into the night when staying at my elderly aunt's house. At one point she knocked, opened the creaky door and just stood watching me paint for a long time. I asked if she would like to come in and sit down, but oddly she said she was fine by the door. With only her silhouette visible, it helped with the mood of the painting.

Also seen here is a close-up of my oil painting *The Pool of the Sorceress*, to compare alongside *Ghost Stories* as an example that digital media and oil media are merely tools. My style always remains the same, regardless of the instrument making the marks.

Above: *Pool of the Sorceress* **close-up; 24 x 36 inches; oil on canvas**

Right: *Ghost Stories*, **18 x 24 inches; digital**

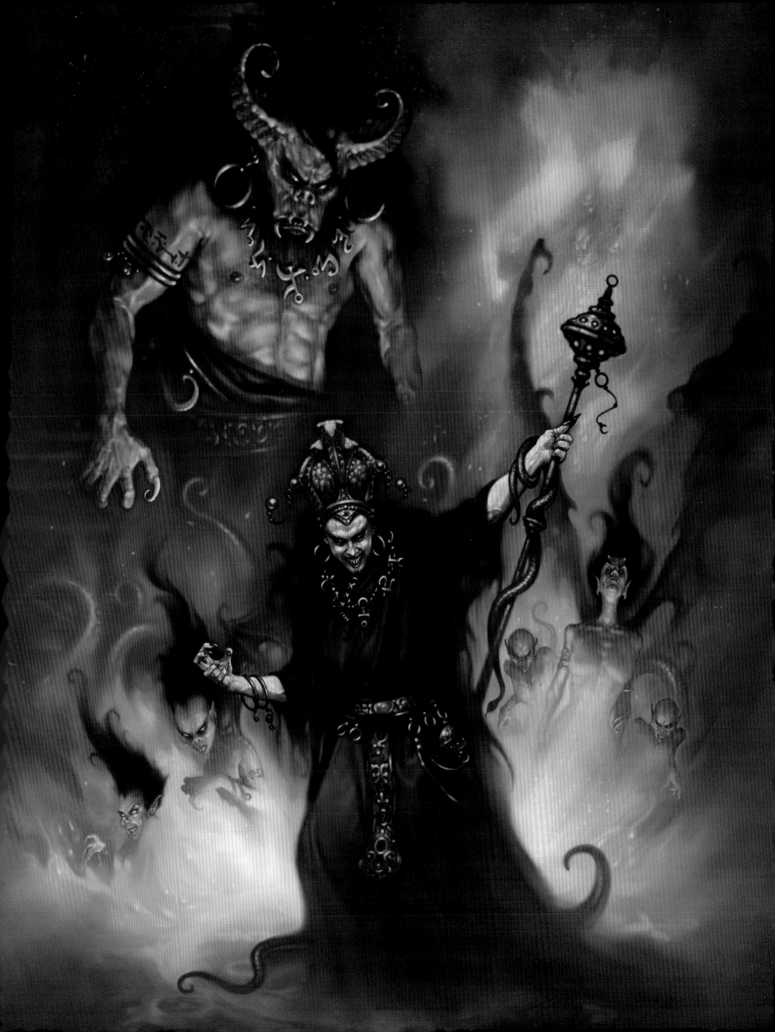

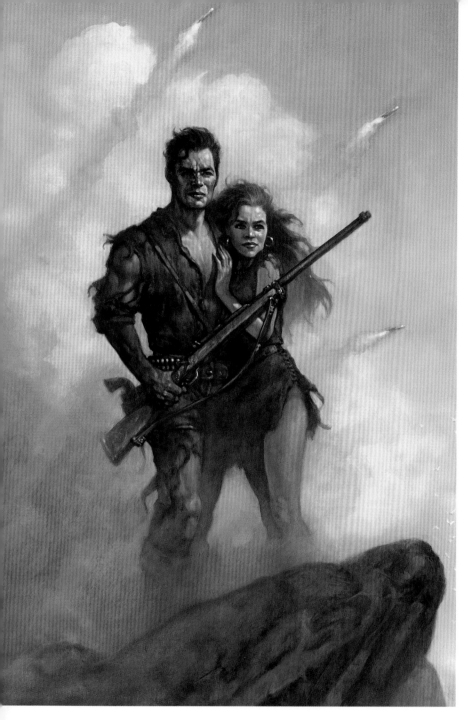

Working for Easton Press was a bookworm's delight, due to the quality of the company's authors. When the brief for four *Apocalyptic* novels arrived, I exploded in anticipation. With this series I wanted to re-create a classic sense of pulp adventure. First up was *Earth Abides*, which was an incredible, undiscovered gem. There wasn't a single copy to be bought in Australia, so I ordered a second-hand copy from the US. Cost: $1 plus $20 postage.

Why there has never been a major motion-picture adaptation astounded me, until I read that Orson Welles had wanted to make one, but never did. Maybe he owned the rights and took them to his grave, but for now it's a cold case I can't solve. I don't paint buildings often but I really enjoyed the idea of depicting a decayed and abandoned New York City, here seen from 3rd Avenue looking up at one of the wonders of 20th-century architecture, the Chrysler Building.

For *Alas Babylon* I didn't hire models but based the pose on an old Tarzan movie starring Johnny Weissmuller and changed the Tarzan and Jane pose until it was almost unrecognizable. I later donated the painting to the IX student scholarship fund.

Above: *Alas Babylon*; 18 x 24 inches; oil on canvas

Right: *Earth Abides*; 18 x 24 inches; digital

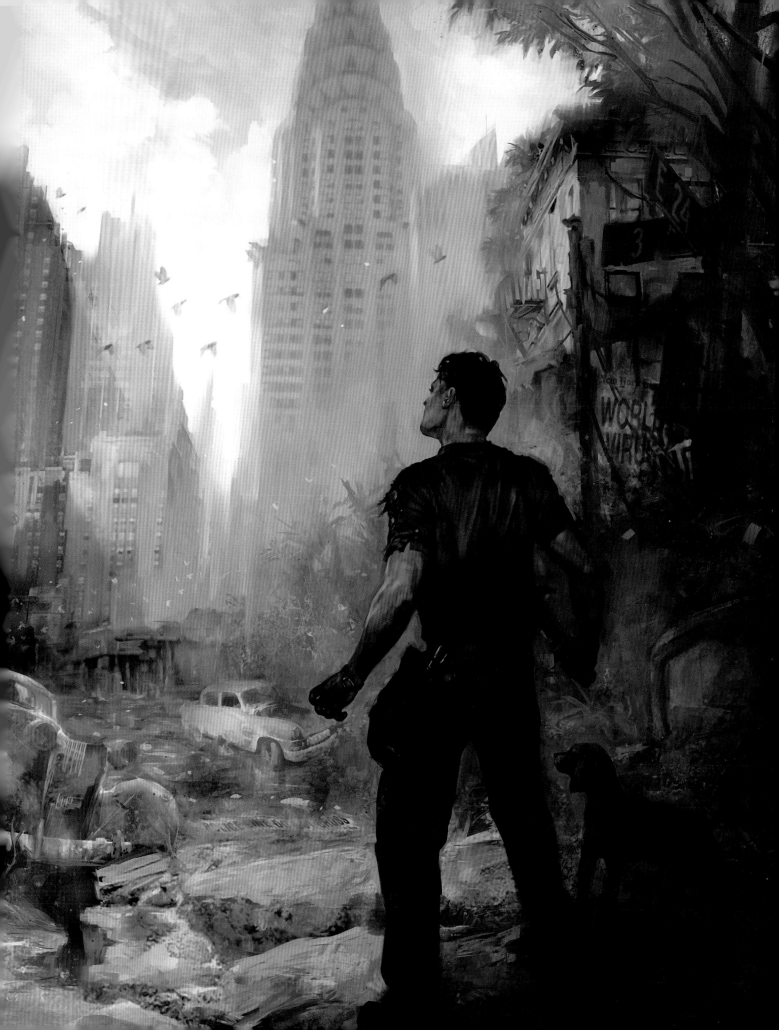

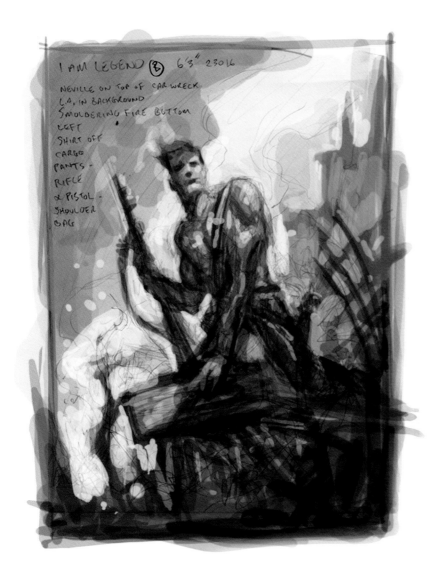

The handwritten notes on the image read:

I AM LEGEND ⑧ 6'3" 23016
NEVILLE ON TOP OF CAR WRECK
LA IN BACKGROUND
SMOLDERING FIRE BOTTOM
LEFT
SHIRT OFF
CARGO
PANTS -
RIFLE
& PISTOL -
SHOULDER
BAG

I Am Legend (1954), a horror fiction novel by US writer Richard Matheson, is one of my all-time favourite stories, and I had great memories of the groovy 1970s movie adaptation, *The Omega Man,* starring Charlton Heston (whom Orson Welles had wanted as the leading man for *Earth Abides*). I think I was ten years old when I first read *I Am Legend*. I was an incredibly young reader and holding a library card in my tiny hand is one of my earliest memories. To my parents' great pride, one of my primary school reports read: "Patrick is very advanced in English and is an omnivorous reader." I remember my Dad looking up the word "omnivorous" and shoehorning it into conversations, to the admiration of his workmates.

I did some research into the kind of retro covers I would have seen as a kid, and those of US publisher Gold Medal Books best conjured the scent of pulped pages and rain-soaked afternoons. I also found the Charlton Heston movie tie-in image, which provided a mystic pulse of déjà vu, so maybe that influenced me towards the heroic. *I Am Legend* seems to have always lived in my dim subconscious.

My first comp for the painting *I Am Legend* focused on the loneliness of the story's protagonist, Neville; the second comp tended towards the heroic, with Neville using an overturned car as a vantage point. In the end I returned to my original musings, showing Neville walking the lonely streets, defiant. Luckily the art director chose that version.

Above: *I Am Legend* **rough; 4 x 6 inches; digital**

Right: *I Am Legend,* **18 x 24 inches; digital**

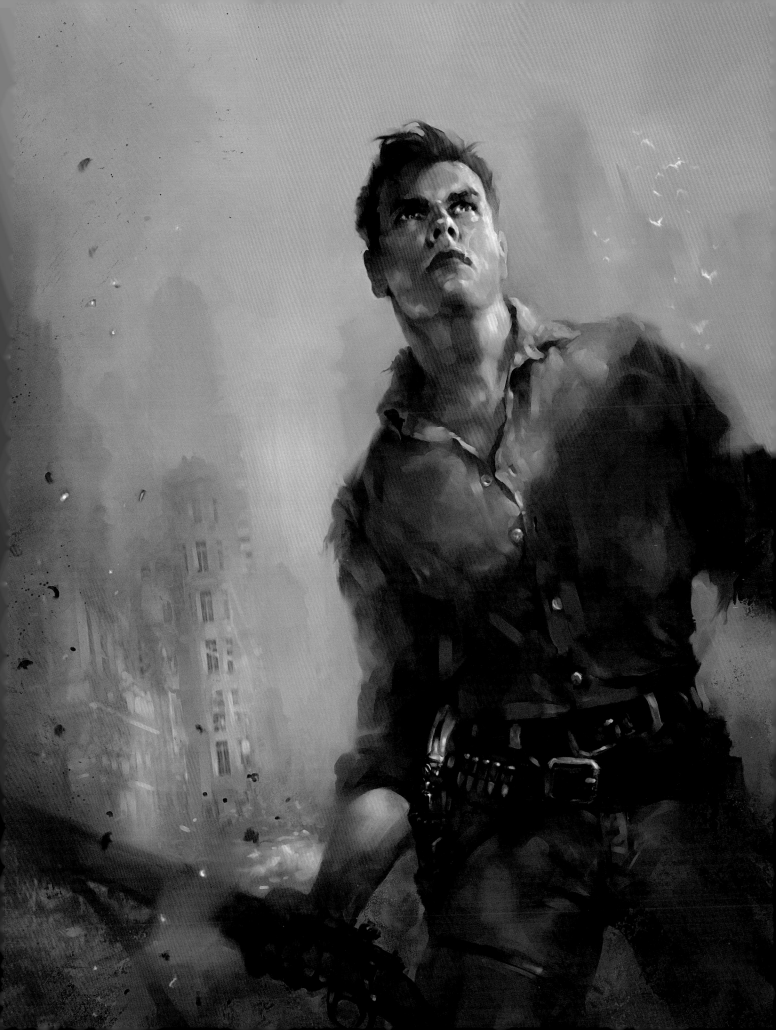

When I saw the UK art for *Death's Head Max*, I thought it looked like a modern military novel, which quickly doused the flames of my enthusiasm. However, after reading the manuscript for what was to be a fresh, leather-bound US imprint made especially for collectors, I decided to go full retro-pulp and be damned. I guess part of me was rebelling against the artistic crushing I had survived at the hands of my previous art director on the dreaded romantic photo-art books, and like a beaten dog I expected to be hauled back by the scruff of the neck, reprimanded and tamed. Instead I got an encouraging go-ahead. Sometimes, it seems, we are adrift at fate's mercy. With one art director I was treated like an indentured slave, with another I was given almost total artistic freedom.

Above: *Death's Head Max* colour rough;
9 x 12 inches; digital

Right: *Death's Head Max*; 18 x 24 inches; digital

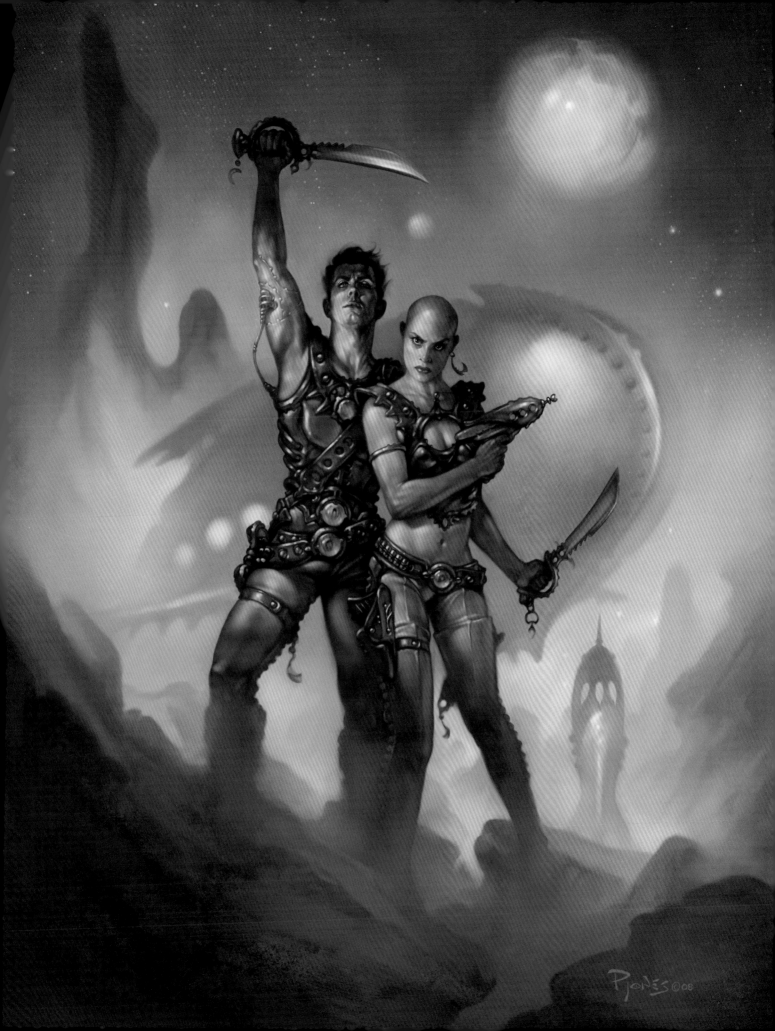

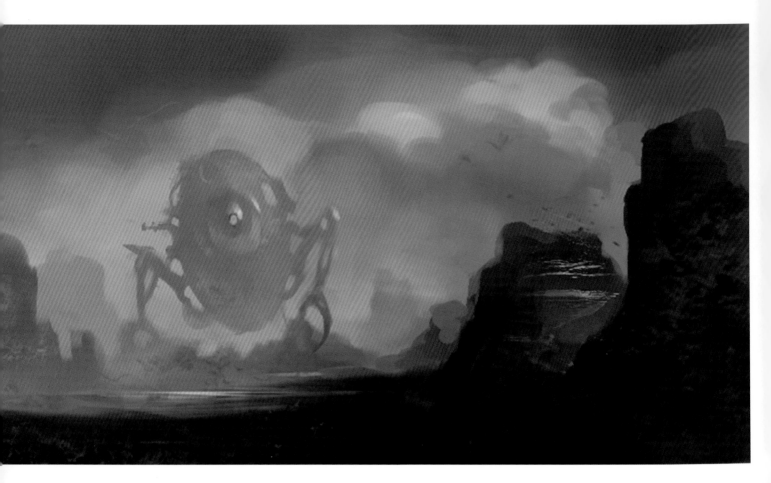

Another of the jobs I did for Easton Press was *I, Robot*. As I was posing for a lot of the heroes in my paintings, I decided to age myself by adding a receding hairline and heavy stubble. Almost a decade later I've managed to hold onto the hair. Strangely, it seems to be encroaching rather than receding. One of the nice things about art is that if you retain copyright ownership of a work (which is the opposite of "work for hire"), you can resell it at a later date. *I, Robot* was used eight years later as a cover for *Analog Magazine*, for which it was nominated for a Chesley Award (given by the Association of Science Fiction and Fantasy Artists). It was as if the younger me had worked hard enough to send the older me a gift from the past.

Right: *I, Robot,* 18 x 24 inches; digital

Above: *I, Robot* sketch; 6 x 12 inches; oil on board

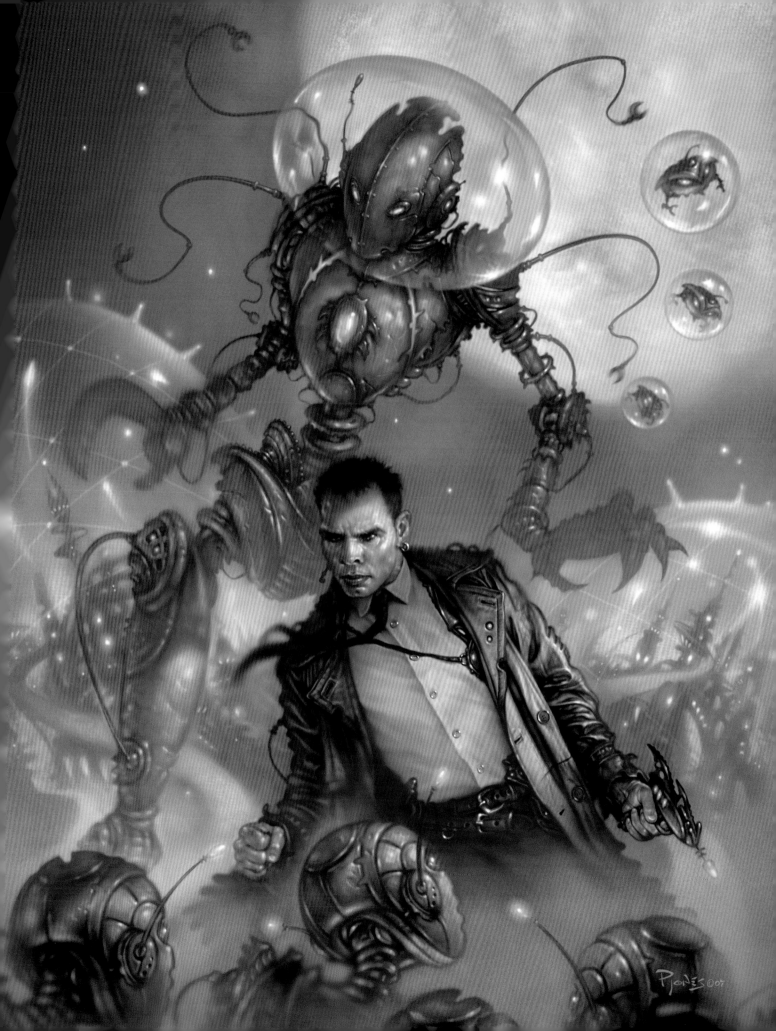

Low camera angles were something I became aware of when watching great TV shows such as the original series of *The Twilight Zone*. They spoke to me: not so much because of my world view of the giant adults around me, but because of the wonders and adventures that lay ahead of me. Staring upwards into the face of the Sphinx in Egypt or the carved temples of Petra in Jordan prove the power and wonder that a low viewpoint evokes, and those memories will live with me forever. Using a low angle will suggest the heroic, or fear, and I use it often, but not so frequently as to make it feel like I have a bag of tricks open for each painting. Every painting receives a lot of thought, with the viewpoint being one of the many considerations.

For *Lucifer's Hammer*, Tora Hylands got a new hair-do and morphed into another character. Before I got to know some famous artists personally, I was unaware that they modelled for their own paintings. Seeing the same artworks today, I recognize their characters clearly as the people I now know, but 20 years younger.

Although it is fascinating to see these classic paintings in a new light, it also breaks the spell a little, so when I model for the hero in my artworks, I try to change my features each time. I always wanted floppy hair like the hero in *Lucifer's Hammer*, so that's how I painted myself in that work. In doing this, I also get the chance to become more handsome, villainous, or rugged. There is a lot of fun to be had as an artist.

Lucifer's Hammer, **frontispiece book illustration; 15 x 22 inches; digital**

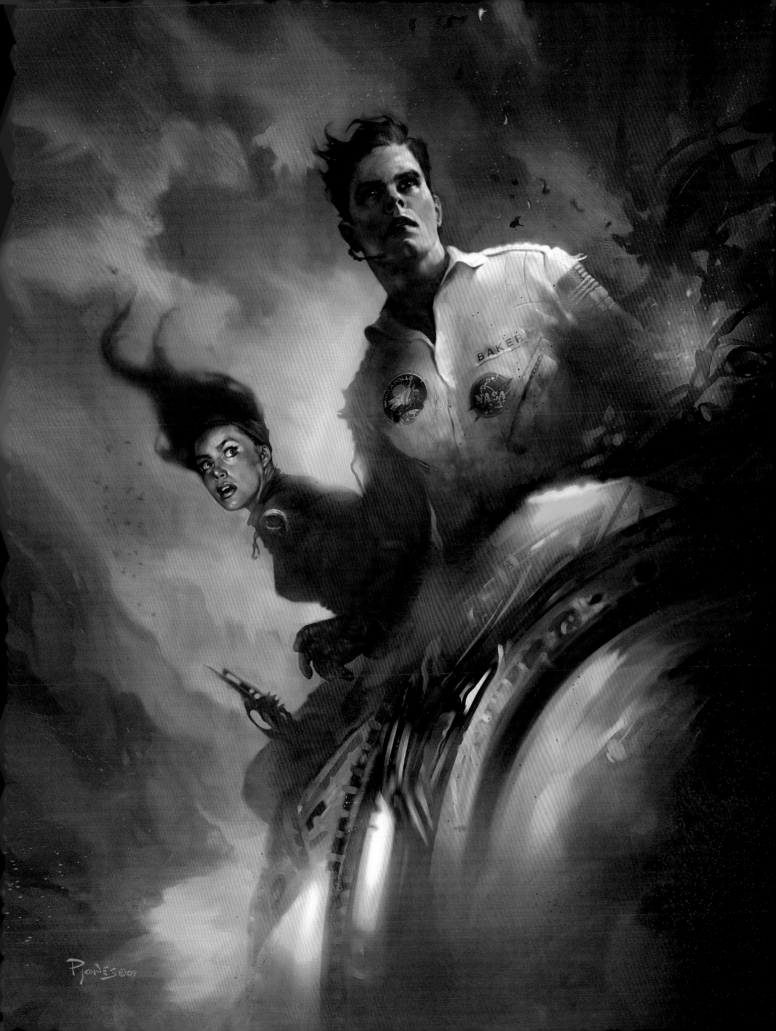

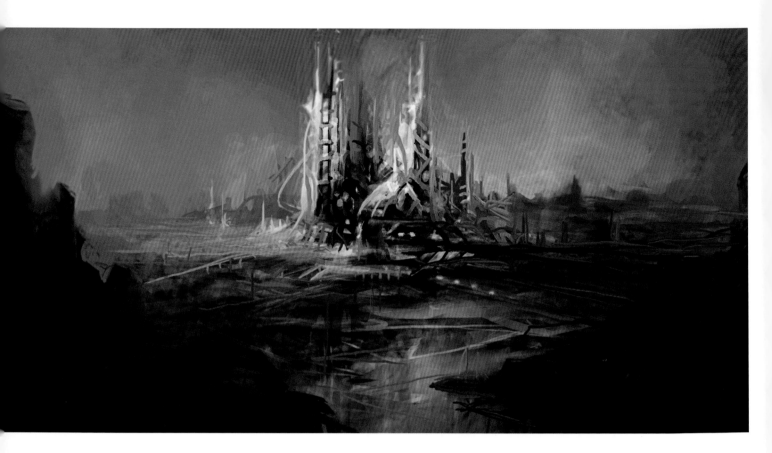

Philip K. Dick's novel *Do Androids Dream of Electric Sheep* is set in a future LA, and in 1982 it was famously adapted into the movie *Blade Runner*. I saw the movie first and was surprised when reading the book later, to find that my favourite rooftop speech by the dying android, Batty, was not in it, and that the main character, Deckard, was bald. I guess Harrison Ford had a chin-wag with the head honcho and put the kibosh on the idea of wearing a bald wig.

The background rendering on my artwork *Blade Runner* was drawn in Adobe Illustrator, which made light work of the kind of mathematical measurements and ellipse guides I would have needed to paint it traditionally. Painfully, not long before I started work on it, I paid a small fortune for a complete set of ellipse guides, only to see them languish forever, pristine and unused, in my studio drawers.

Tora, who posed for this painting, would eventually leave Australia for Canada, to work in movies and television. Although I encouraged her to follow her dreams, I was obviously sad to see her go, as she had been an integral fragment of my creative process. I saw her on TV a few years later, as a guest star in the "Monsoon" episode of the sci-fi series *Sanctuary*. Every time she had an action scene I took credit for it from the hillbilly comfort of my reclining armchair. "See how Tora 'owns' the gun," I said, stuffing my big stupid face with mashed potato. "I taught her that."

Above: *Los Angeles*; digital

Right: *Blade Runner*; 18 x 24 inches; digital

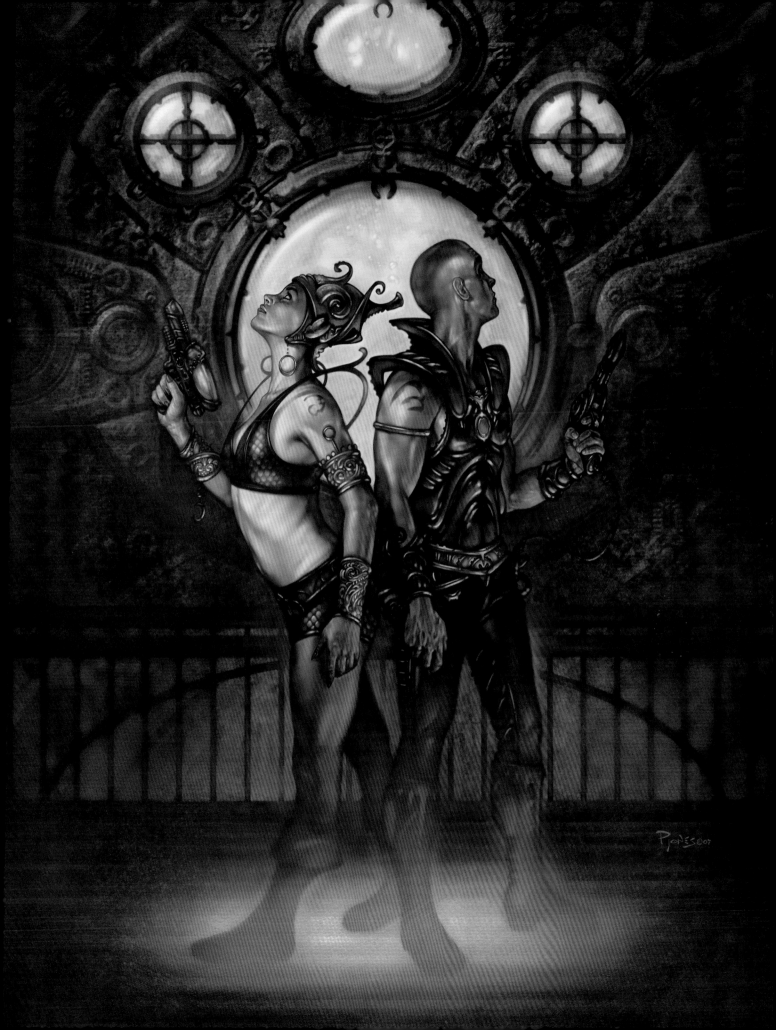

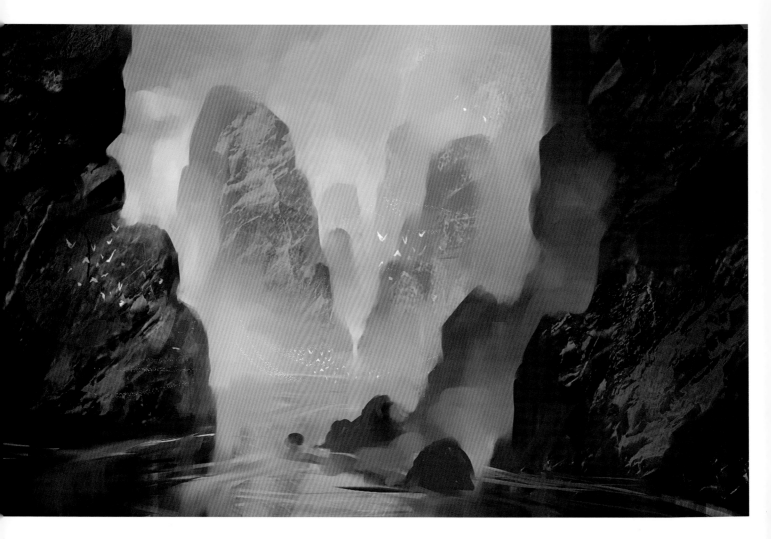

Abandoned Art was created out of the wreckage of a live demonstration I did for my students. The original art was a chaotic mess of brush techniques I was demonstrating in Corel Painter. I later revisited the art as a challenge and produced an online video demo on how to rescue an abandoned piece of art. To make some kind of order out of chaos I created a story for the face I was pulling out of the abstract mess.

Once I had the idea of a robot bride given human emotions but sold as a synthetic product without human rights, I had all I needed to be creative. The title *Abandoned Art* then became a sad analogy for the robot bride the art depicts. Adding hidden backstories may seem like a lot of trouble to go to, but it actually makes creating art almost self-perpetuating, due to the energy it creates. Finding imagined histories and allegories is, for me, one of the most rewarding parts of creating art. I once read that in preparation for the movie *The Dark Knight*, actor Heath Ledger kept in a notebook a collection of jokes that he thought his character, "The Joker", would find funny. That kind of obsessive detail might seem crazy, but there is no doubt he bestowed The Joker with much more depth than anyone expected from a comic-book character.

Also shown here is *Lost*, another live, unfinished demonstration that explores world-building. As the demo was basically about creating and using rock textures in Corel Painter, I never got around to adding anything more to the art once the students had the idea. I have loads of unfinished landscapes like this one: more abandoned art. When creating live demonstrations I can see the appeal of abstract art, as there is a great sense of freedom in working without the burden of reference. The added thrill is – just like the audience – I am unaware of exactly how the painting is going to turn out, which is a kind of magic.

Above: *Lost;*
demonstration;
digital

Right: *Abandoned Art;*
18 x 24 inches; digital

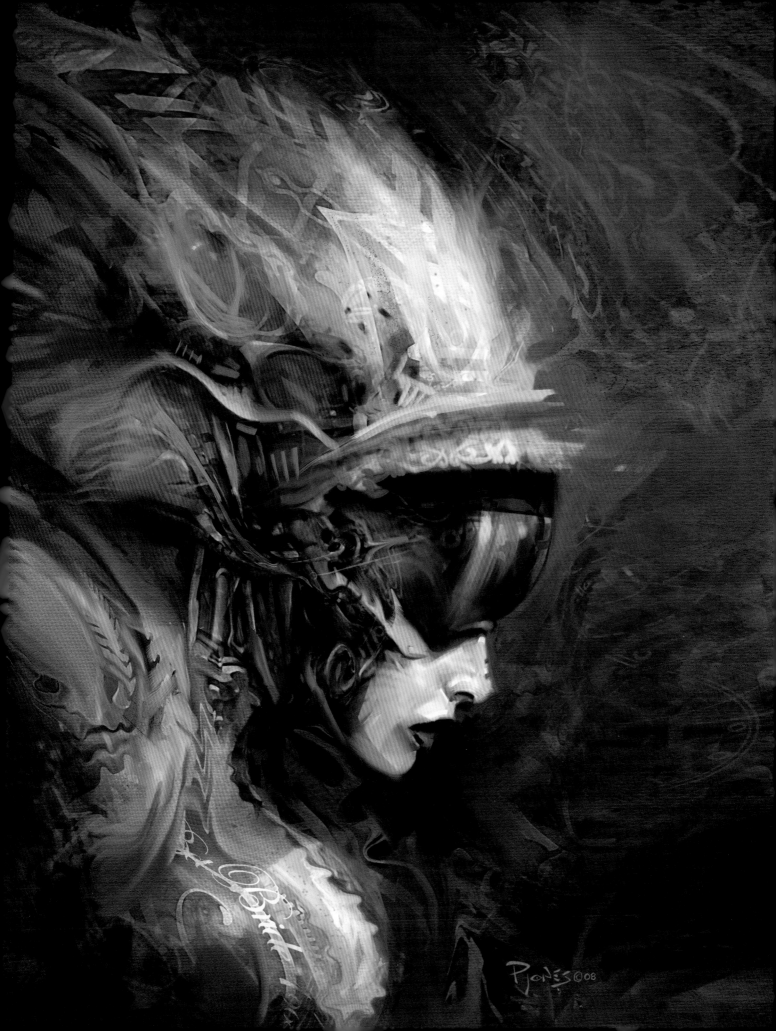

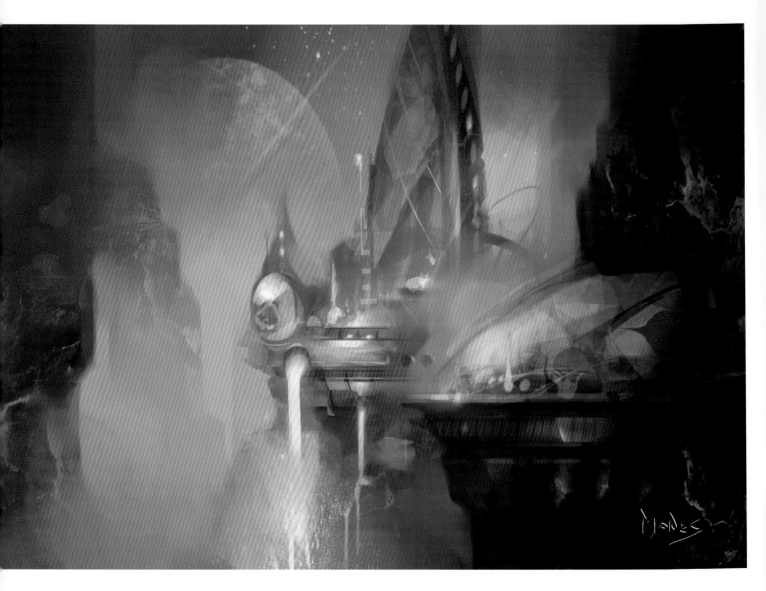

Out of a violent future the Sentinels are born: a new breed of killing machine, devoid of fear, compassion, and mercy – Earth's first deadly artificial intelligence. Led by renegade berserker Dan Mendez and his band of savage marauders, the gleaming robot horde is unleashed upon an alien planet and its unsuspecting civilization. Crash landing in their destructive wake, Lieutenant Merabah finds herself marooned on a primitive planet facing terrible odds. Then, out of the mysterious jungle, an old friend emerges in the form of Corporal Jim Burns. But as they face a wild destiny together, Merabah soon discovers Burns is not what he seems. From the desolate Earth to the rain-soaked jungles of an uncharted planet, comes Sentinels, a rip-roaring adventure brimming with mystery, romance, betrayal, greed, and raging vengeance…

That is the jacket copy of my online novel Sentinels, offering a taste of the adventure contained within its pulp-fuelled pages. Writing a novel was one of the most artistically fulfilling experiences of my life and took almost a year to complete. Seen on the right is the artwork for the jacket and above is an environment sketch of the future world described in the book.

Above: Sentinels study; 8 x 10 inches; digital

Right: Sentinels; 18 x 24 inches; digital

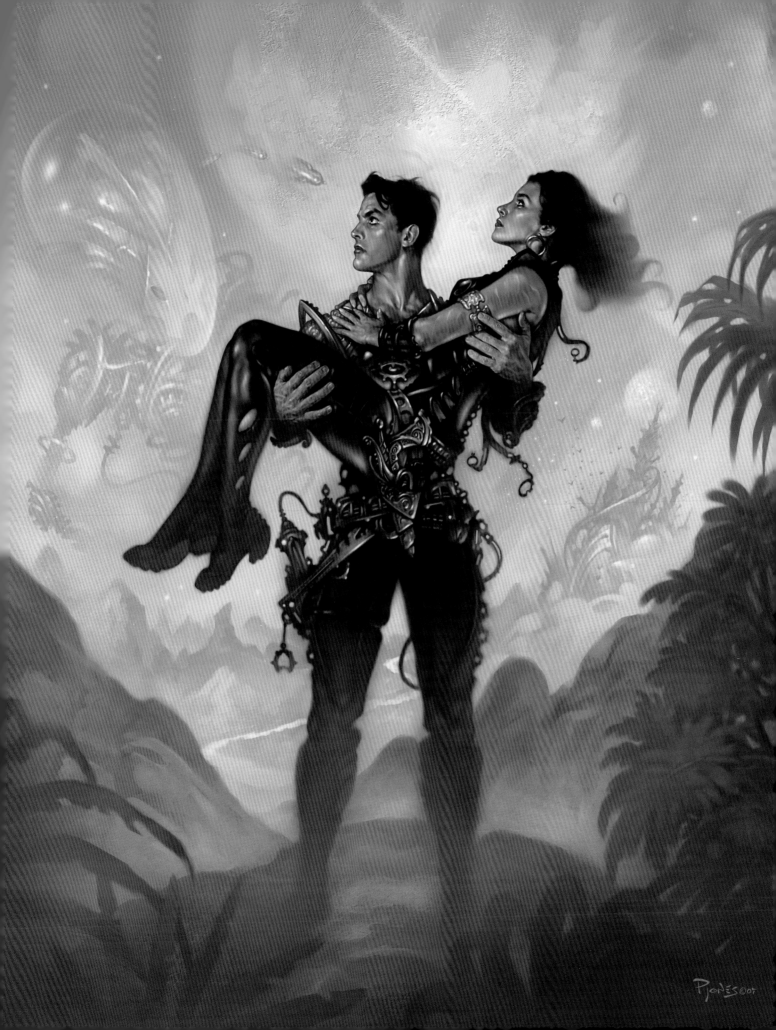

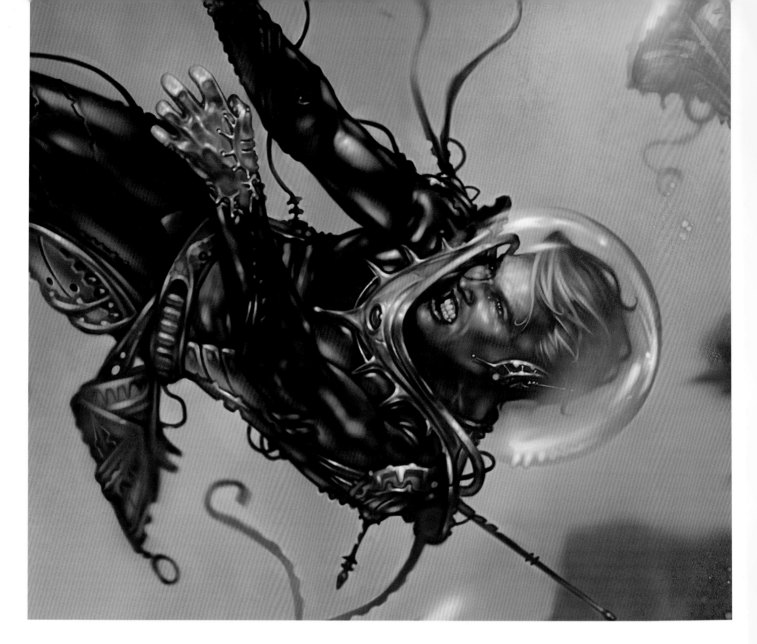

Back in 2007, a publisher friend of mine asked whether my cover artwork for the novel *Matter* could be re-used to promote the Auriels Awards for fantasy and sci-fi writing – held in my home city of Brisbane – at which I would be a guest speaker. He also asked if they could close in "on the pretty lady's face" at the top of the painting as a big-screen presentation backdrop. As I had posed for the (male) character he was indicating, I was unsure whether I should be flattered or insulted.

Public speaking is something that's dreaded by almost everyone, and I am no exception. For the awards ceremony, I had written a speech peppered with numerous anecdotes to take the edge off my nerves. I had also made a careful note of the names of the specific publications I needed to mention, and the full details of the author to whom I would be presenting the award. But as I took to the stage and began to speak, the event organisers suddenly turned off the lights in the auditorium so the Matter artwork could be shown in the background, leaving me, literally, in the dark as to what to say next. To begin with, having to wing the entire speech from memory was a living nightmare, but surprisingly I found that talking without notes was much more engaging to the audience, which I am now sure is down to being "in the moment". From that day onwards I never worked from a written speech or notes again.

Above: *Matter,* close-up; digital

Right: *Matter;* 18 x 24 inches; digital

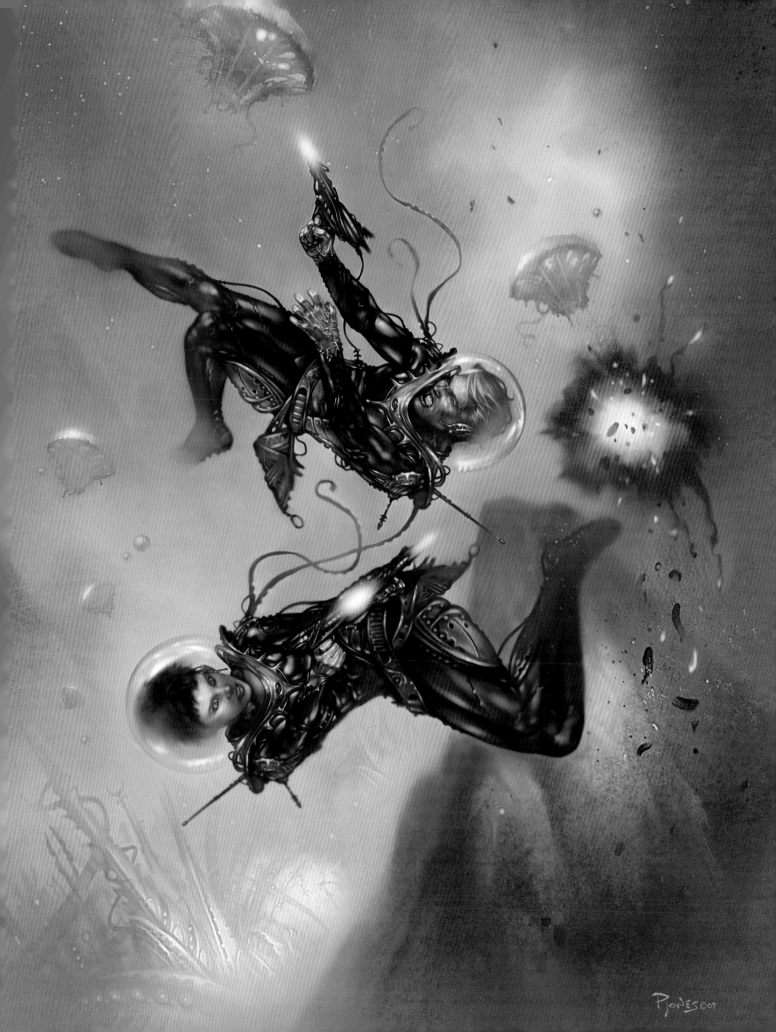

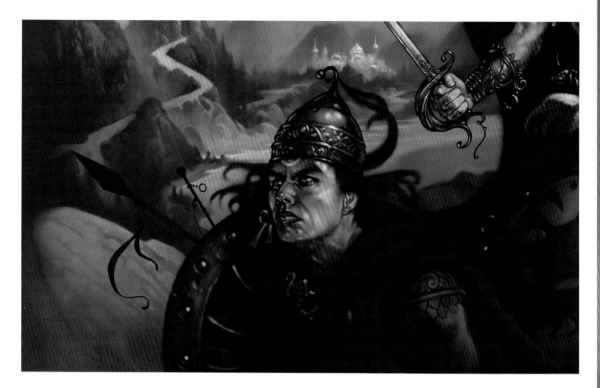

Opposite is the completed artwork for my final commission for Roc Books, *Shadow's Past*, and above is a close-up of the painting that offers a classic example of the kind of alterations that were driving me crazy during the digital publishing years. Even after sketch approval I was asked to change the entire position and direction of the lead scout in the work, mid-way through painting it. If these had been 3D characters it would not have been a problem, but for me it meant an entire repaint. Today I can admit that in this case, the art director was right in wanting to change the position of the character, as it made the composition more fluid, but he was still wrong to do so after sketch approval. Making such alterations wasn't *that* important in the grand scheme of things – today I can laugh about how trivial they were, compared to genuine problems – but back then I was kicking

over furniture at the injustice of it! Art is an odd, all-consuming passion when you are in the middle of it.

In the close-up, you can see how similar in method my digital and traditional art is. At this stage I had blocked in the underpainting in preparation for glazing colours on top. In the digital arena I used layer modes such as Overlay, Color, Screen and Multiply for my glazed colours, whereas for traditional oil painting I used glazed (thinned) oils. One final problem with digital art is that expectations are high when it comes to detail, and how much emphasis is placed on the strange obsession that every stroke should be clear and crisp. Here, the art director thought the figures in the distant road were hard to read when he zoomed in on the art. In traditional art they would be indicated by vague blobs of paint, which, ironically, is all they appear to be when reduced to book jacket size!

Above: *Shadow's Past,* work in progress close-up; digital

Right: *Shadow's Past;* 18 x 24 inches; digital

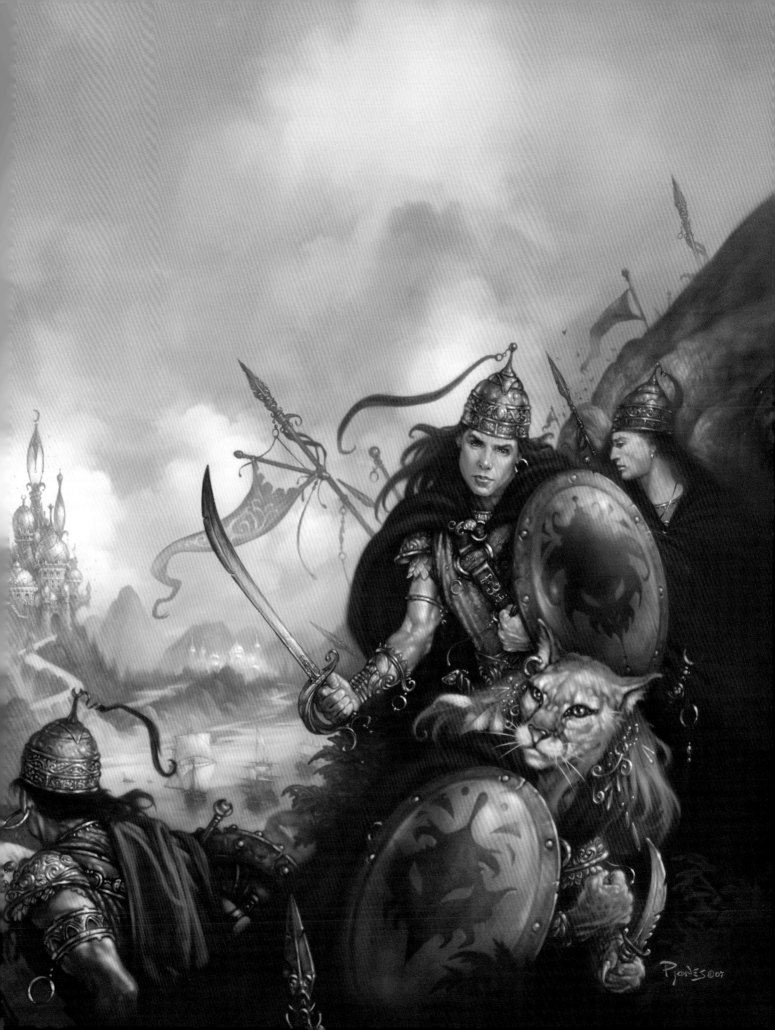

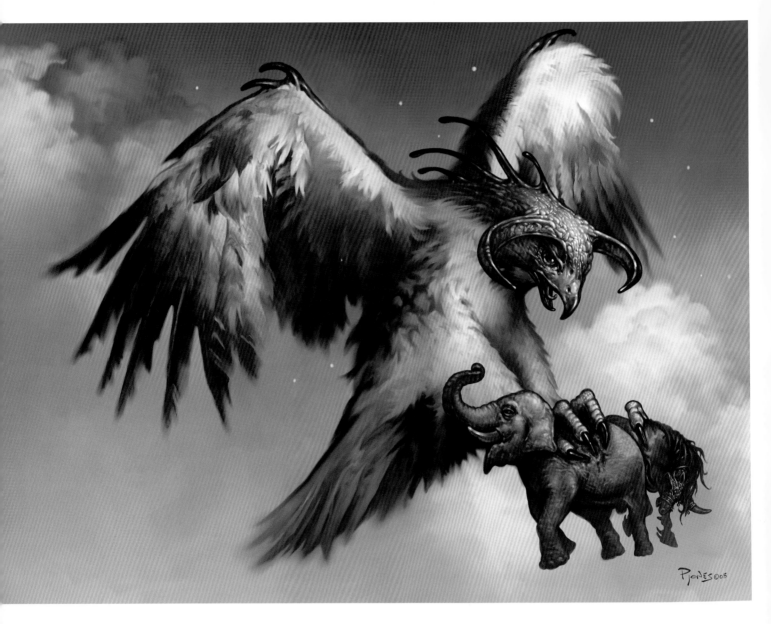

*S*eraph was created at the point when I felt I had finally mastered digital art, yet ironically, it was probably my last major digital artwork before I returned to traditional oils. I would do a few more digital works here and there, to save time when deadlines were tight, but this painting marked the beginning of the end of my digital art output.

It was the dying days of 2007 and commissions from the USA were slowing to a crawl as the country headed into the great recession; I sensed the same winds of change that had blighted my early career. Like everyone else, I was worried about my future, especially due to the precarious nature of an artist's chances during a serious economic downturn. So, things were looking grim, and I paled at the prospect of returning to advertising art with my dreams crushed once more. But, unbeknown to me, two great minds on the other side of the world were working on an event that would put me firmly back on the path I had been heading down all along.

Above: *Sinbad's Tale;* 18 x 24 inches; digital

Right: *Seraph;* 18 x 24 inches; digital

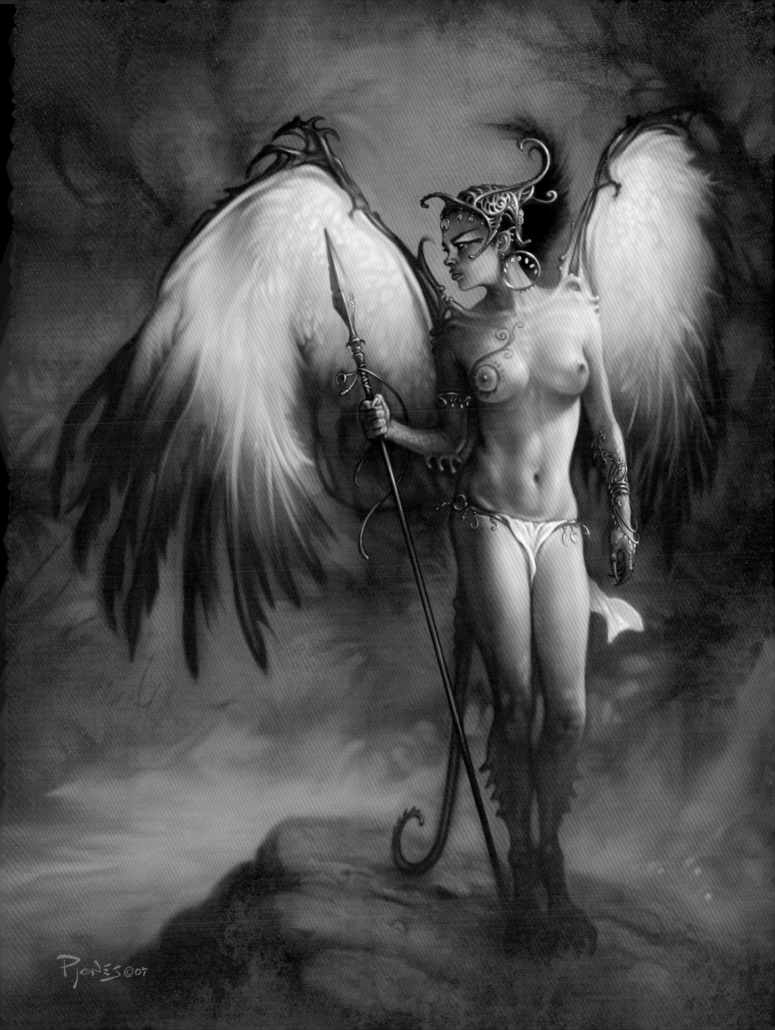

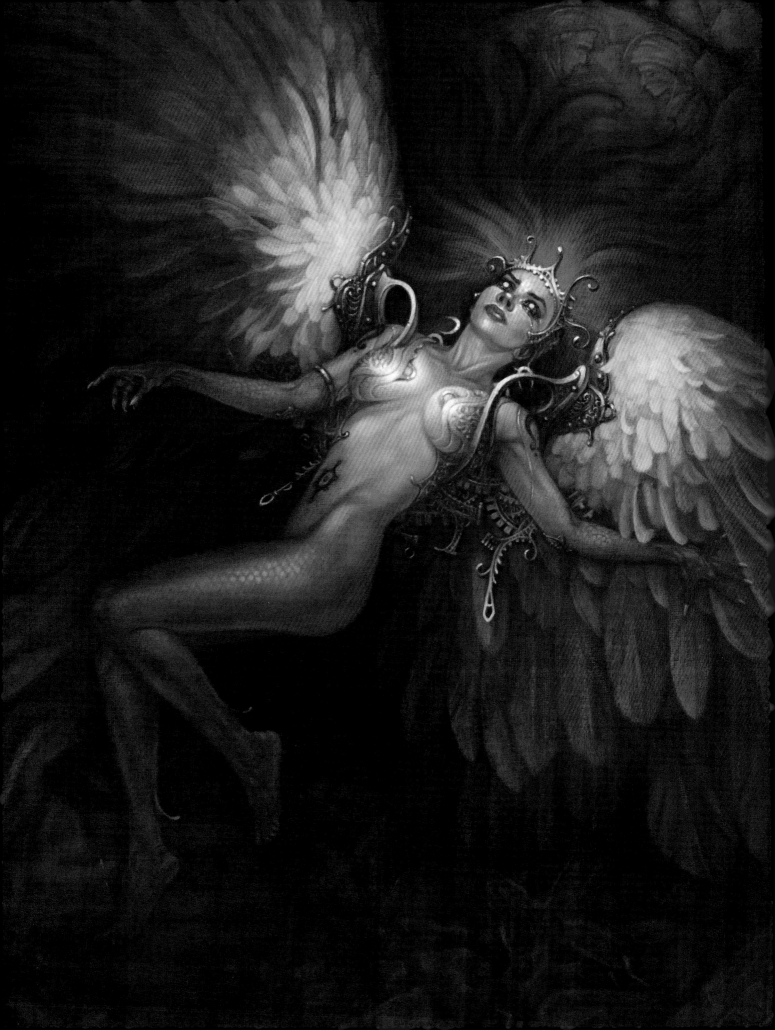

> *If you hear a voice within you say you cannot paint, then by all means paint and that voice will be silenced.*
>
> Vincent van Gogh (1853–1890)

The Collectors

Gallery Art

In 2008, Illuxcon (IX) was born, and once again I bent the world to my will. IX was a dream come true – a symposium of the world's greatest traditional fantasy artists, displaying their work under one roof. The fact that my childhood hero Boris Vallejo would be at the inaugural show was reason enough to cross the continents to Pennsylvania in the US. I secured a last-minute exhibitor's booth from Pat Wilshire, the show's co-creator, plus a commission to paint IX's official poster art and name tags. There was no turning back.

Jet-lagged but adrenaline-fuelled, I strode towards the first IX show on a frosty morning. After a decade in subtropical Australia, I marvelled at my cold breath on the air: it was the chill of my childhood returned. I was one of the first guests to arrive, and as I stood waiting on the silent upper level of the showcase, I read the information boards about the other artists.

Exhibiting to my left was Greg Hildebrandt, to my right, Justin Sweet and Michael Whelan; straight ahead was the mighty Boris Vallejo and his wife, Julie Bell. My long-cherished dream had finally become a reality, and as a film crew approached me for a TV interview, I found that my heart was pounding. That evening, as I enjoyed a post-show drink, the bartender turned up the TV as the square-jawed newsreader announced that Illuxcon was in town. It was a strange, almost *Twilight Zone* experience, watching myself being interviewed on US television while my newfound friends cheered and patted me on the back. After years of obscurity I was in the right place at the right time!

The creative process of some of the paintings in this section are documented in my companion book, *Sci-Fi & Fantasy Oil Painting Techniques*. Here I expand on the stories behind the paintings, making both books a richer reading experience. On the following two pages is *Darkdreamer*, the first oil painting I created after a decade away from working with traditional media. I went in boldly on this one: using my previous digital version of the art (which you can see on page 26) as the premise for a new, large-scale painting. It proved a wise move. I believe my fearless approach was the result of constantly working in Corel Painter, which had felt uncannily like traditional media. If anything, I found that traditional painting was easier than I remembered.

Left: *IX;* **18 x 24 inches; oil on canvas board**

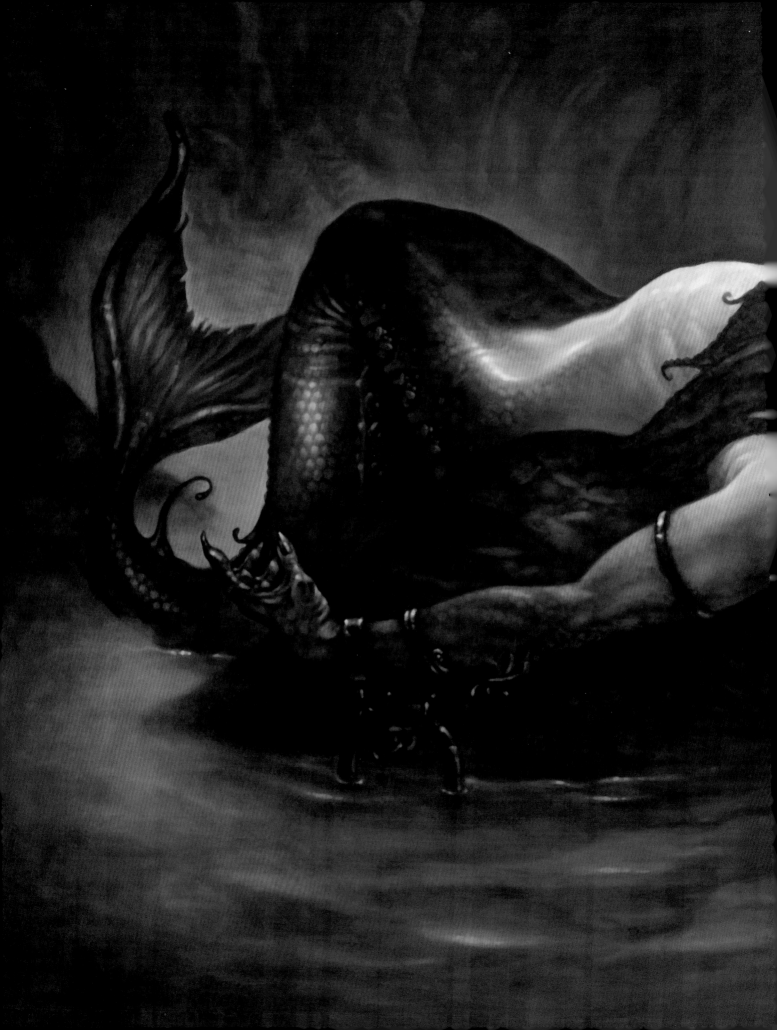

Darkdreamer; 40 x 40
inches; oil on canvas

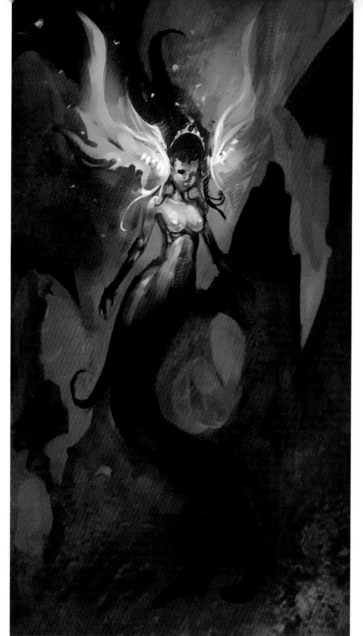

Song of the Siren was the second painting I produced for IX. Once again it went in pretty easily, mostly due to the fact that I had spent time on preparation, especially in posing my treasured models, Max and Tora. Having modelled for the Roc Books *Deathstalker* series, the pair were familiar with my art direction. When I suggested they sway as if dancing, then stop, they created a fluid pose that could never be achieved by simply "assuming" a pose.

As I sat in my booth at the first IX, I was aware of someone in my peripheral vision staring at the detail on *Song of the Siren*. It was Boris Vallejo! Around his neck hung an IX name tag emblazoned with my art. For a moment I couldn't speak. "Boris," I said, eventually, grinning out of fear, admiration, and embarrassment, "don't look *too* closely." He smiled back, then with a serious look said: "Man, this is great work." It was my first encounter with the master artist, and I couldn't have daydreamed it better.

Above: *Song of the Siren* alternate concept; colour rough; 6 x 18 inches; digital

Right: *Song of the Siren*; 48 x 36 inches; oil on canvas

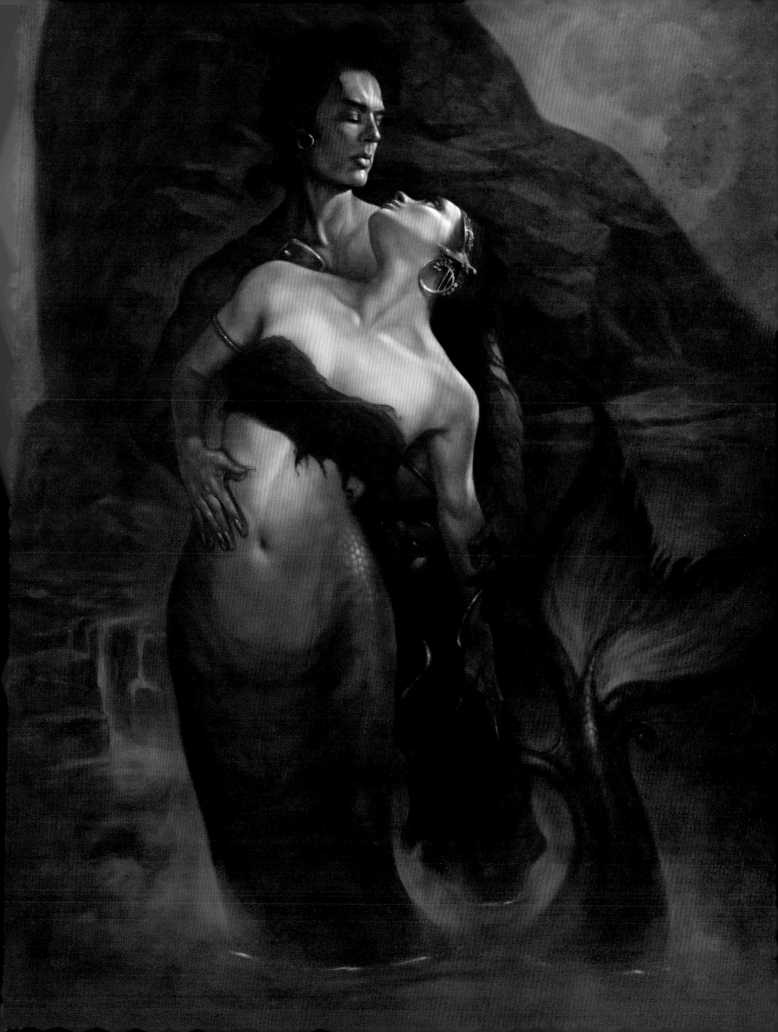

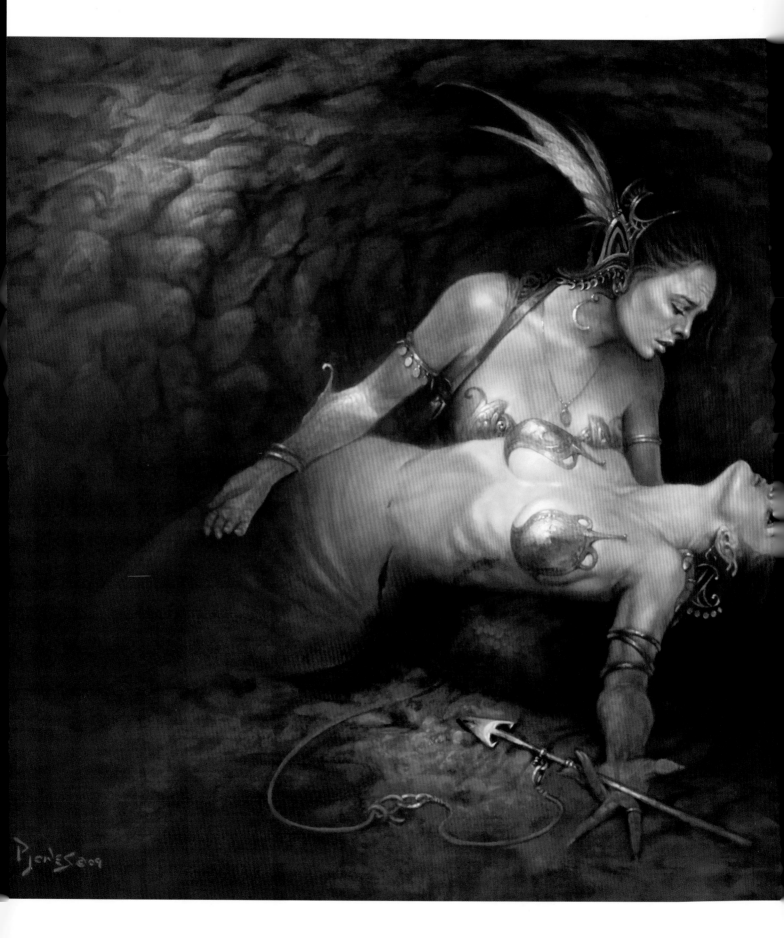

IX provided me with the opportunity to give art demonstrations and talks. My first talk, on art and inspiration, was at 10 am, but with the Main Show doors also opening at that time, obviously everyone headed to see the art first. Initially, my presentation was a washout, attended only by a few friends I had met during the show's set-up, but after a while people started to trickle in. I was discussing Boris Vallejo's influence on my work, when I noticed his wife, Julie Bell, standing at the entrance. She stayed a short while and then left as the room filled. Five minutes later she returned with Boris, and they both sat at the back.

My talk ended with a spirited question and answer session and a great round of applause. When that died down, I acknowledged Boris and everyone joined me in a standing ovation. He gave a short speech, saying how proud he was that I attributed my success to his influence, even though, he assured everyone, it was my own efforts that counted. As much as I tried to disguise the fact, my damned eyes filled with tears.

IX also introduced me to art collectors for the first time, and gave me a presence. *Death of Diana* was painted when I returned home, and was intended as the first in a series of speculative works for the next show. I uploaded the colour rough online and the painting was pre-sold to collector Richard DeDominicis, based on the early vision of how the art might look. I met Richard at the following IX show, and was impressed by his sophistication. He proved to have a keen eye, too, as this was my first traditional painting to be nominated for a Chesley Award.

Above: *Death of Diana* colour rough; 6 x 12 inches; digital

Left: *Death of Diana*; 18 x 24 inches; oil on board

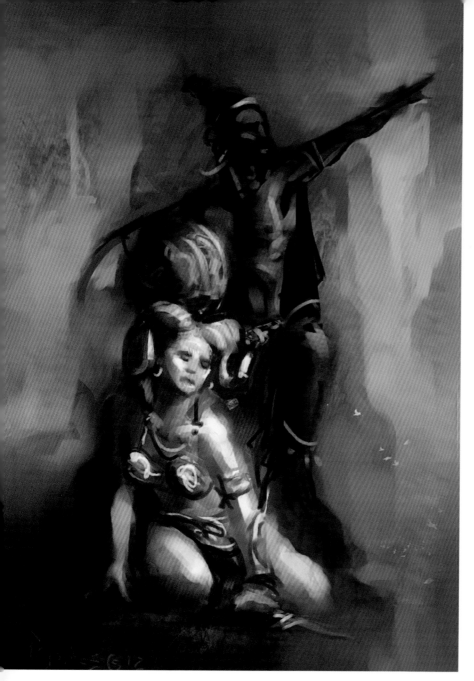

Although my first IX show garnered interest from collectors, and praise from my fellow artists, my displayed art hung unsold. Undeterred, I believed a return trip would tell a different story, and despite my vacant pockets I was determined to prove it so.

My second IX, in 2010, rewarded my faith. It began with three paintings sold during a collector's pow-wow before the doors even opened, and further sales and big commissions followed during the five-day event. I offered the small gathering of collectors a discount if they could wait until the end of the three-day show to collect the work. It was a great incentive for other buyers to see a red dot "sold" sticker so early in the show, and encouraged further sales. A pre-sale would usually be a big no-no, but as IX takes no sales commission, it was all above board.

I originally painted *The Lost World,* seen here, for myself, as the title artwork for a future project– an illustrated novel featuring pirates shipwrecked on a lost world filled with exotic cities, mermaids, dinosaurs, and vampires. This was the first painting I sold to collector Tim Shumate, who would prove a great patron of my art in the years that followed.

I can clearly remember the day my model Carly Rees posed for *The Lost World.* I needed the Dragon Princess character to be coiled tight as a spring – every muscle in her body taut – at the first sign of the pirate invaders. Carly had just – voluntarily – plunged into an ice-cold pool for me to achieve another pose, and was therefore in a perfect state of frozen tension to hit this one. It was a feat above and beyond the call of duty. I particularly liked Carly's knees in this work: a rarely admired feature of human anatomy.

Above: *The Lost World* concept; colour rough;
6 x 12 inches; digital

Right: *The Lost World*; 18 x 24 inches; oil on board;
private collection

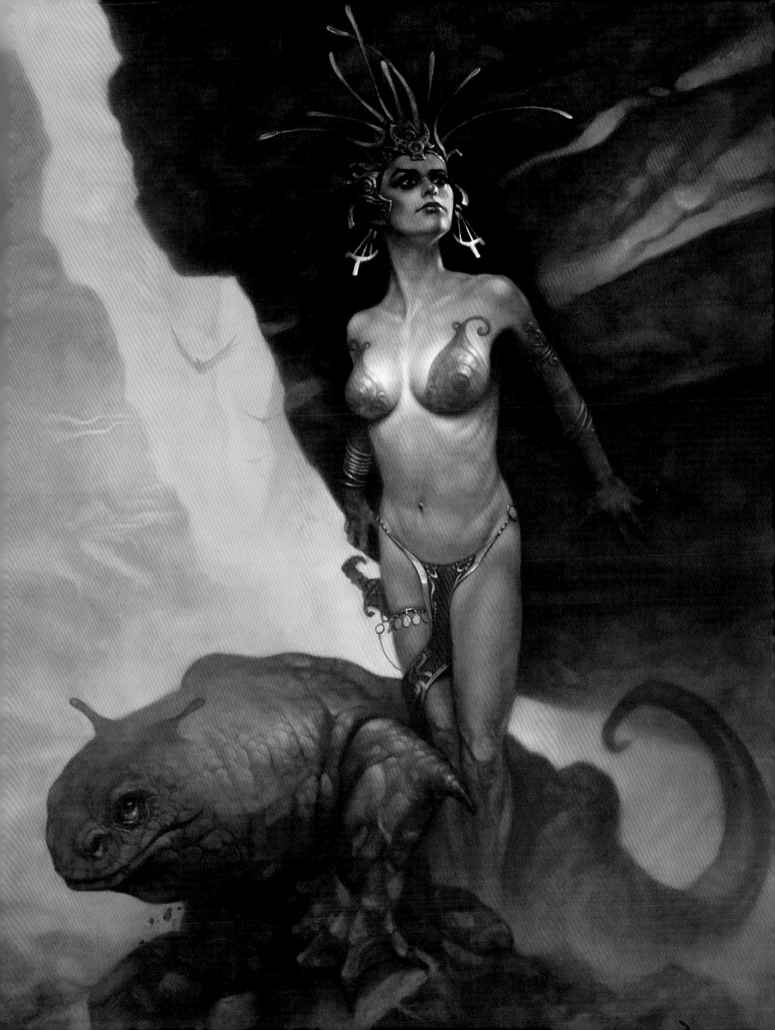

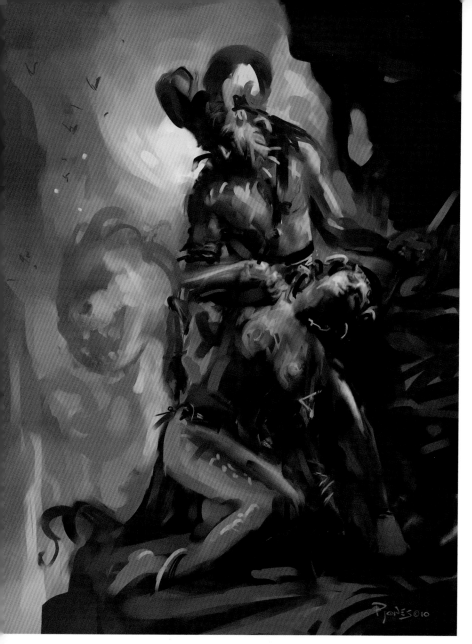

Like *The Lost World*, *Valley of the Serpent* was smaller than my usual art, and was painted on gessoed board. I sold it to collector Greg Spatz during IX's 2010's pre-show pow-wow. Greg passed by the booth the following day and asked me if the painting was buckling – sure enough, it *was* starting to warp. Oils dry slowly and the room was warm; on top of that I had framed the painting with faux frames made from light plywood. However, a quick spray on the back of the board with water and we were all straight again.

Before I discovered Brisbane's Leeton Agency (which supplies models for art schools, groups, etc), I often hired my best art students to model, as they understood my fantasy art methods. For *Valley of the Serpent* I used two ex-students, Mary Ricci and Jason Clarke, who also posed for the large oil painting *Artemis and the Satyr*. Although I have taught hundreds of students whom I rarely see again, Mary and Jason have remained friends of mine almost a decade after graduating. They both practise martial arts, which is a great discipline for holding long poses.

Above: *Valley of the Serpent* concept; colour rough; 6 x 12 inches; digital

Right: *Valley of the Serpent*; 18 x 24 inches; oil on board; private collection

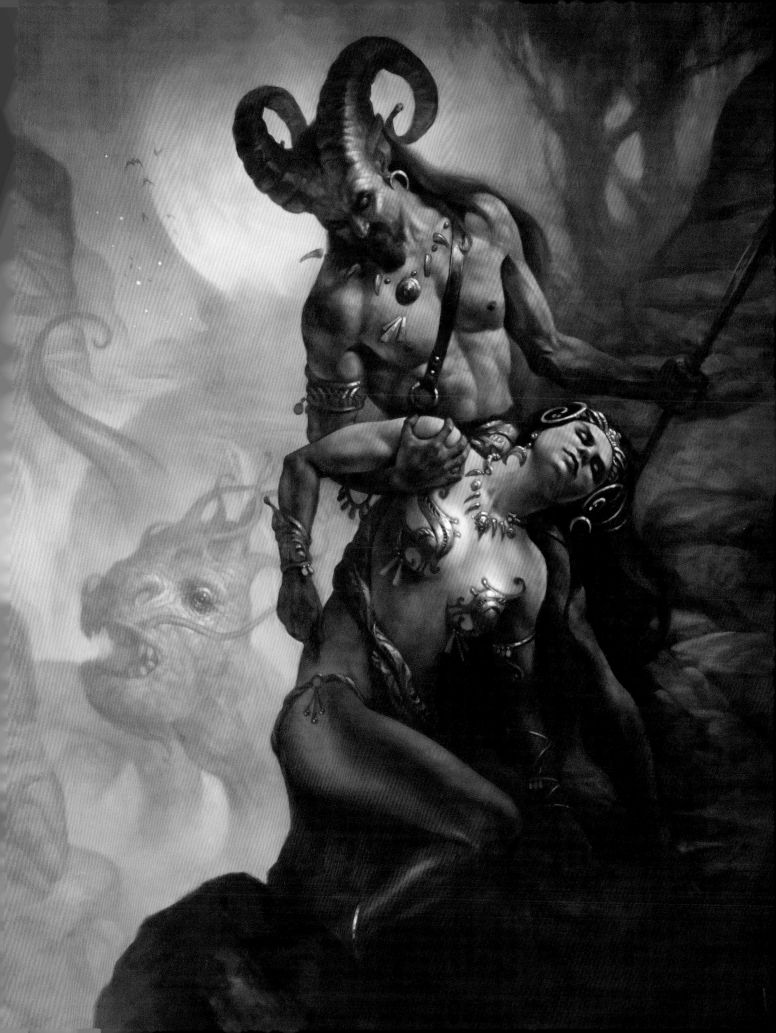

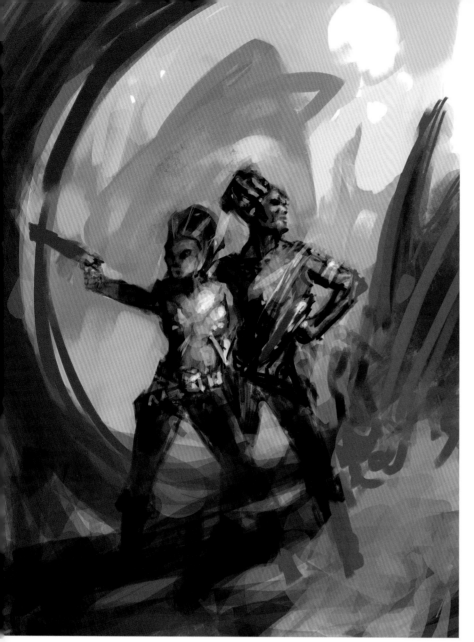

*S*tarship, Flagship was the cover painting for a novel commissioned by Easton Press and was my second published artwork created in oils. This left me with the original art to sell at IX 2010, thus taking the pressure off creating something specifically for the show. Painting in oils for publishers is a chance to get paid twice for the same artwork, as all they need is a digital scan of the work. Afterwards the original painting is the artist's to sell, as long as they haven't signed the rights away.

For me, this proved an astute manoeuvre as *Starship, Flagship* was then sold to collector Dan Fowlkes during IX's pre-show pow-wow. I had met Dan at the first IX in 2009, and it was great to see him again. He helped set up my booth and after much clowning around, he surprised me by donning his serious collector's hat to buy this painting. With the deal done, clowning around was then resumed, unabashed.

Above: *Starship, Flagship* concept; black and white rough; 6 x 12 inches; digital

Right: *Starship, Flagship;* 18 x 24 inches; oil on canvas; private collection

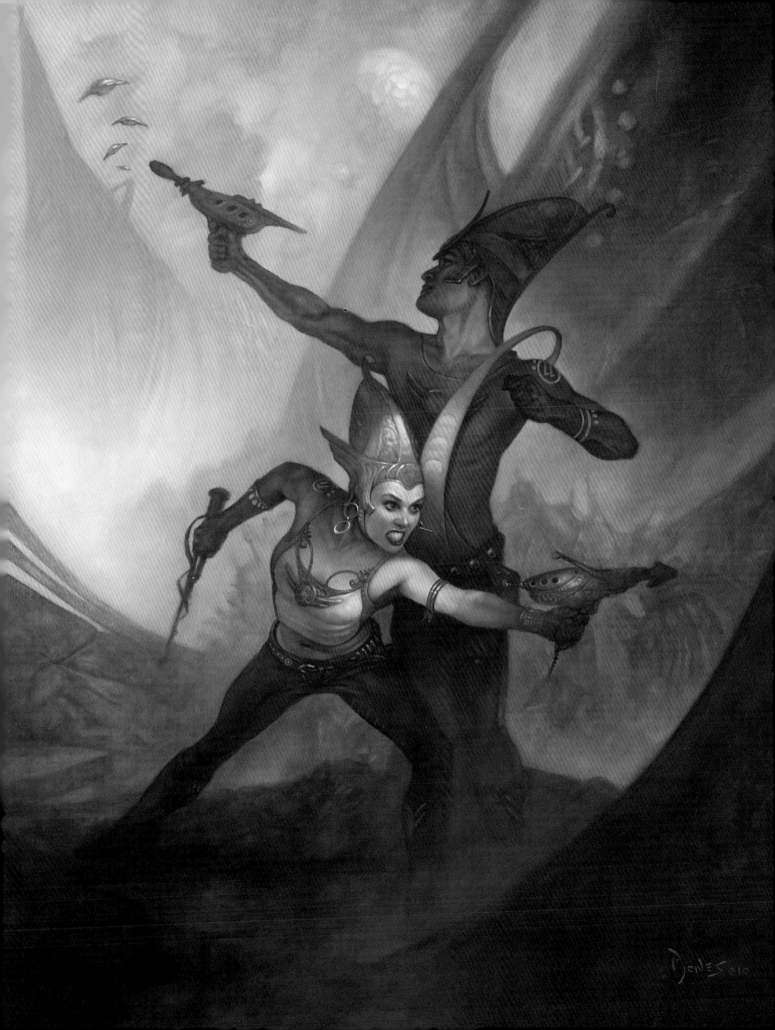

ales from IX 2010 had already cemented the symposium as a bi-yearly event for me, but commissions procured during the event itself proved even more important, as I could return to Australia and continue to paint pictures. My painting *Artemis and the Satyr* inspired collector Gareth Knowles to commission *The Sacrifice* based on the same scale and colour scheme.

It was the final hour of the final day of IX, and a lot of the artists and collectors had packed up and gone. At this point I was approached by Gareth to paint what would be my largest commissioned work. Gareth was a humble and gracious man who I later learned had a great scientific mind: his company was advancing NASA's space programme and the science world in general. As Gareth walked off through a sea of wrapping paper and empty tables, I considered my good fortune. The show ain't over till it's over.

Above: *The Sacrifice* colour rough; 6 x 12 inches; digital

Right: *The Sacrifice*; 48 x 36 inches; oil on canvas; private collection

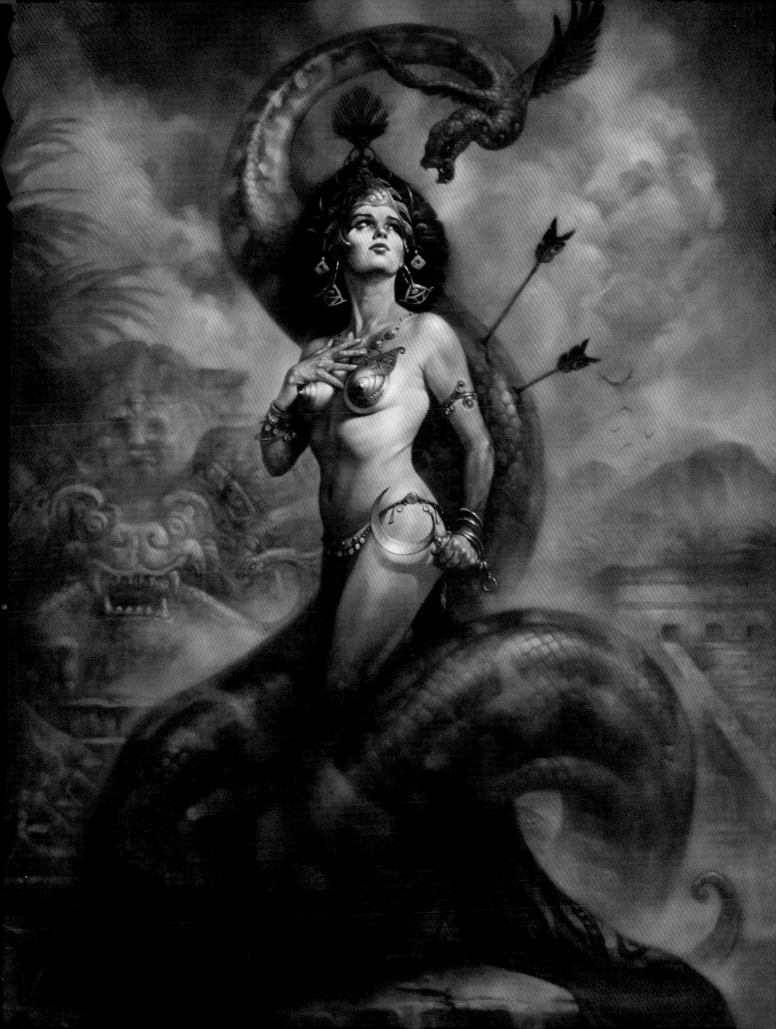

Although *Artemis and the Satyr* did not sell at IX 2010, it generated a tremendous buzz. Everyone wanted something like it: the colours, the mood, etc. It remains one of my favourite pieces and more recently it was sought after by various buyers; it is now in a private collection. The little colour rough of it seen here resides with my good friend Tim Shumate, who always loved the big painting and made bids to own it when it was out of my hands. Had he been at IX at the time, he would have owned the original too.

And so, as my second IX drew to a close, many great artists – including Daren Bader, Raoul Vitale, and Dan Dos Santos – came to personally congratulate me on earning the highest sales of the show; such is the spirit of IX. An unexpected highlight was an invite to Donato Giancola's studio. That day I will never forget. Not only did I hustle the last meter space in Brooklyn with an impossible reverse park, but I also got to hang out and watch a master artist at work. Afterwards, I drove the length of Manhattan's Broadway with my windows down and the sounds of New York City in my ears, very aware of how much my life had changed since the impoverished, charcoal streets of my Belfast childhood.

Above: *Artemis and the Satyr* colour rough; **6 x 12 inches; oil on board**

Right: *Artemis and the Satyr*; **48 x 36 inches; oil on canvas; private collection**

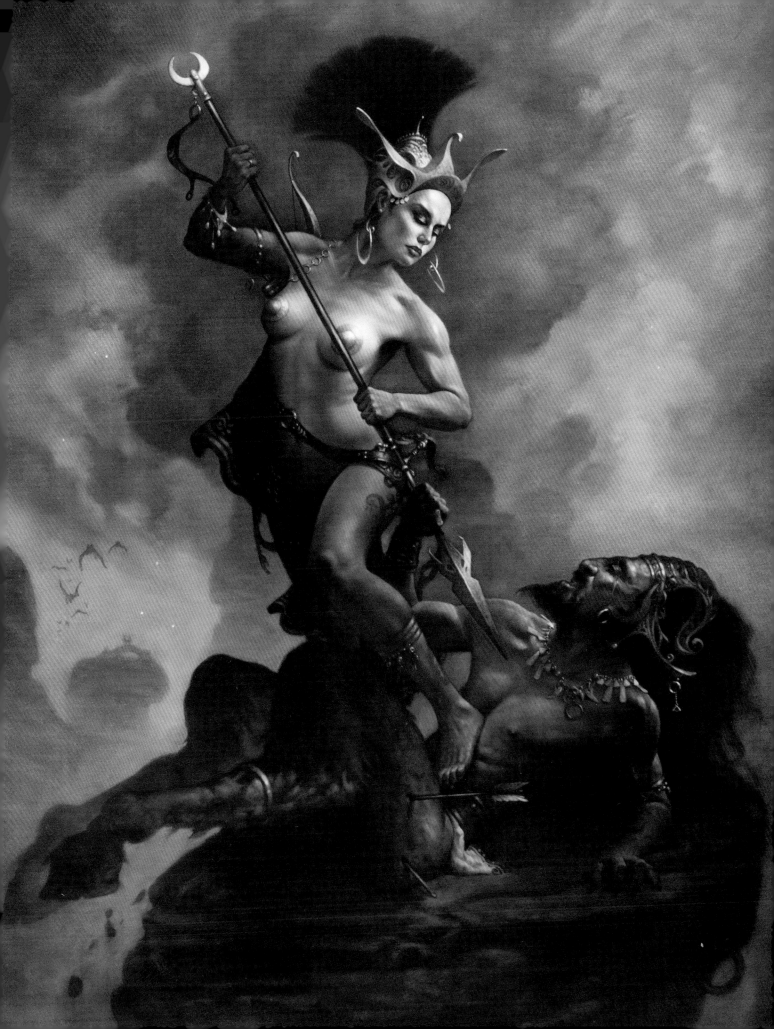

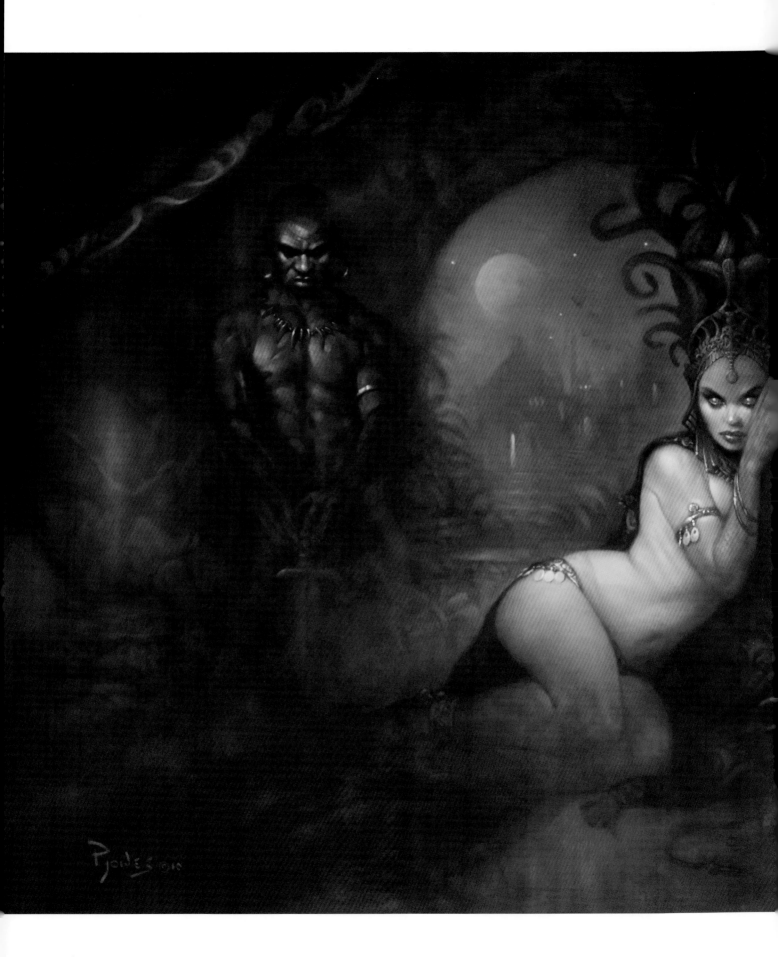

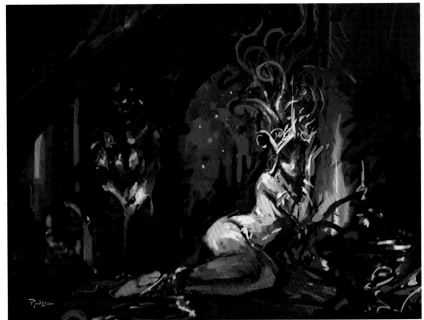

Artistically, 2010 was blemished only by the death of Frank Frazetta. The tragedy was compounded by an unrequited invite to his home. When Pat Wilshire Skyped me earlier in the year that Frank was expecting us after IX, I screamed like a teenage girl! We joked about the greats of fantasy art crowding onto a coach, throwing gum at the driver and having a sing-along all the way to Frank's door. I'm sure Frank would have been amused by us, and humbled by our collective love for him, but sadly it was not to be.

Palace of Medusa was another painting in my *Lost World* series and was later bought by collector Colin Fagg. It was inspired by one of my favourite Frazetta works, *Egyptian Princess*. I later discovered that *Medusa* had been bootlegged as a Frazetta print, with my name replaced with Frank's signature. This may have explained the confusion at *ImagineFX* magazine when they asked me to submit a Frazetta-inspired work for his tribute issue. I submitted *Medusa*, but instead of being placed in the tribute section, it was mistakenly inserted into the Frazetta Gallery, where the reviewer went into detail about how Frazetta knew how to hold our gaze with his portrait of Medusa.

Although I'm extremely proud of this piece I have since made a conscious effort to break away from Frazetta's influence, which is much harder than it sounds. His legacy is so indelibly engraved in my subconscious that I have to check every idea in case I'm duplicating the master of fantastic art. There is only one Frank Frazetta, and he is truly missed.

Above: *Palace of Medusa* colour rough;
6 x 12 inches; digital

Left: *Palace of Medusa;*
18 x 24 inches; oil on board; private collection

I first met brothers Leigh and Neil Mechem at IX in 2008 and we became great friends. What I was unaware of was they are also art collectors. On the next occasion we met, at IX 2010, the boys commissioned my first ever Conan painting. Although Neil and I both believed we had the perfect physique to pose for Conan, we were missing the perfect princess. With only Leigh left to choose from, we sat rubbing our chins. Amazingly, during our pondering, artist Alina Osipov breezed past, and with great style, she agreed to pose with Neil as I did some initial scribbles at the table. With scribbles approved, I returned to Brisbane, which left the problem of how to proceed to the next stage, which was a photoshoot with Alina.

The second amazing coincidence was that Alina lived in Toronto, the same city as the boys. Using a cross-continental solution I posed my own model, Emily Campbell, in the dramatic light required to achieve the atmosphere I needed, and sent Neil a plan of my Brisbane studio layout to match camera distance, angles, position and lighting. Together we synchronised our studios to pose and shoot reference photos of the perfect princess.

Above: *The Forbidden Kingdom*, **colour rough;
6 x 12 inches; oil on watercolour paper**

Right: *The Forbidden Kingdom*; **24 x 36 inches;
oil on canvas; private collection**

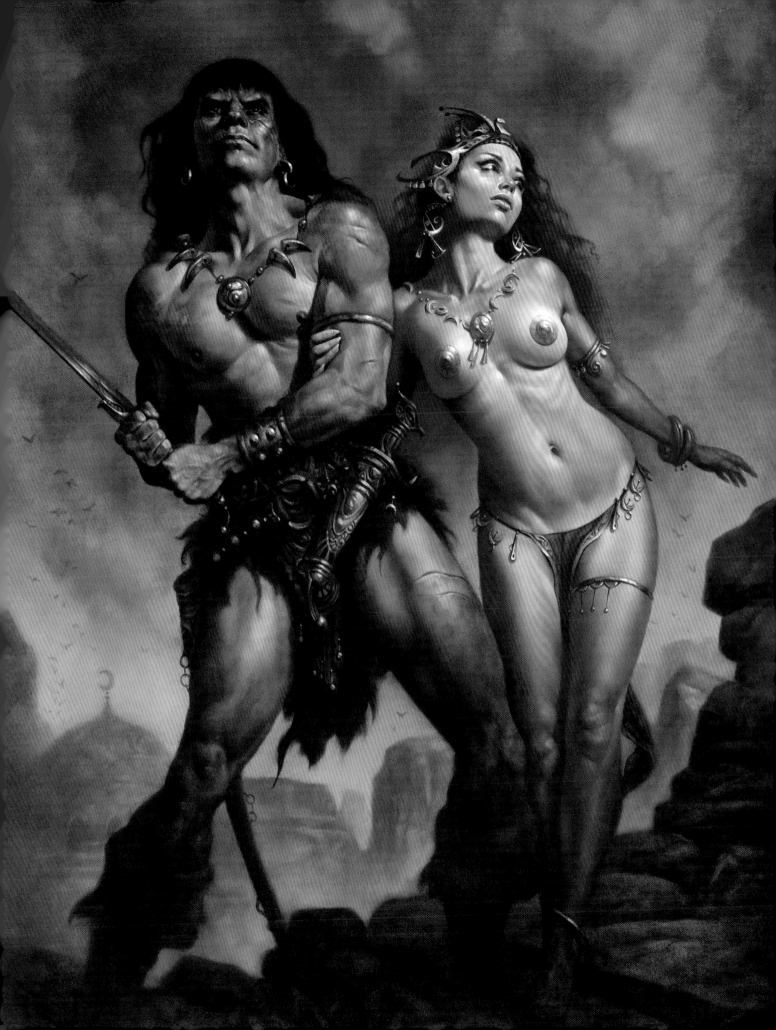

The Mechem boys heaped humongous praise on me on receiving their first barbarian in the mail, and soon after they asked for a companion piece in the vein of Frank Frazetta's famous painting *Conan the Destroyer*, which I consider one of the greatest fantasy paintings of all time. *Army of the Damned* (which was originally named *Dawn of the Dead)* and the painting I created before it, *The Forbidden Kingdom,* were the first fantasy artworks I had released as prints (today, they are available from Girasol Collectables). Neil Mechem posed for Conan's torso and I posed for the face. Neither photo-reference looked much like the final barbarian, as they were just a starting point to achieve the most heightened degree of savagery possible.

Around this period of great change I also embarked on my own publishing adventures with the launch of my website and online store. The latter was something I couldn't even have dreamed of when I first started out, as the technology for it hadn't been invented. I remember the shadow of it though, back in the 1990s when walking down Tottenham Street in London with my agent, Jon Hughes. A bus blared by with an ad on its side bearing a message that was incomprehensible to us: visit us at www.buystuff.com! "What the hell kind of language is that?" I asked Jon. "I'm not sure," he replied. "It's a new world." We both knew it was something to do with computers, though, and it frightened us. Luckily, despite our fears, we were not trampled underfoot by the march of technology.

Above: *Army of the Damned* colour rough; 6 x 12 inches; oil on watercolour paper

Right: *Army of the Damned*; 24 x 36 inches; oil on canvas; private collection

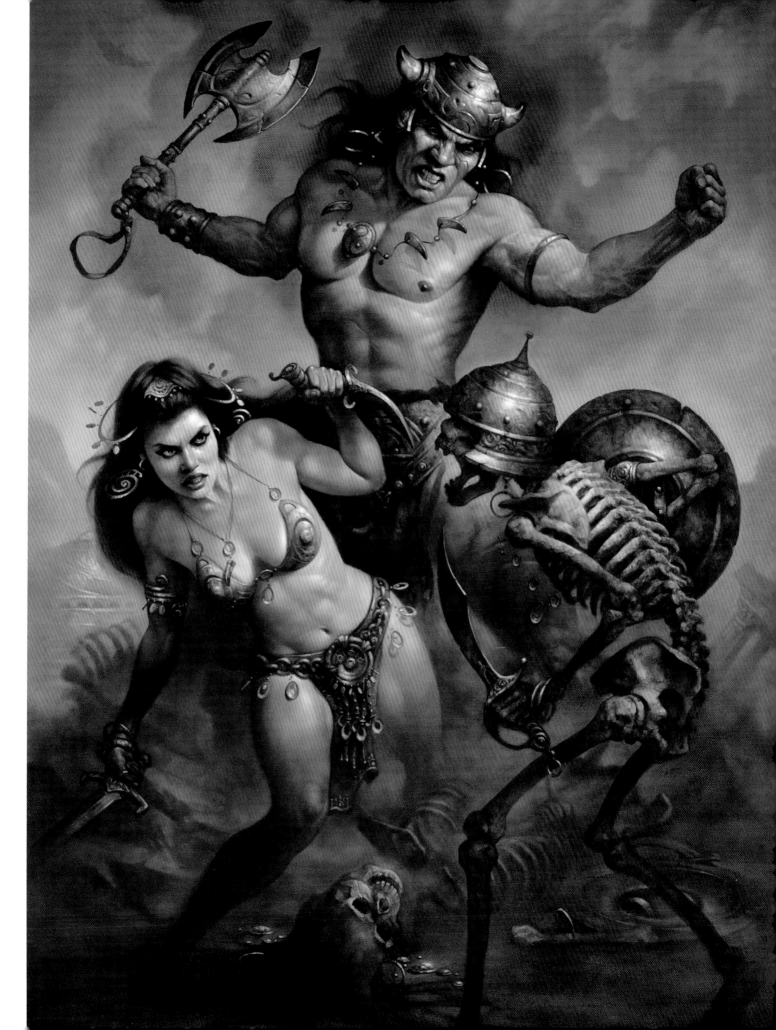

As I write this book, my commissions are renewing in a consistent six-months-ahead timeframe, which is an incredible, and almost surreal, thing. For now, there is no time to create art purely for myself, but no doubt that chance will come again. When it does I will not think of myself as unemployed, which is something that every artist could be labelled when commissions end; instead, I will consider it an opportunity to paint something for myself.

The work shown here, *Winter's End: Cleopatra's Last Dance,* was born of an opportunity to enjoy painting between commissions. The fact that art collector Tim Shumate got in touch to buy it soon after was a great validation, but my philosophy is to paint for pleasure; then, whether the work is sold or not, it was quality time well spent. For me, there is also the added value in knowing the work is bought by a collector such as Tim, who buys art for the love of it. Knowing a painting will be treasured, makes it a little easier to let go of it. For *Winter's End*, contemporary dancer and artist's model Katy Woods posed for me. I performed a faux flamenco dance for her to mirror, and she showed me what true gracefulness looked like in return.

Above: *Winter's End: Cleopatra's Last Dance*
colour rough; 6 x 12 inches; digital

Right: *Winter's End: Cleopatra's Last Dance;*
18 x 24 inches; oil on board; private collection

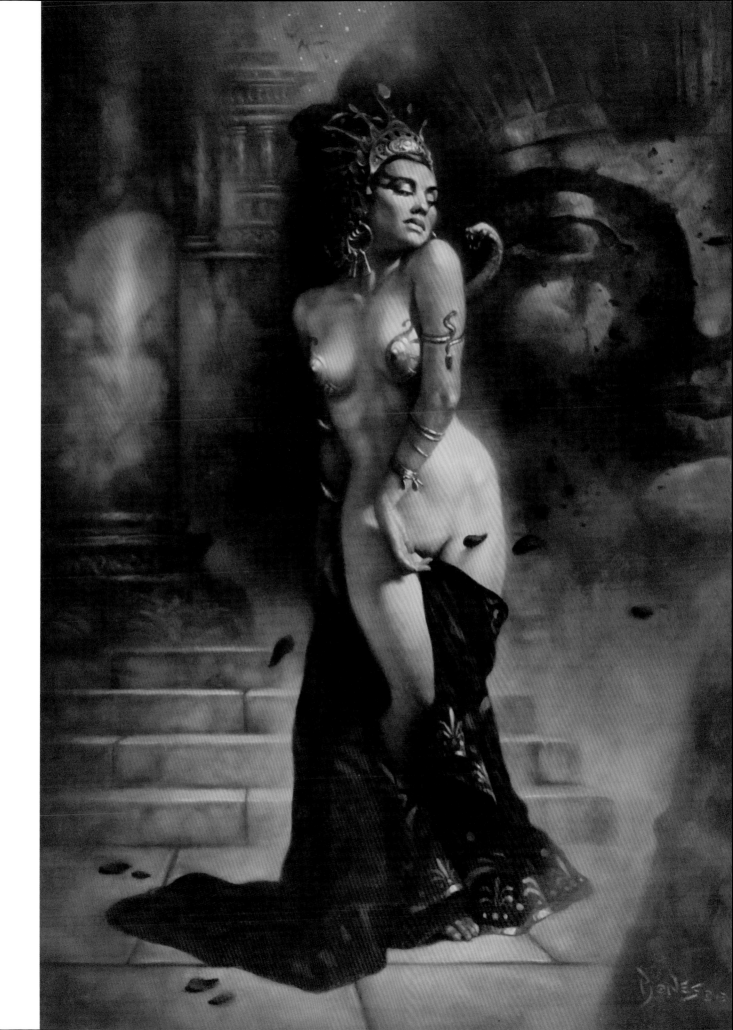

The *Lost Treasure* was a birthday present to Neil Mechem from his brother Leigh. It gave me the chance to paint a diver in the style of those adventure movies I'd loved so much as a kid, such as 1948's *Wake of the Red Witch* starring John Wayne. That movie also haunted me due to the heroic theme of self-sacrifice, and as a kid, even the ropey special effects, like the rubber octopus, were completely convincing. I have a fantastic memory of my mum letting me stay up late to watch it on a Friday night, which meant I had to sneak out of bed and tiptoe down the creaky stairs, lest my sisters howl the house down at the injustice of it all.

The model here was one of my ex-students, Kelsi White, who is also an artist and was enrolled in one of the first classes I ever taught. Kelsi was one of those super-bright kids who never missed a class and would befuddle me with terms like "hexadecimal". She soaked up everything I taught her like a sea-sponge, then worked on her assignments in unbroken silence.

Teaching has given me an insight into the next generation with a much broader scope than would be possible within the confines of a single family group. Students today may be more aware of the world and its technology, but overall they appear, to me, to be no smarter or dumber than the generation before theirs. Yet if I had a classroom full of Kelsi Whites, I would have my feet up and be smoking a pipe after each lecture (if indeed I smoked a pipe).

Left: Mermaid concepts; digital

Right: *The Lost Treasure;* 24 x 36 inches; oil on canvas; private collection

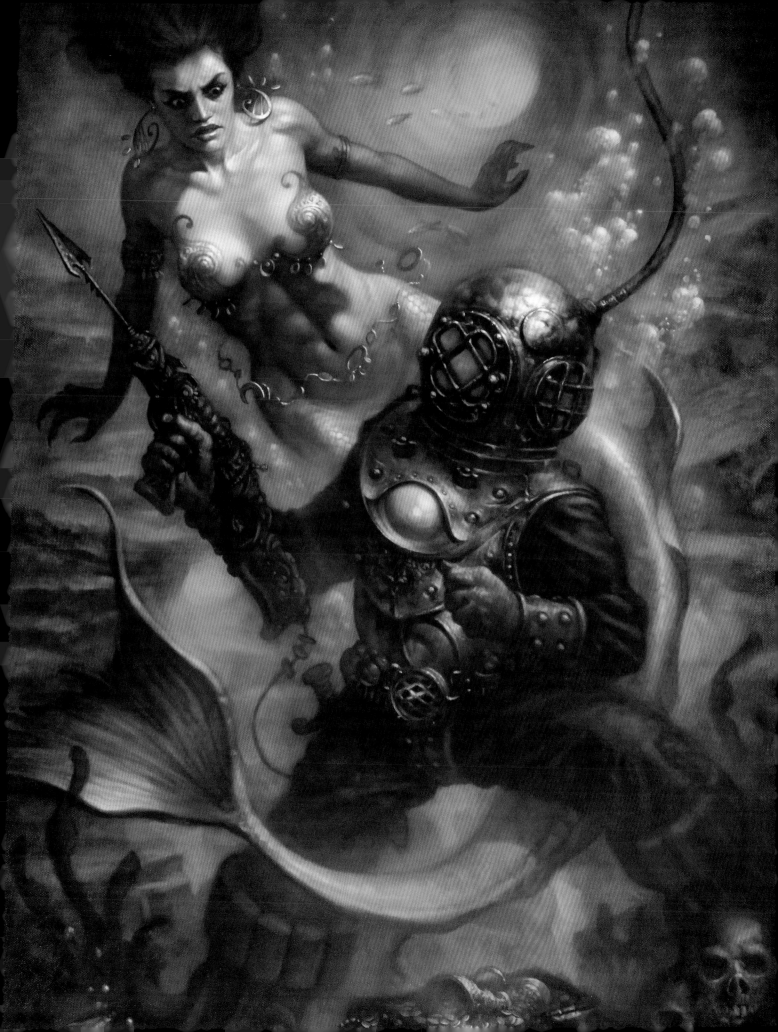

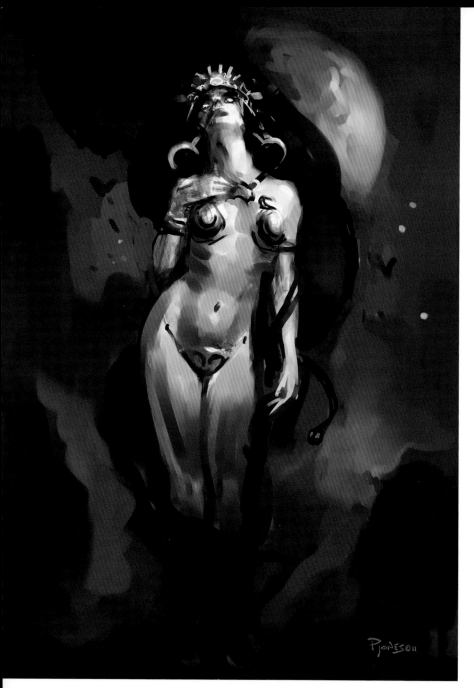

Night of the Zombie was a rare deal struck with an art collector. He was a real nice guy with a limited budget who wanted a zombie artwork, so I proposed a small one without a timeframe so I could paint anything that came to mind. I had complete artistic freedom and he had the opportunity to collect one of my paintings. He commissioned the work at IX 2010, and I delivered it by hand at IX 2012. Collectors have incredible patience.

The art was based on a pose from the Alina Osipov *Forbidden Kingdom* photoshoot. I sketch lots of ideas in preparation for photoshoots and will usually realize at least a few of the concepts for future paintings. On a side note, the great American figurative artist Nelson Shanks (1937–2015) left us recently and I found some footage of him painting Alina; she had attended his workshop but ended up as his model, just as she had done for me at IX. Sometimes I doubt reality, as the international art world, which was totally inaccessible to me in my early years, now feels like a strange dreamscape to which I am now connected, filled with reoccurring characters and coincidences.

Above: *Night of the Zombie* colour rough;
6 x 12 inches; digital

Right: *Night of the Zombie;* 12 x 19 inches;
oil on board; private collection

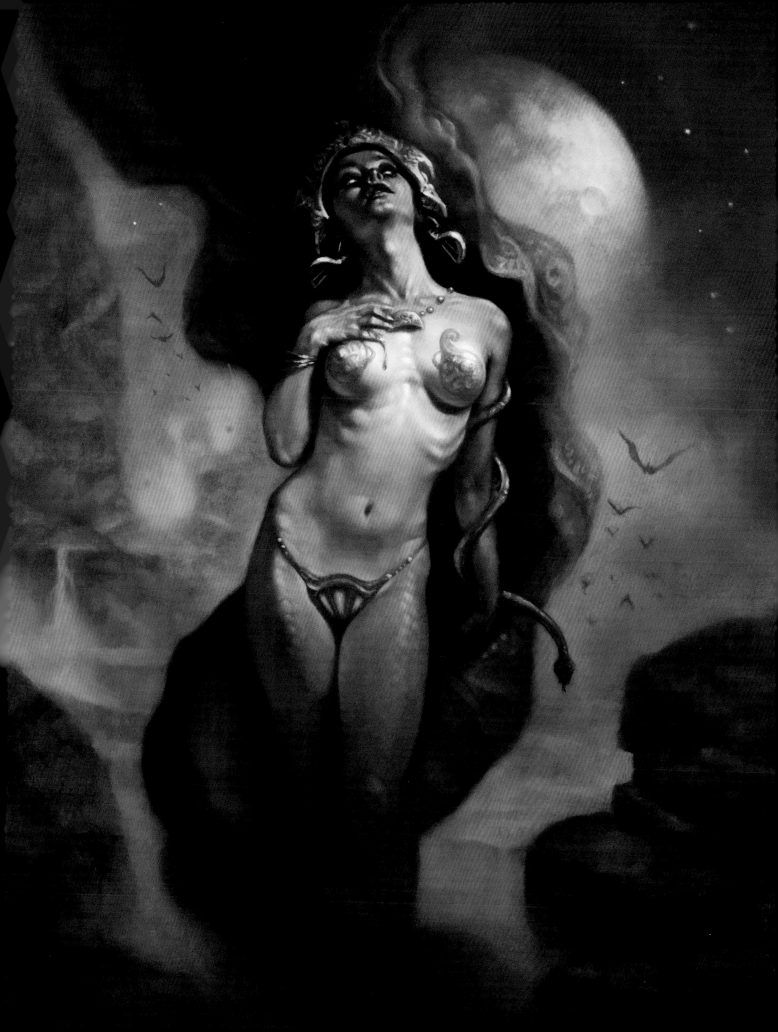

Collectors are not handcuffed by the restrictions that bound most art directors – nudity, say, or format, or where to leave space for type. A collector will commission art based simply on his or her love of the artist's work. I first met Dan Fowlkes at IX 2008, where he quickly befriended everyone: making jokes and being willing to roll up his sleeves and help artists set up their work. Each year Dan commissions a Christmas card artwork from a list of artists he likes, and every Christmas, collectors and artists around the world find Dan's card on their doormat.

Dan is a true patron and beloved member of the IX symposium, and in the spirit of festiveness and good cheer he embodies, I promised I would paint him a snow queen... those were the only words needed for Dan to give the go-ahead for the work.

Above: *The Snow Queen* comp; 6 x 4 inches; scanned pencil/digital tone

Right: *The Snow Queen*; 12 x 18 inches; oil on canvas; private collection

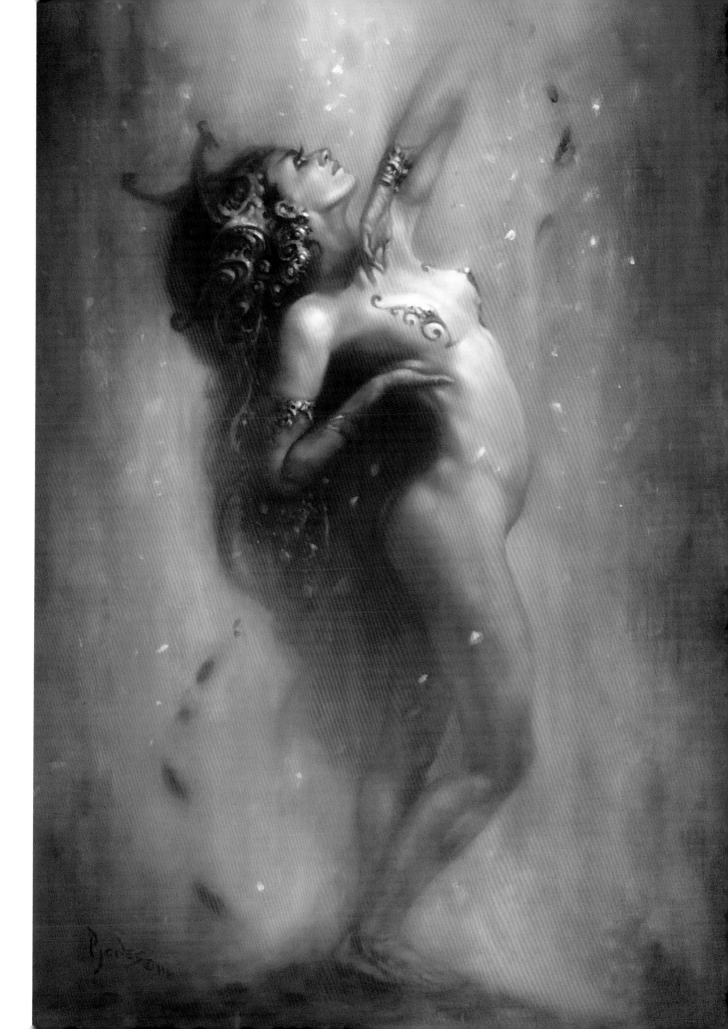

I expect most commissions to be a one-off affair, but although I didn't know it at the time, *The Gathering Storm* was the genesis of an incredible collaboration. When Catherine Gyllerstrom commissioned the painting, the brief was a simple invitation to be creative: "The Boston Tea Party with mermaids."

This work was one of the last I rendered on flat board. With traditional art came the fearful challenge of transporting it by post: on the sturdy mailing box, I wrote instructions on how to open it simply and safely – yet customs chose to ignore the advice completely. When Catherine showed me the Neanderthal damage they had wreaked on the box, I thought it was a miracle the painting itself remained unscathed. Luckily I had double packed it or they would have scraped whatever chisel instrument they had used in their primitive struggles, across the face of the painting.

After the horror of that incident, I found the perfect solution for future mailings in the plumber's aisle of my local hardware store: PVC tubing, plus the caps that are traditionally used to seal off the end of water pipes. Having found a virtually indestructible, and waterproof, container, I vowed to send rolled canvas artworks by tube in future.

For *The Gathering Storm* I posed for the boat crew, and actor and artist's model Carmen Olsen posed as the feisty mermaids. I think my early stint in the Merchant Navy added some authenticity to the scene.

Above: *The Gathering Storm* comp;
6 x 4 inches; digital

Right: *The Gathering Storm*; 22 x 29 inches;
oil on board; private collection

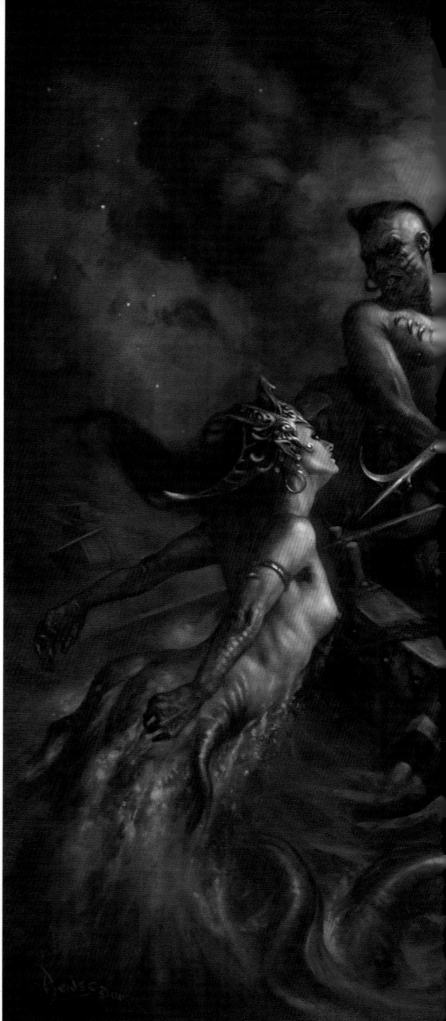

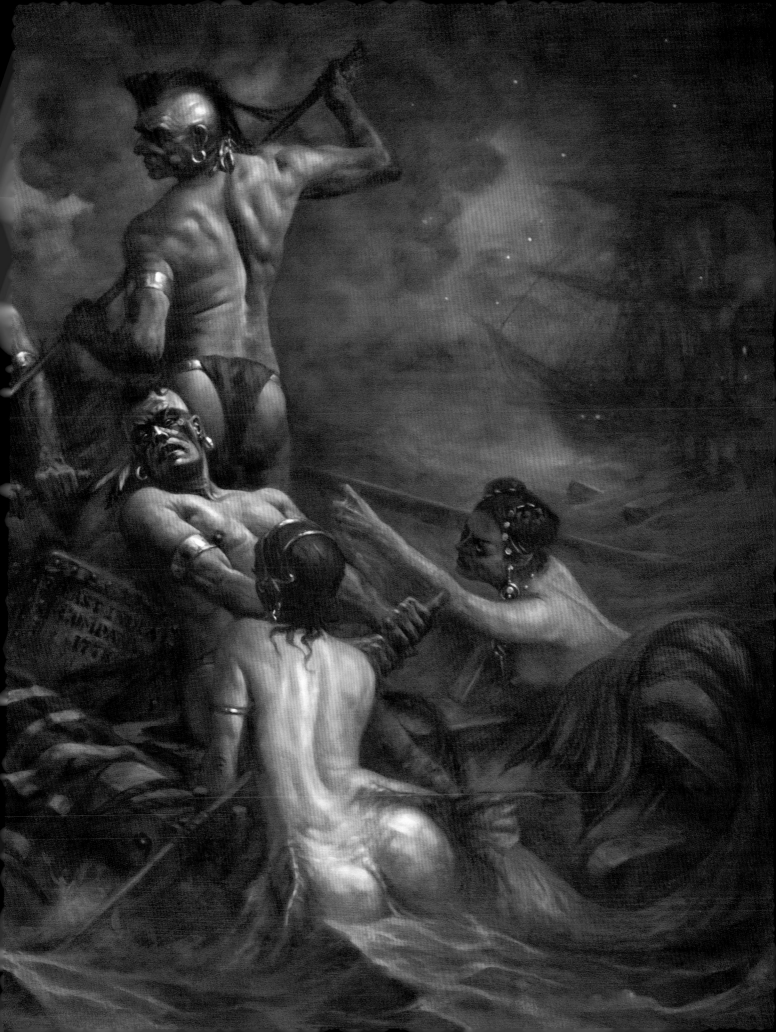

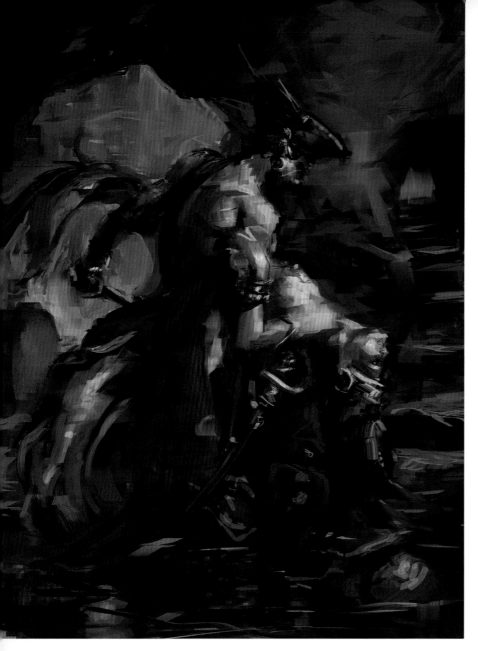

I know it's not nice to choose one child over another, but *The Captive* will always be one of my favourite paintings. It was painted as an experiment – a process that I explain in great depth in *Sci-Fi & Fantasy Oil Techniques*, but the gist of it was that I was my own art director, with a strict brief and timeframe. Despite being executed within the confines of an illustration brief, the artwork sold soon after to French collector Jean-Michel Brie, to hang on his wall, proving there is no real difference between fine art and illustration.

Emily Campbell – another of my former students – posed for *The Captive* (as well as for *The Sacrifice*). Emily had lived a truly tough life – she had been a ward of the state before enrolling in art college – and yet she was one of the most upbeat students I taught. She proved to be a terrific model, but this was the last time I saw her before she headed off to Las Vegas for adventure overseas.

Above: *The Captive* **colour rough;**
6 x 12 inches; digital

Right: *The Captive*; **18 x 24 inches;**
oil on board; private collection

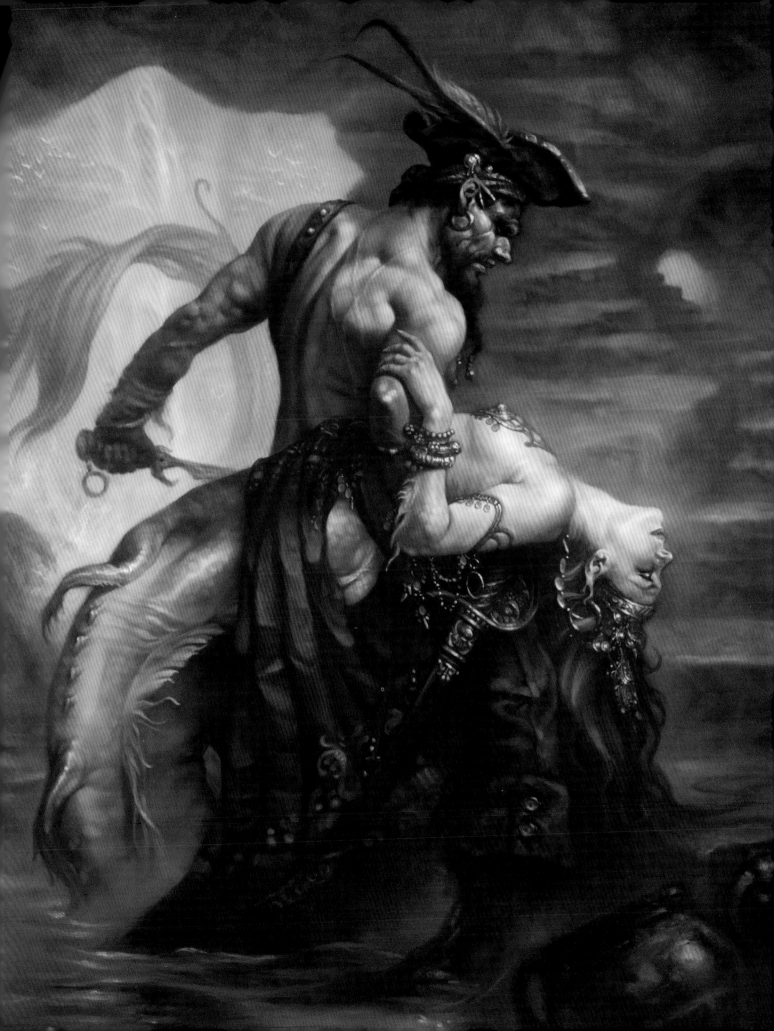

The Devil's Gates had one of the longest gestation periods of all my paintings. It started as a scribble many years back, then I painted the little comp seen on the left a few years later, while I was working on some other comps for actual commissions. I planned to paint it in my own time, but of course that provided the universe with the opportunity to keep me eternally busy as the little colour comp slept in the corner of the studio for another year.

Finally I got a call from collector Earl Weed to paint something. He liked my work and was happy to hear of any ideas I might like to paint. I went to the corner of my studio and woke up my little colour comp to show to Earl. He loved the idea and it was finally time for the fledgeling comp to grow up; however, it still took a further six months before I could fit it into my painting schedule. At last, here it is...

Above: *The Devil's Gates* comp; 7 x 5 inches; oil on canvas

Right: *The Devil's Gates*; 18 x 24 inches; oil on canvas

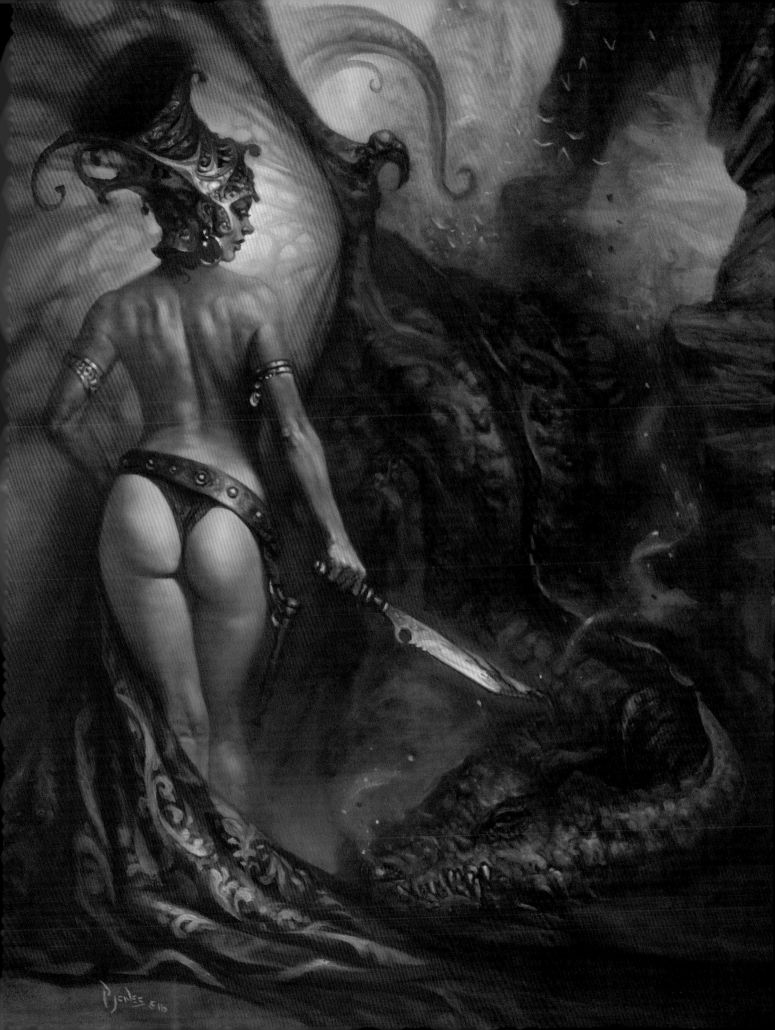

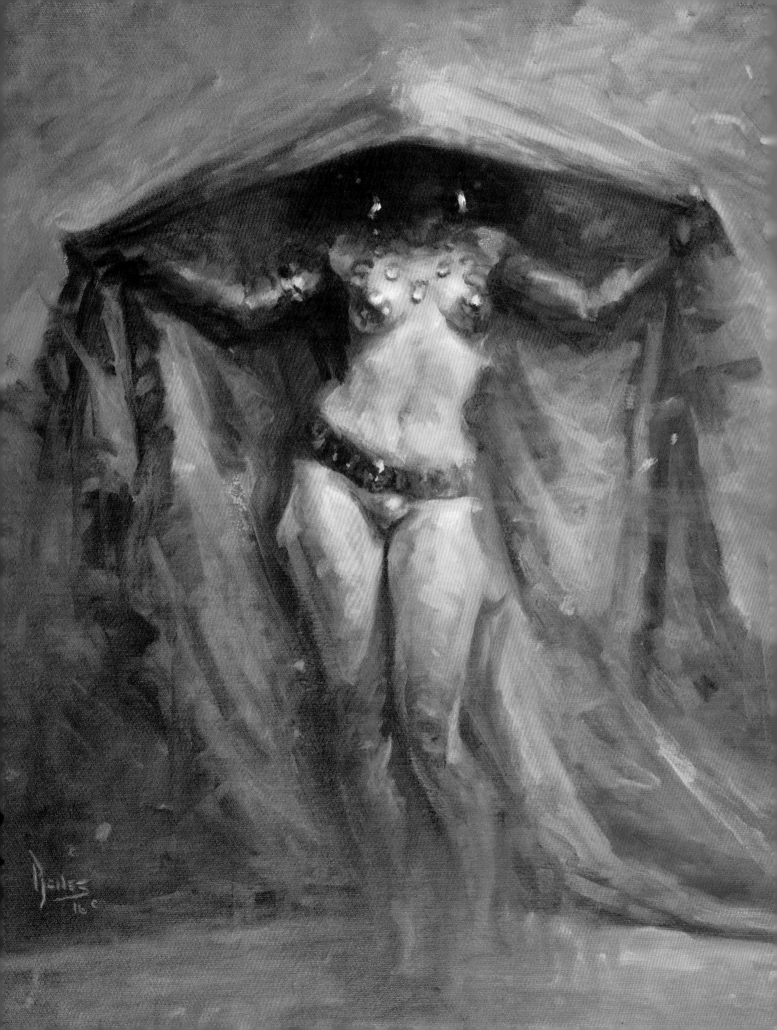

The important thing is this: To be able at any moment to sacrifice what we are for what we could become.

Charles Du Bos (1882–1939)

The Changeling

Recognition

The year 2014 was a momentous one for me, as I was not only returning to my beloved IX, now held in Allentown, Pennsylvania, I was also "Artist Guest of Honour" at Dragon Con in Atlanta, Georgia. My first stop was LA, where I spent a few days adjusting to jet lag. I arrived there at 7 am, having left Australia at 7 am the same day, which is a form of time travel based on world time zones. I had hired an apartment, and to make sure I didn't fall asleep when I arrived there, I dropped my luggage in the living room and walked for hours through the blistering streets up to Beverly Hills, where I hired a bicycle. Cycling around the eerily quiet suburb of the rich and famous, having gone without sleep for over 30 hours, was a dreamlike experience.

This chapter includes colour roughs I created for some of the paintings that follow, and pencil sketches for possible future artworks (*pages 142–43*). Although I rarely work on more than two paintings at a time, I like to get ideas down well in advance to chew over, in readiness for the moment of pressing paint to canvas.

The Sentinel colour study; 6 x 12 inches; oil on canvas

The Sentinel was painted for collector Earl Weed. I have yet to meet Earl, but I feel I know him quite well from our email exchanges. As with all prized collectors, he awards me creative freedom, and in return I bequeath my soul. This artwork is a prime example of why I believe a colour rough and preliminary sketches are important. I only have to squint at the colour rough to see the finished art.

I was approached by the good folk at *ImagineFX* to write an article about this artwork after it was posted on my Facebook page. There are few pursuits I enjoy as much as art, yet writing is a powerful craving I have always answered when my artistic batteries need a charge. Although I had written comic books as a kid, lots of articles as an adult, and, lord of lords, a novel, this was another kind of joy – complete freedom to jabber on about my art!

Other fantasy artists I know – among them Todd Lockwood, Stephen Hickman, and Brom – also share this dual yearning for writing and art, and during a spirited conversation with Stephen we both agreed that writing our novels was as all-consuming as art itself. This led me to wonder whether my life's path would have been different had there been a typewriter in my home while I was growing up.

Above: *The Sentinel* colour rough; 6 x 12 inches; oil on canvas

Right: *The Sentinel*; 18 x 25 inches; oil on canvas; private collection

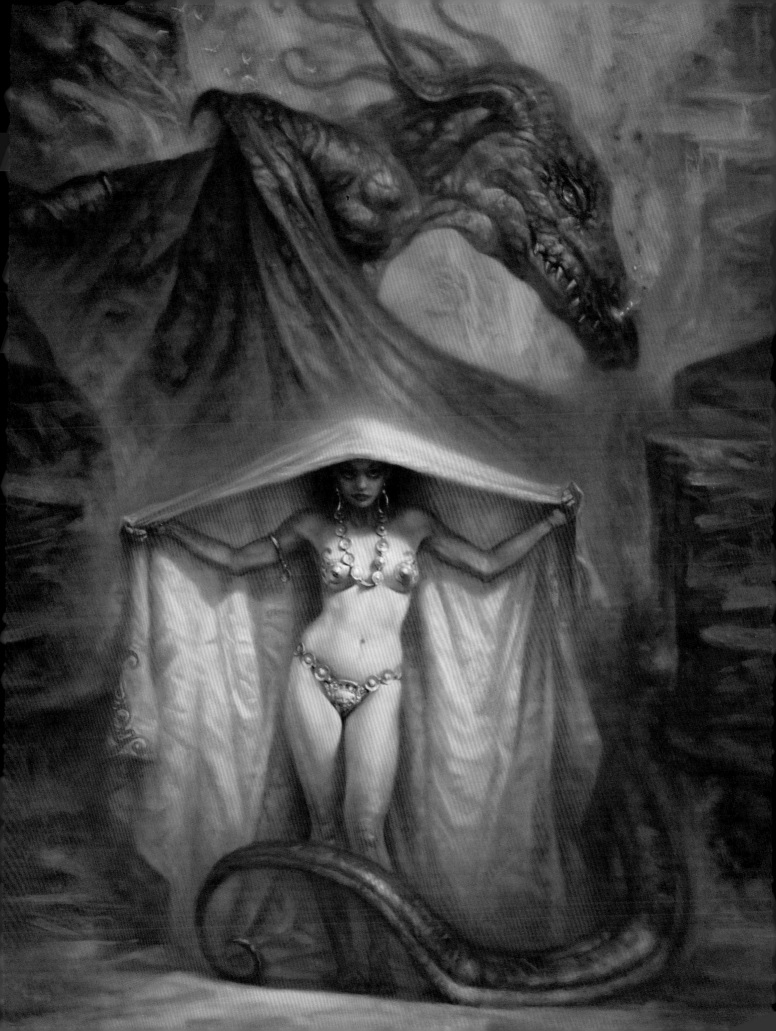

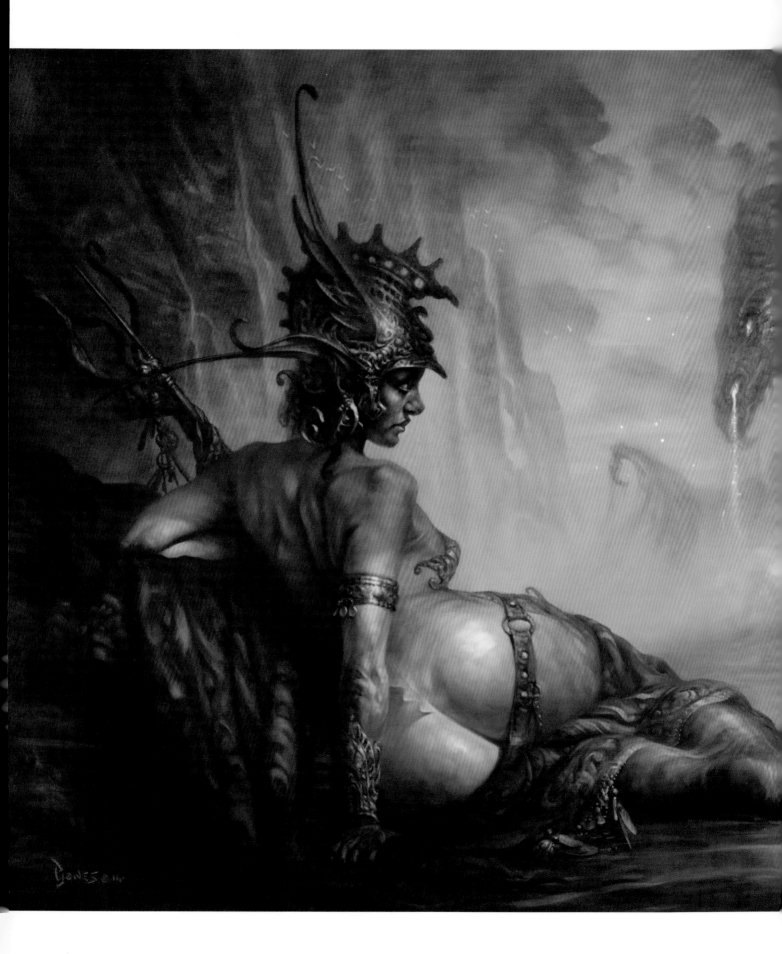

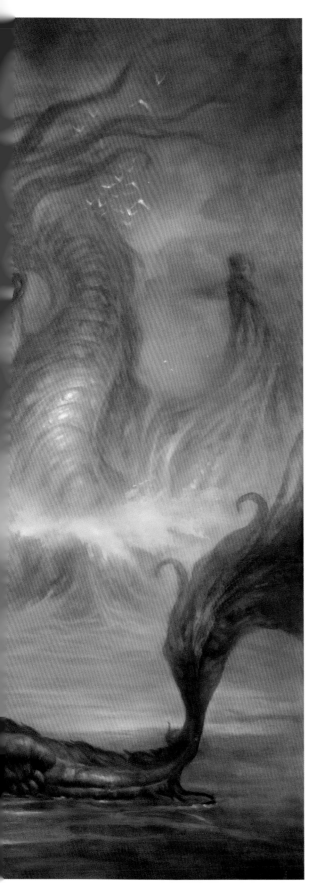

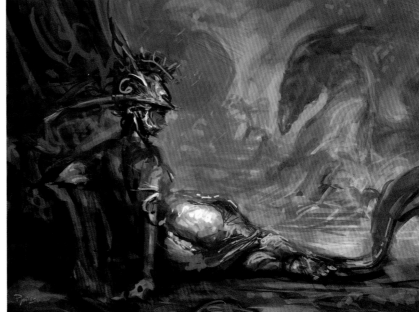

The Awakening was commissioned as the official 2014 poster for Dragon Con – the USA's leading multimedia and pop culture convention, which showcases the latest science fiction and fantasy gaming, comics, literature, art, music and film. Although the Dragon Con directors, John and Anne Parise, were my warrior champions, the poster art met with the dreaded "art direction by committee". After some debate, it was decreed that the female's "ass be airbrushed from sight".

With my spine barely able to support my dejected body, I slumped forward and censored the digital file. However, I didn't touch the original artwork, which was flagrantly flaunted at the very event where the poster might have caused offence! Of course, when fans saw the censored poster they didn't buy it. Looking around the event at the decapitated corpses painted and on display, I was bewildered at how a hint of bare flesh was considered the main concern.

2014 also saw the publication of my first book with British independent publisher Korero Press – *Sci-Fi & Fantasy Oil Painting Techniques* – and I was high on life. My publisher, Yak, flew out from London and we had a great time hanging out in subtropical Georgia. Yak introduced me to some of his other authors, a collection of merry bohemians also attending Dragon Con, and we all laughed our heads off one night over dinner. I wish I could have sent a snapshot back to my younger self during the dark winter nights of London's bedsit land. It would have cheered me up.

Left: *The Awakening*; 48 x 36 inches; oil on canvas

Above: *The Awakening* colour rough; 12 x 9 inches; digital

Left: Here are three pencil sketches scanned from my sketchbook and coloured with tone in Adobe Photoshop. Most sketches don't make it to the painting stage, but the more exploration I do, the more chance I have of striking gold!

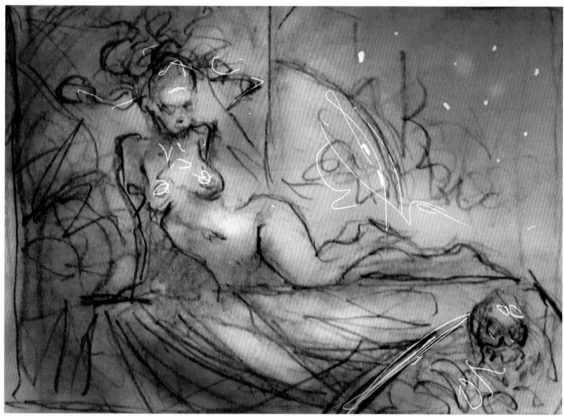

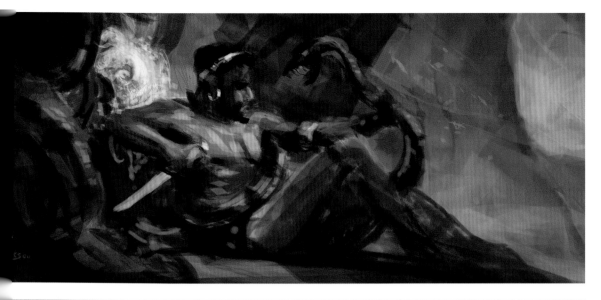

Left: colour roughs created for a selection of paintings featured in the following pages. I find myself doing more digital roughs than traditional oil roughs due to the speed of changes possible when using digital tools, especially when it comes to glazes.

Top: *Jason and the Golden Fleece* colour rough; 6 x 12 inches; digital

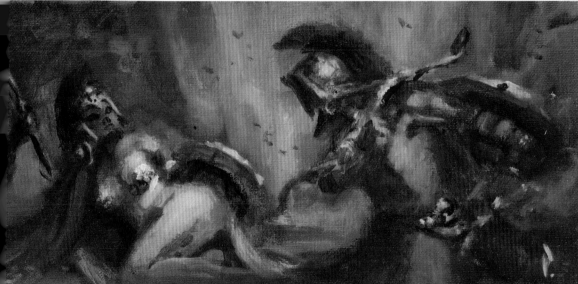

Middle: *Heracles and Hippolyta* colour rough; 6 x 12 inches; oil on canvas

Below: *Theseus and the Minotaur* colour rough; 6 x 12 inches; digital

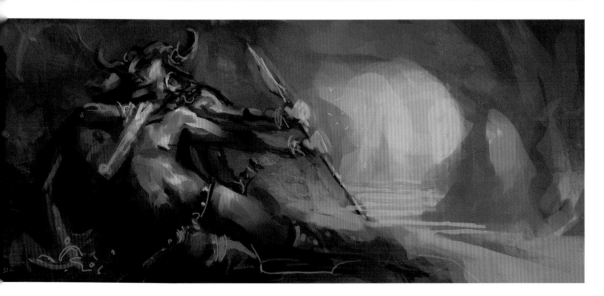

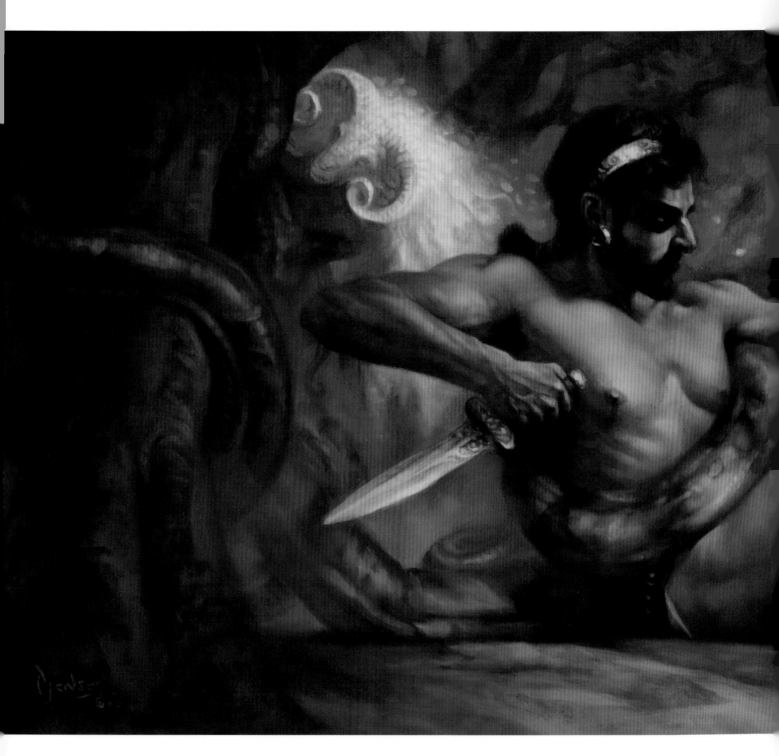

The oil painting *Jason and the Golden Fleece* was a challenge for me, due to its landscape format. The male figure is not usually depicted in a reclining position (as many female figures are), so in order to make him look heroic rather than sensual, I placed him in a deadly situation. That said, a man, or a woman, fighting a snake will always have erotic undertones. Model and dancer Nima posed for this painting, and

he portrayed the savage hero very convincingly; that is a testament to his skills as he is one of the most gentle people I have ever met.

With this painting I was experimenting with a more oily paint mixture and made a great leap forward in technique. I loved painting the soupy nature of the patina-stained rock surface and the gloss of the snake. I once held the mistaken belief that all artists peak at the

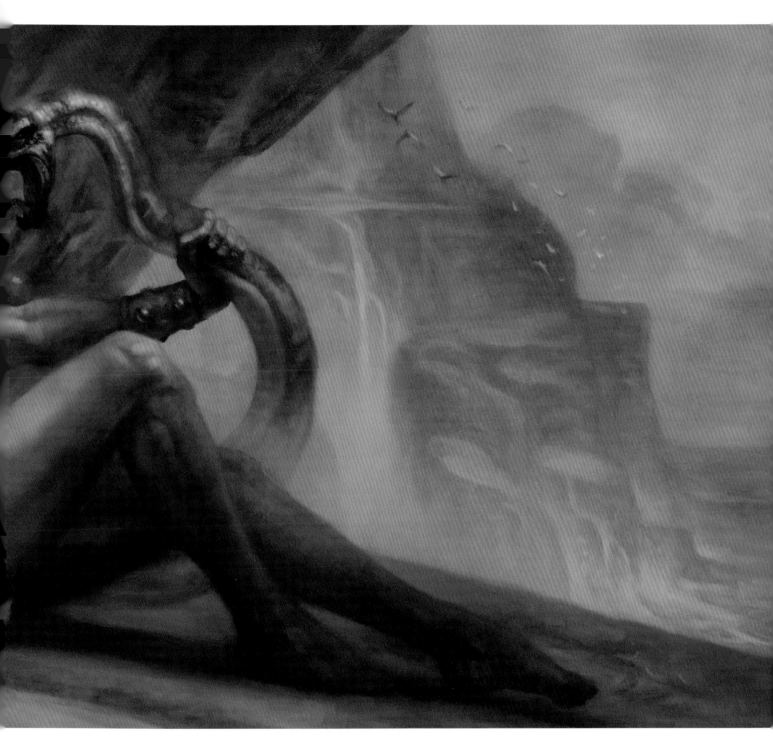

age of 36; this was based on my gathering of favourite paintings by favourite artists, and checking the dates. So 36 was an age I wasn't looking forward to passing. Fortunately it turned out to be a foolish notion, and it's heartening to know that I can continue to grow artistically, even after eons at the drawing board. I truly felt the spirit of the great Boris Vallejo channelling through me as I painted *Jason and the Golden Fleece.*

Jason and the Golden Fleece; 36 x 15 inches; oil on canvas; private collection

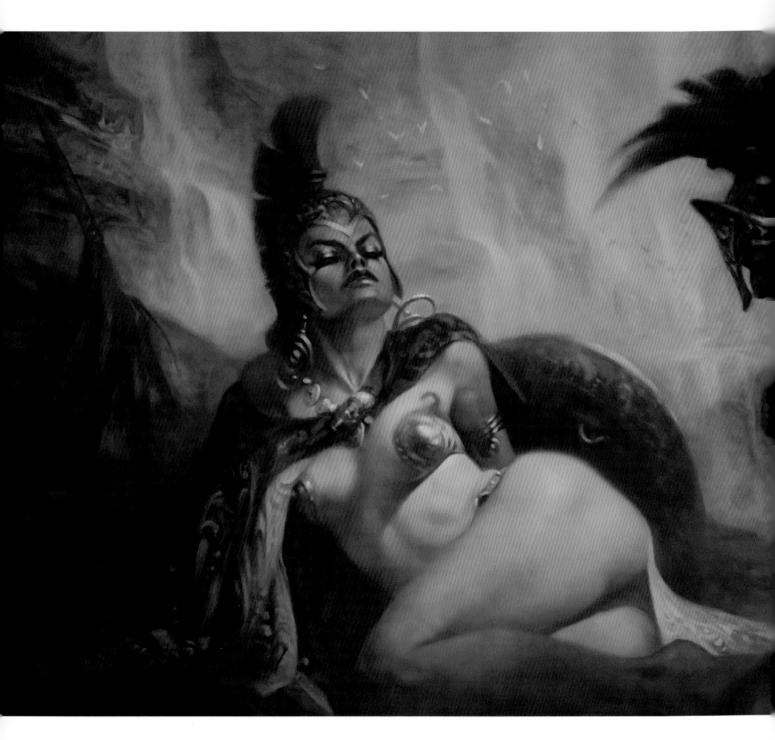

For *Heracles and Hippolyta*, I hired two of my favourite models, Alana and Nima. The ancient myth on which it's based tells of Heracles's quest to find Hippolyta, the queen of the Amazons, and steal her magical belt. On meeting, the pair are savagely attracted to each other, and the seething lust between them is what I wanted to capture for this piece.

The preliminary sketching and art direction required for a painting are very much like directing a movie with a script in hand, the result being one definitive image rather than the many needed to tell a dramatic story. Here, to get the expression I needed from Alana, I asked her to imagine she had been cheated on by the love of her life and was now hell-bent on savage vengeance. She conjured up the perfect expression with blood-curdling ease. Nima, meanwhile, used his considerable ballet skills to produce a very fluid action pose.

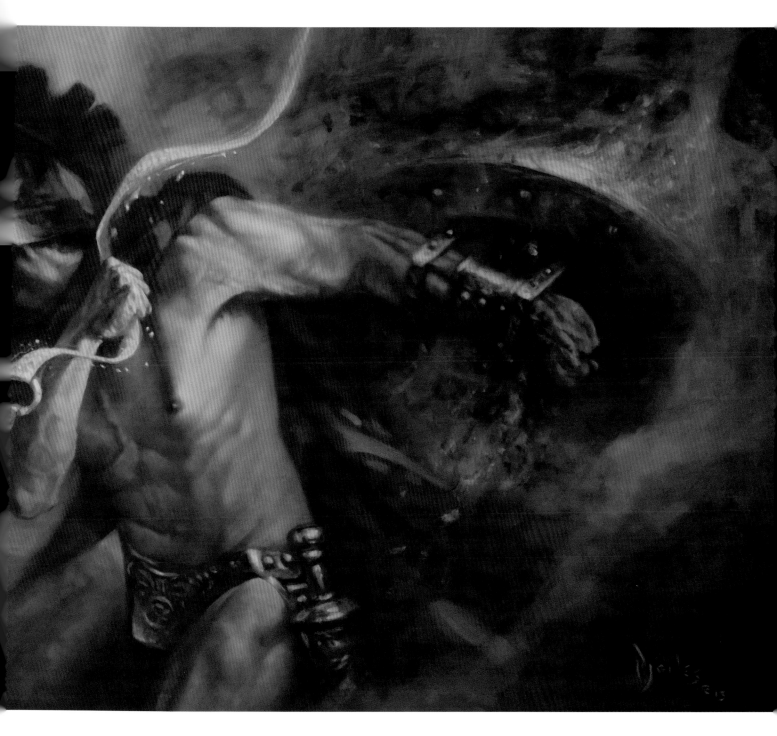

During the painting of this artwork, I was also teaching a lot of life drawing classes and wanted to get the feel of motion that naturally comes from drawing fast. As painting is a slower process, it is one of the more difficult things to achieve or sustain in a narrative piece like this, without the entire artwork becoming a different style than the collector commissioned. Here I found the opportunity within the motion of Heracles's arm pulling back his shield.

Heracles and Hippolyta;
36 x 15 inches; oil on canvas; private collection

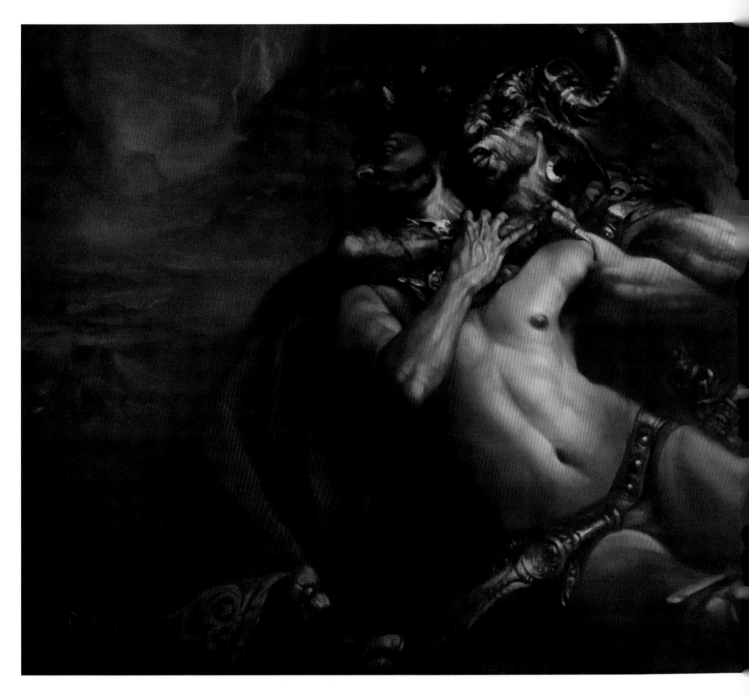

Dragon Con hosts one of the largest gatherings of cosplayers in the world, and in 2014, as I stepped out of the glass-domed lift at Atlanta's Hyatt Hotel I was greeted by the sight of a whirling, beeping, R2D2 robot. The Hyatt Hotel, whose futuristic architecture had served as a backdrop in the movie *The Matrix*, was positively teeming with hordes of fantasy and sci-fi creatures and characters, all of whom were strolling through the lobby into the city's streets. I was overwhelmed by the scale of it all, and felt nervous at being the Artist Guest of Honour at such a huge

event. Following *Star Trek Voyager* star Jeri Ryan and legendary Monty Python member Terry Gilliam on stage to accept my award was pretty nerve-racking, but engaging in a bit of banter with Terry was memorable.

During Dragon Con I had the great pleasure of meeting one of my art collectors, Catherine Gyllerstrom. Catherine had commissioned *The Gathering Storm* a few months earlier. As the Dragon Con people-storm raged outside my booth, Catherine talked about commissioning a series of five paintings based on the Ancient Greek myth of Jason and

the Argonauts. Jason and the Argonauts! I was so overwhelmed at the thought of that, I almost needed oxygen delivered! The 1963 American-British movie version of the myth that I had watched as a child – featuring the stop-motion animation of the great Ray Harryhausen – had entranced me for life. For a collector to commission five paintings in advance is an incredible show of faith and I was determined to do my best work for Catherine. *Theseus and the Minotaur* was the first in this series.

Theseus and the Minotaur; 36 x 15 inches; oil on canvas; private collection

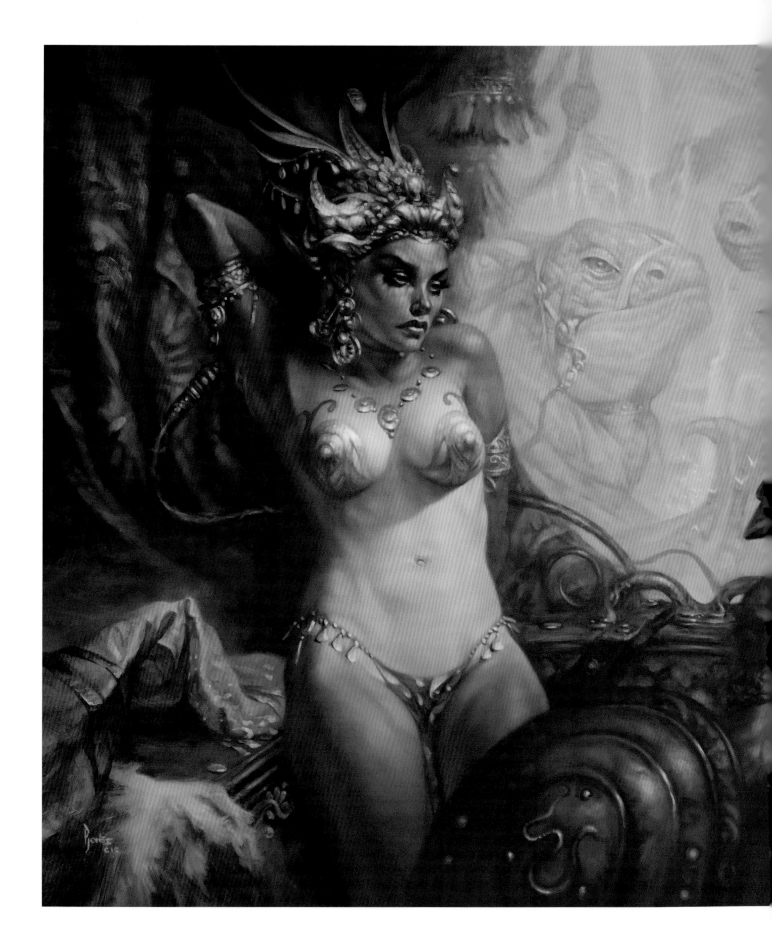

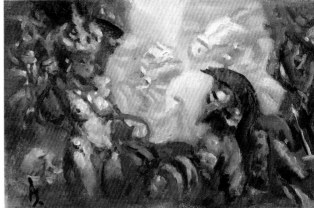

Alana modelled for me again on the final painting in the Jason and the Argonauts series – *The Dying Embers*, which portrays Jason and the sorceress Medea – and I pulled out all the stops to make it a grand finale. I Skyped with the collector, Catherine, afterwards, during the Christmas holidays to celebrate the season, and I showed her the finished painting on screen as a surprise.

Catherine then surprised me too – with commissions for a further three paintings to extend the Jason and the Argonauts myth collection. Christmas cheer doesn't get much better than that!

Left: *The Dying Embers* (*Jason and Medea*);
36 x 24 inches; oil on canvas; private collection

Above: *The Dying Embers* (*Jason and Medea*)
colour comp; oil on canvas

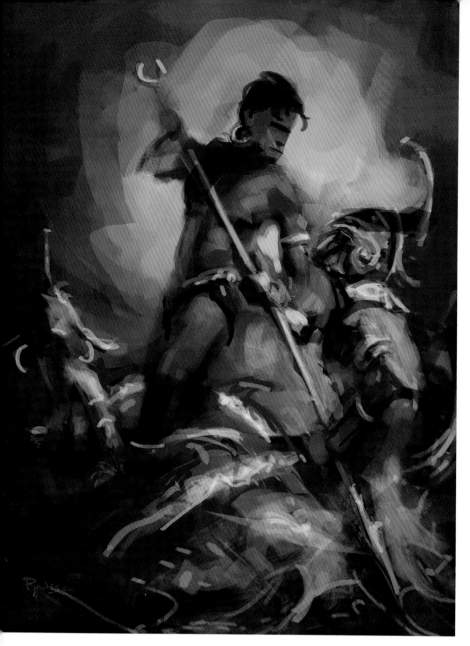

The Betrothed was commissioned during Dragon Con by the wonderful Carmen Wegner. Carmen is a southern belle from Atlanta, Georgia, and a friend of fellow collector Catherine Gyllerstrom. They helped me at my booth and were great fun. At one point we abandoned Carmen to the crazed rantings of a cosplay, apocalyptic zombie killer. In my defence, my publisher Yak had called me away on a false errand, leaving Carmen alone to hide behind her fluttering "I do declare" folding fan. During a zombie apocalypse it's everybody for themselves!

Dragon Con coincided with the release of my book *Sci-fi & Fantasy Oil Painting Techniques*. It was, therefore, the perfect opportunity to sell a few signed copies. I wasn't sure how many books to order, so I took a guess. When they were delivered I almost passed out at the number of boxes. I was, however, surprised at how many I got through, especially as I had less time to sell them than expected, for I was often away from my stand doing panels or judging.

At the end of Dragon Con, I was left with only 90 copies. "I could sell those at IX", I thought: an event that was just a few days away. But how would I get them there? I couldn't take them on the plane. Just when all seemed lost, I was rescued by my fellow IX artists also attending Dragon Con. Sam Fleagal turned up with a trolley to take the bulk, then Rebecca Yanovskaya, Justin Gerard, Annie Stegg, Tom and Kara Kuebler all offered to pack the remainders into their already filled-to-the-brim vehicles! If I wasn't a manly man, some might have thought I was crying tears.

Above: *The Betrothed* colour rough

Right: *The Betrothed*; 18 x 24 inches; oil on board; private collection

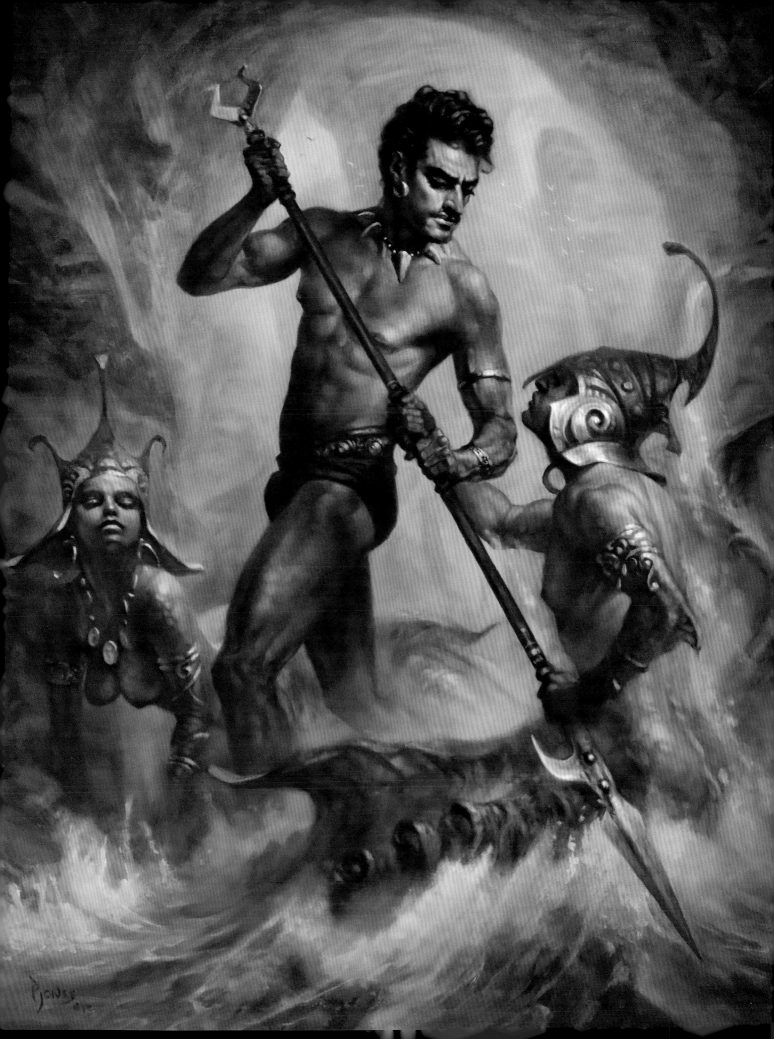

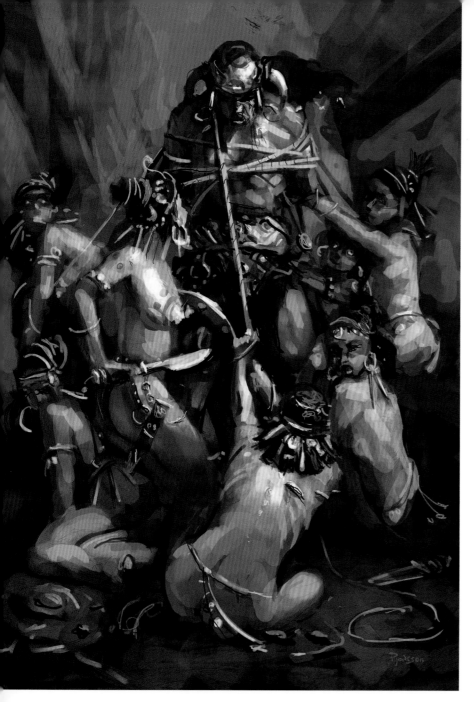

After Dragon Con I flew up to my fourth IX show. As I entered the Allentown Museum I was smothered in the energetic warmth of Pat and Jeannie Wilshire, who were a marvellous sight after a month on the road. Pat nodded towards *Vanquished*, which stood almost six feet tall in its gold frame, waiting to be hanged. They were proud that I was proud; it was a magnificent thing to see since I last rolled it up in a tube for the Fed-Ex man to send across the world.

Vanquished was my second IX commission from Pat and Jeannie and it also served as the promotional poster and name tag art for the show. The *Vanquished* image was everywhere: in the hotel lift, in restaurants and on every artist's chest. It always gave me a pleasant, surreal jolt each time it "popped up".

Since it was my biggest painting to date I decided to record segments of the entire creative process and present the movie at the event. It was a lot of work, recording and painting such a huge artwork, but it was worthwhile, as I ended up with 11 hours of footage documented for posterity. It's great to hear praise from people all over the world who have downloaded the movie from my website. I often think how incredible it would have been for the likes of Leonardo Da Vinci and Michelangelo to have been able to record their working methods – not that I am in their orbit of genius by any means... but just imagine.

Above: *Vanquished* colour rough;
6 x 12 inches; digital

Right: *Vanquished*; 60 x 40 inches; oil on canvas;
private collection

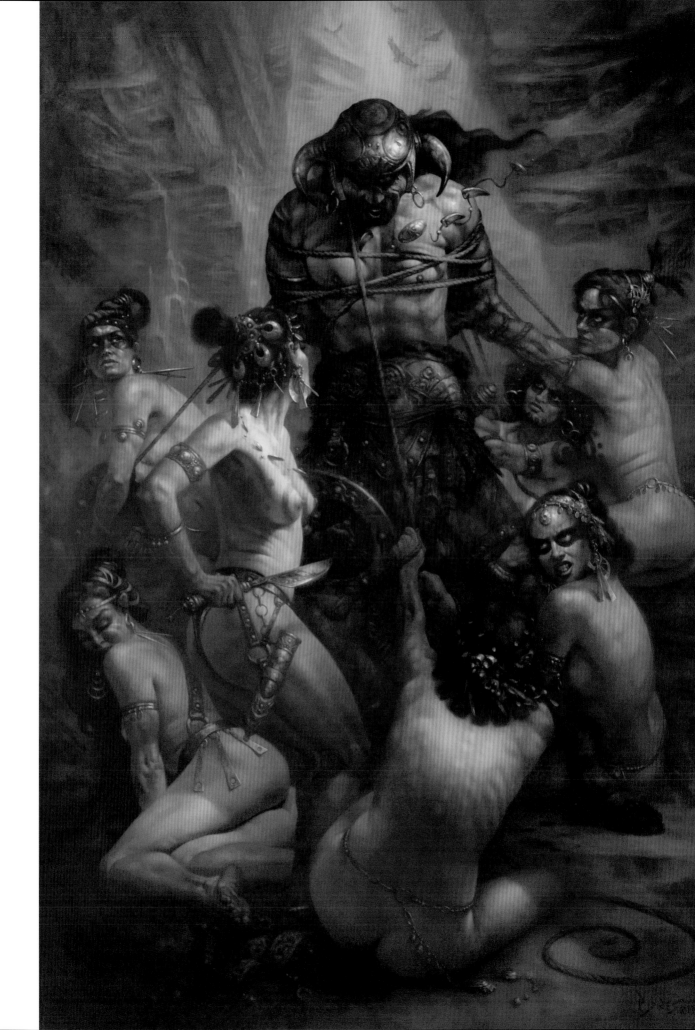

By the time the commission for *Bloodstone* came along, I was in the mindset that I no longer wanted to work on art-directed projects – which is just about all commercial work. I know that sounds crazy, but so did giving up my advertising art career. The thing is, I could see in every piece what the weak spots were, and they were (nearly) always the art-directed changes: "Can we turn the girl's head to face the viewer?" or "Can we change green to red, as it clashes with the house type?" Once the composition has been compromised in this way, the painting is just a withered husk of what it could have been.

Yet, could I turn down *Bloodstone*, the commission of a lifetime, the chance to follow in Frank Frazetta's footsteps? I had first seen Frank's version on the original book jackets as a kid, and it was an incredible memory. Here was the chance to create my version for a new generation. What was I to do?

I sent the art director my heartfelt thanks, but stressed I could only do it without art direction as I no longer wanted my work compromised. I also asked for six months to do it: to fit it into my schedule. These demands were clearly the rantings of a madman, an illustrator broken by the system, an artist who wasn't going to take it anymore, a crazy fool with nothing left to lose! But to my amazement he said "okay". The decision to take on the commission was further rewarded when the original painting was bought a few months later by collector Tim Shumate.

Above: *Bloodstone* colour rough; 6 x 12 inches; digital

Right: *Bloodstone;* 36 x 48 inches; oil on canvas; private collection

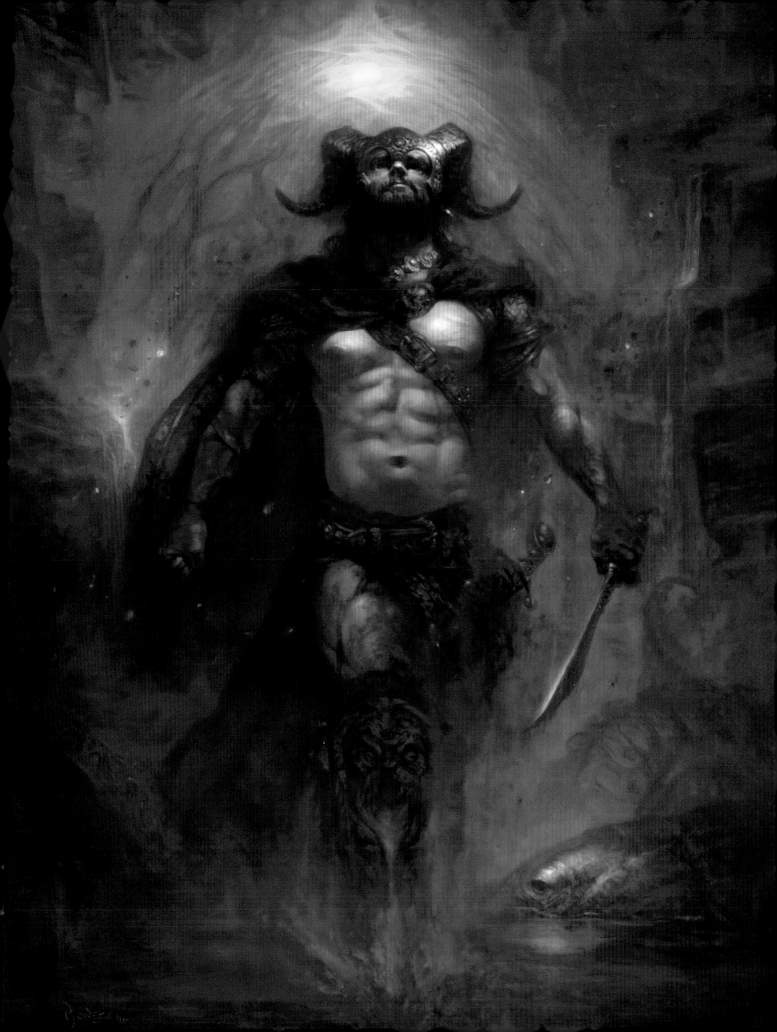

For each show I was taking large artworks on canvas that would have benefitted from some gold frames, but the cost of shipping framed art back and forth from Australia is a huge financial gamble if the art is not sold. I hit on a plan so outrageous it was bound to fail… and yet it worked! Another trip to the hardware store provided me with all I needed to make fake frames: lightweight decorative moulding strips and gold spray paint.

I sent my rolled-up canvases and fake frame strips ahead by post and stretched the canvas behind the constructed frames when I arrived at the show. The "framed" paintings looked a million dollars yet each weighed just a few pounds! My painting *The Lair of the White Witch,* seen here, was sold alongside its companion piece, *Bloodstone*, to collector Tim Shumate during IX 2014. Tim was tossing up between buying this piece and *The Awakening*, and it was exciting to guess which way the pendulum would swing as he pondered such a grand decision.

Above: *The Lair of the White Witch* **colour rough; 6 x 12 inches; digital**

Right: *The Lair of the White Witc*h**; 36 x 48 inches; oil on canvas; private collection**

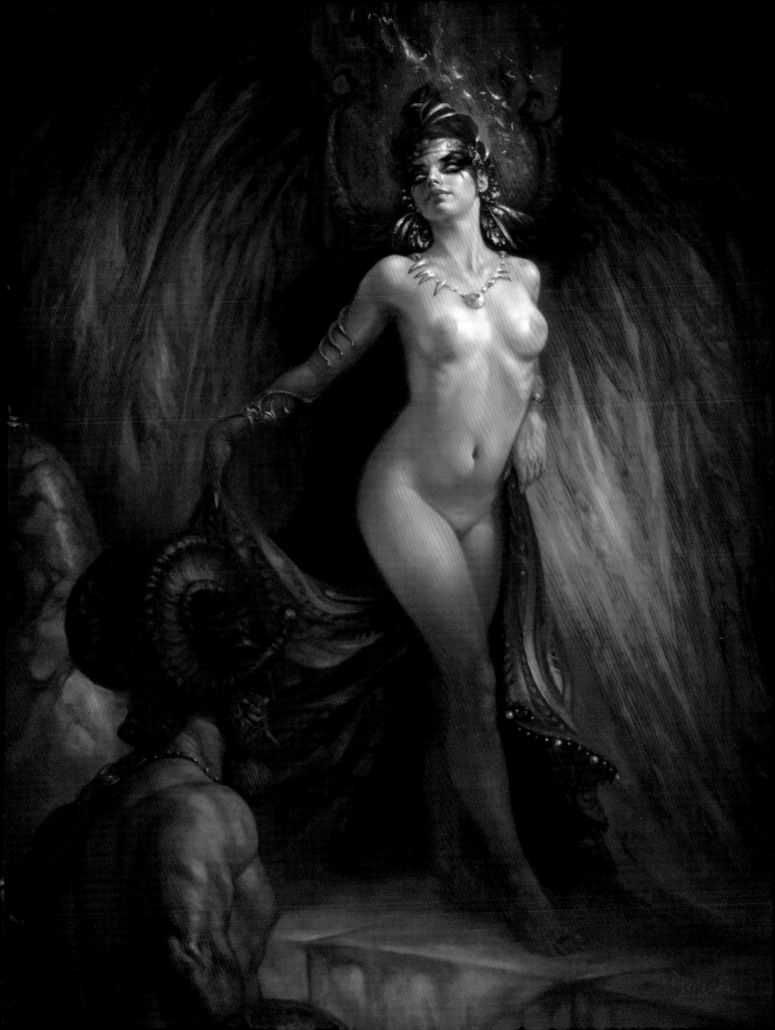

I painted *The Beguiled* for collector Colin Fagg. We first met at IX 2010, where, along with fellow artist Vincent Villafranca, we laughed like hyenas for a straight half hour. I won't go into the juvenile detail of what was so funny, but it concerned an evil smell and a room full of suspects pretending nothing was amiss. At one show, Colin asked Boris Vallejo for a student discount on a painting, and when he looked bemused, Colin asked me to liaise on his behalf. Boris told me he didn't quite know what language Colin spoke. I looked over at Colin, who was sat in my booth, encouraging me with gesticulations to close the deal. "Cockney," I said. Colin still didn't get his student discount.

With the Australian summer approaching I wasn't looking forward to the dizzying scent of turpentine in my studio, so for *The Beguiled* I decided to try linseed oil as the only thinning agent. The good news was the beautiful buttery flow. The bad news was the long drying time. I struck on the notion of rubbing a thin layer of linseed oil and Liquin into the surface I was to paint on each day, and, by George, it worked!

My next problem was that the painting's surface was now drying to a glossy finish and my oil layers were "beading up" like raindrops. I solved some of this issue by scrubbing colours onto the surface, spreading them paper thin. This created a "tooth" to work on top of. When I say "scrub", it was a gentle scrub, not like a piglet digging for truffles! I'm still experimenting…

Above: *The Beguiled* colour rough; 6 x 12 inches; oil on canvas

Right: *The Beguiled*; 24 x 36 inches; oil on canvas

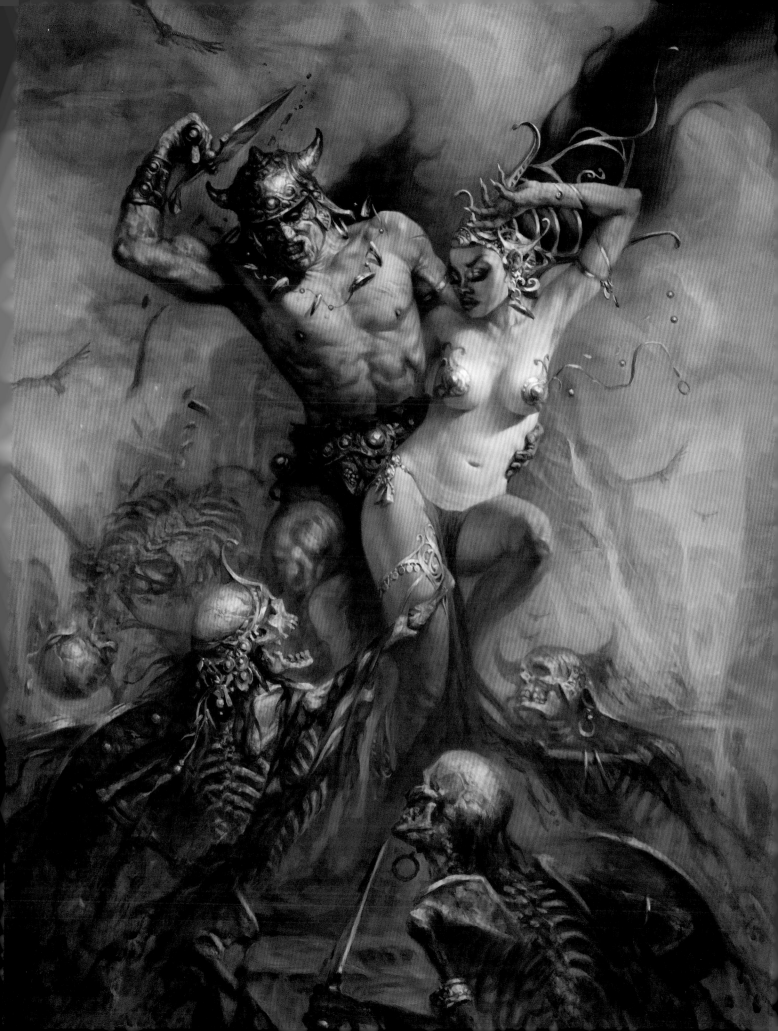

ost of my paintings are stored ready to be rolled and sent out into the collector's world when required, but *Solomon's Loss* hangs proudly on my wall, adorned with a gilded Victorian frame. Although I painted it myself, I love it like a collector would, which is a strange vanity. In the recent past this painting did not exist – then there it was. The fact that I conjured a dream with liquid colours is both odd and fascinating to me. Of all my paintings I think this one is a keeper.

Apart from the nuances that can never be captured in reproduction, the magical quality inherent in glazed oils reveals hidden depths with every viewing. In the early morning sun, *Solomon's Loss* sometimes seems to vibrate with colour and depth, to the point where the figures appear to move. An oil painting is more than pigment on stretched canvas, more than abstract shapes that bewitch the eye into seeing an image, more than an artist's dream – it is a living enchantment.

Above: *Solomon's Loss* colour rough;
6 x 12 inches; digital

Right: *Solomon's Loss*; 30 x 40 inches;
oil on canvas

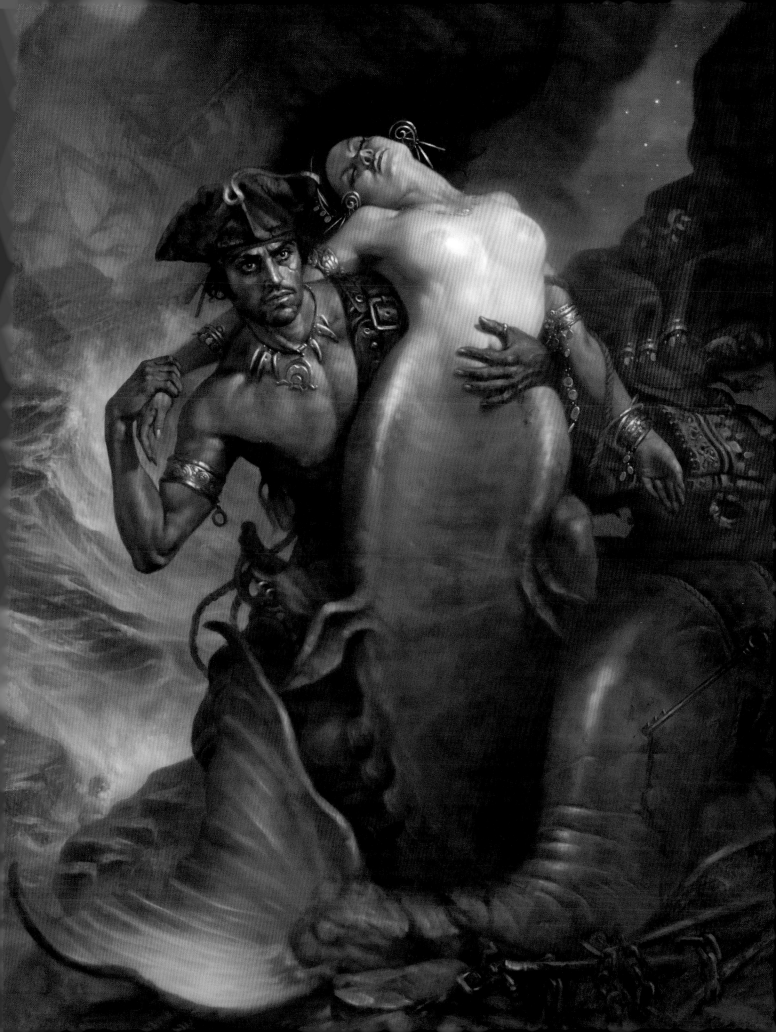

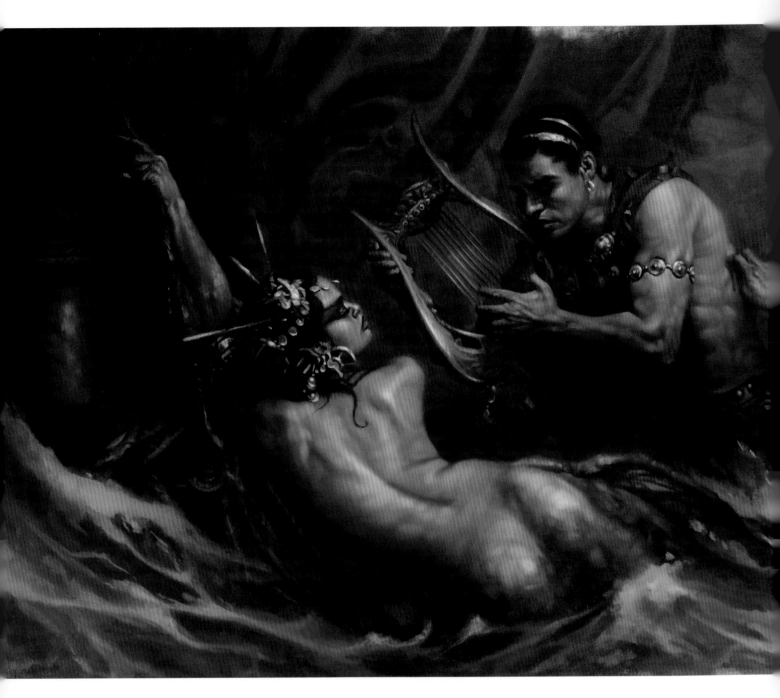

The opportunity to paint mermaids always brings a smile to my simple face, and to celebrate I expanded my usual limited palette for *Orpheus and the Sirens* and played with colour to give the mermaid's flesh an iridescent quality. As usual even the highest quality printing and photography can only go so far in reproducing the oil painted image. The distance of the mountains and sea, for instance, are almost three-dimensional in the glazed oils, and the flesh of the mermaids looks wet enough to touch, and feel the glistening water, even though the painting is dry.

I remember well the first time I saw Victorian artist William Waterhouse's *Lady of Shallot* in London's Tate Gallery. Even though I was penniless at the time, I felt as rich as a king standing there alone one wet afternoon. The evening light was so masterfully painted that it gave me a chill and I became lost in the depth of the painting. Every reproduction I have seen since is simply a flat version of the original, even if it's printed on the best glossy paper money can buy. I treasure my art books, but I still advise my students to study original art at every opportunity.

Above: *Orpheus and the Sirens*; 42.5 x 15 inches; oil on canvas; private collection

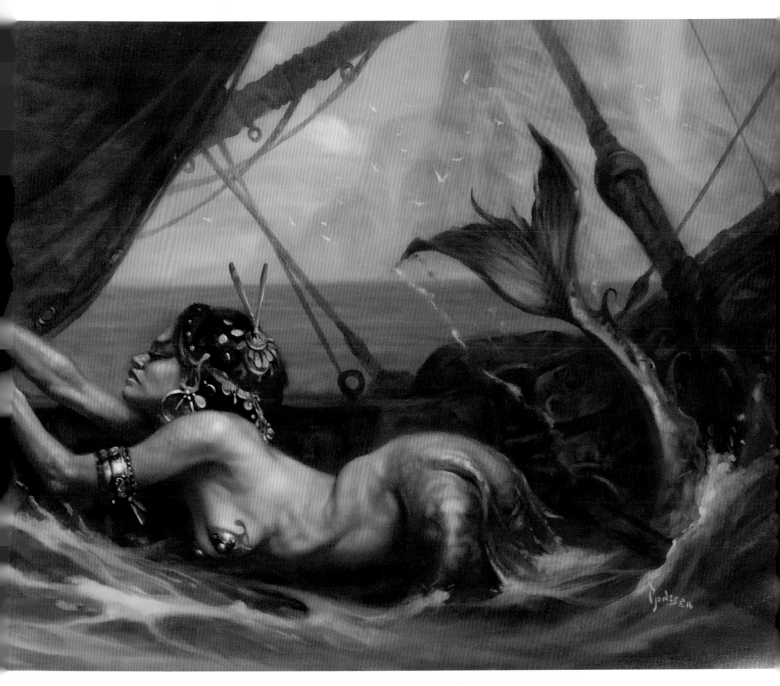

Left: *Orpheus and the Sirens* colour rough; 4 x 15 inches; digital

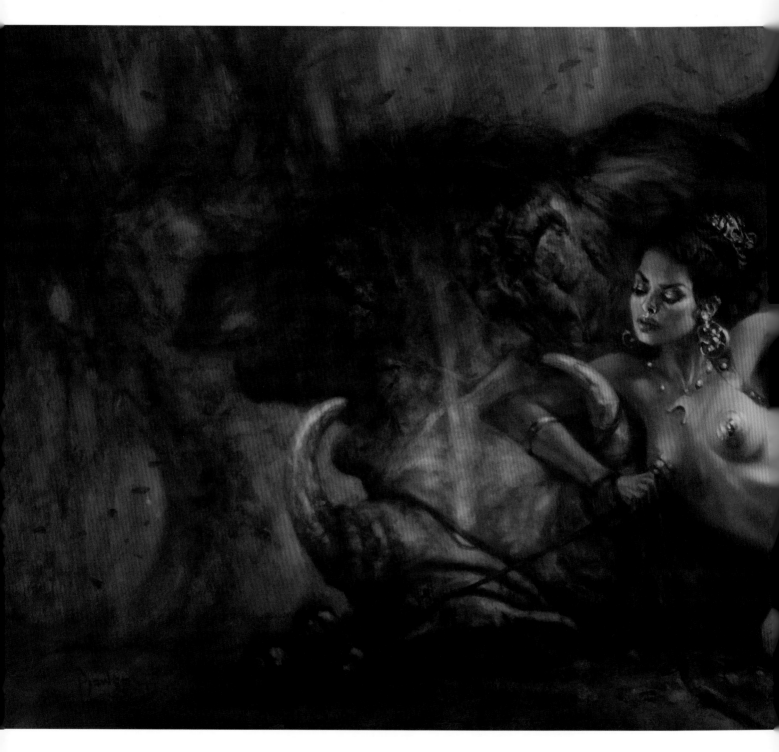

talanta and the Giant Boar was my first painting using Alana, who had posed for my life drawing class many times. Like most life models, Alana is a smart cookie, and combines modelling with university studies. Before I discovered the Leeton Model Agency I hadn't given the "secret" lives of models much thought, but I have since learned that most are also artists, writers, singers, or actors – kindred spirits, in fact.

Alana's dedication and professional nature were exceptional, and as I'd hoped, she was sensational in understanding how to make the scene convincing. Holding a plastic hose and looking at it as if you really believe it to be the horn of a giant boar, while at the same time conveying a heroic manner, takes considerable skill. Holding back laughter, however, is a skill that is a bit tougher to control, but then I would

never want a photoshoot that excludes fun.

On a side note, Alana also posed for the male Minotaur in *Theseus and the Minotaur (see pages 148–49),* which required a whole other level of method acting.

When I showed Alana the painting later she was fascinated to see how it had worked out, comparing it to a movie sequence acted against a green screen with the special effects added in later.

Atalanta and the Giant Boar; 36 x 15 inches; oil on canvas; private collection

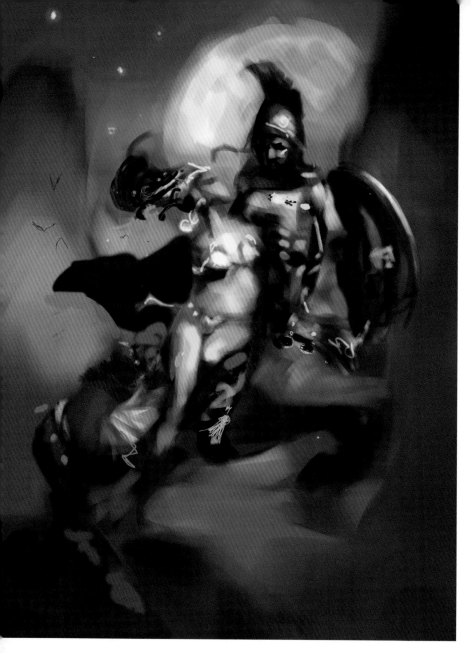

After a series of CinemaScope compositions, *Clio and Chiron* felt easy to compose. I love the dramatic "Scope" of the landscape format but since we humans generally appear upright in most situations, this makes portrait formats easier to compose figures within. I hadn't given this much thought until my figures, rather than the usual environmental landscapes, became the main focus. When film director John Ford (1894–1973) was forced to work with the CinemaScope ratio he hated the challenge, saying, "You've never seen a painter use that kind of composition...Your eyes pop back and forth." In the 1963 Jean-Luc Goddard movie *Le Mépris,* Fritz Lang's character remarks that it "wasn't meant for human beings. Just for snakes – and funerals."

But for all the challenges, these long paintings forced me to be more creative, compositionally – bringing one of my more subconsciously buried art skills to the fore. With one more painting left to go in the Argonauts series, I wanted to go out with a bang. I composed *Attack of the Harpies* (seen on the following two pages) as if it were a scene from those CinemaScope epics I'd loved so much as a kid. The sound of flapping wings was in my mind when I scribbled my first sketches for it, then shadowed foregrounds and multi-planed lighting. I think cinema has had as much of a subconscious influence on how I compose my images as art has done.

Above: *Clio and Chiron* **colour rough;
6 x 12 inches; digital**

Right: *Clio and Chiron*; **26 x 24 inches;
oil on canvas, private collection**

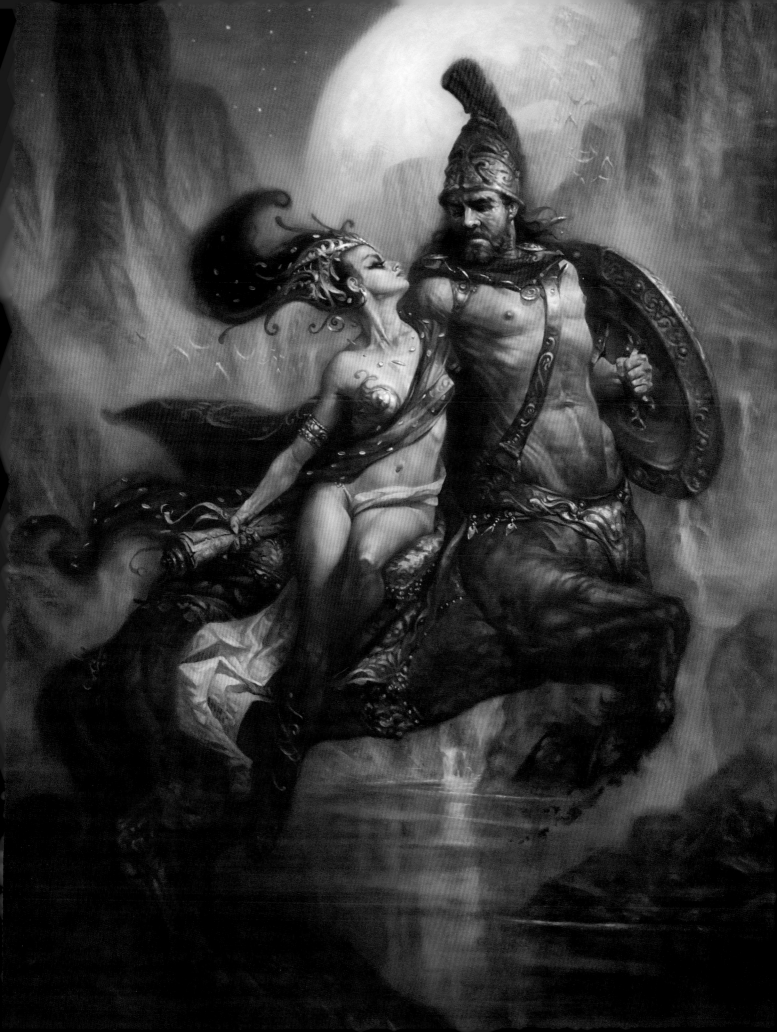

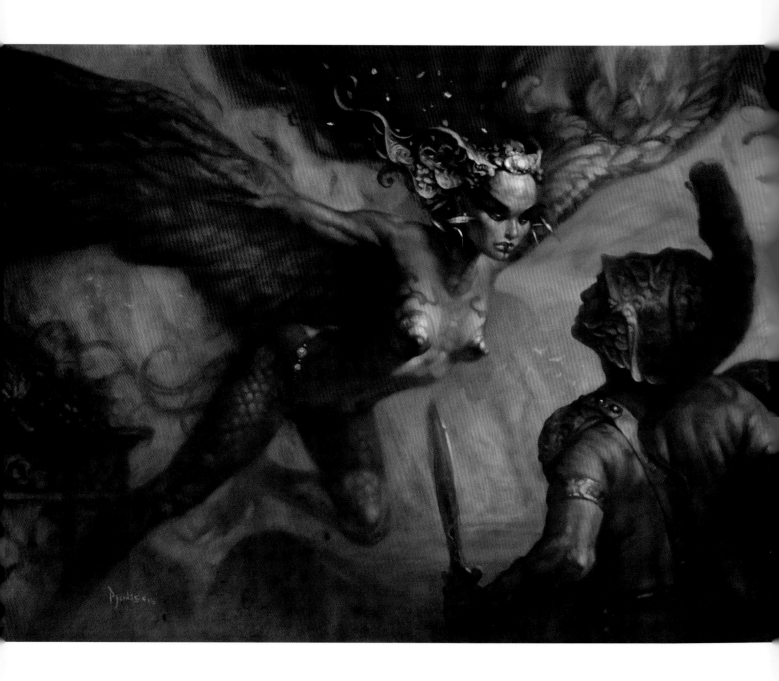

This is the final commission from my Jason and the Argonauts oeuvre, but there are still further Greek myths on the horizon. In the age-old tradition of artist and patron, I am looking forward to my invitation from the collector, Catherine Gyllerstrom, to view the entire collection at the Gyllerstrom home in the USA. In an extended gesture of patronage and goodwill, Catherine has also offered to bring the framed paintings to display at IX 2016. For a rough-edged, working-class lad from the streets of Belfast, that is quite an honour, and my gratitude to Catherine is eternal. And so 2016 marks the end of my first decade as a fully fledged fantasy artist. Back in 2005,

I had taken a heady risk in discarding the solid client list of ad agencies I had worked so hard to establish, but looking back I remember myself sometimes as a lonely ghost passing through a landscape that was never meant for me.

Today, as I sit pondering those fading memories, *Attack of the Harpies* rests proudly on my easel. It took faith, a dose of self-indulgence, and bull-headed commitment to get to this painting, but there it stands, a tangible reality, a symbolic celebration of a new decade for an escapee from the advertising world, no longer a slave of my own making, but an artist unshackled.

Above: *Attack of the Harpies;* 42.5 x 15 inches; oil on canvas; private collection

Right: *Attack of the Harpies* colour rough; 4 x 10 inches; digital

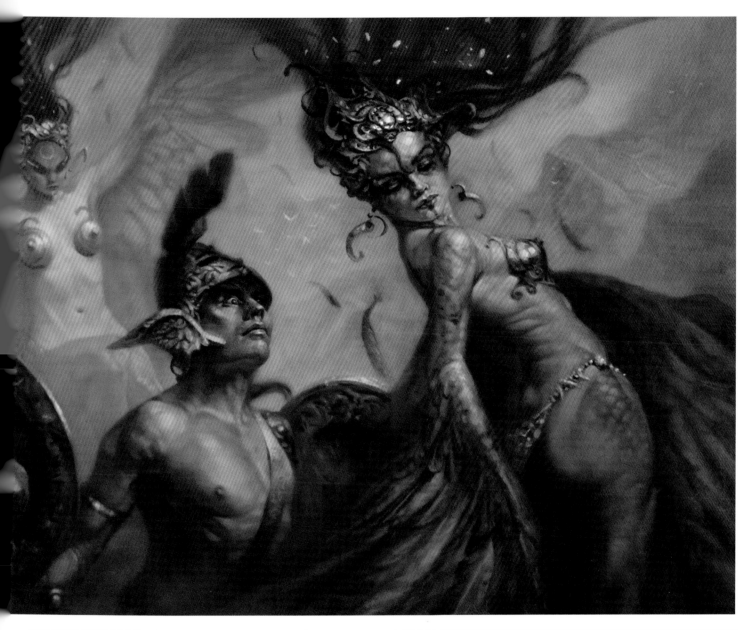

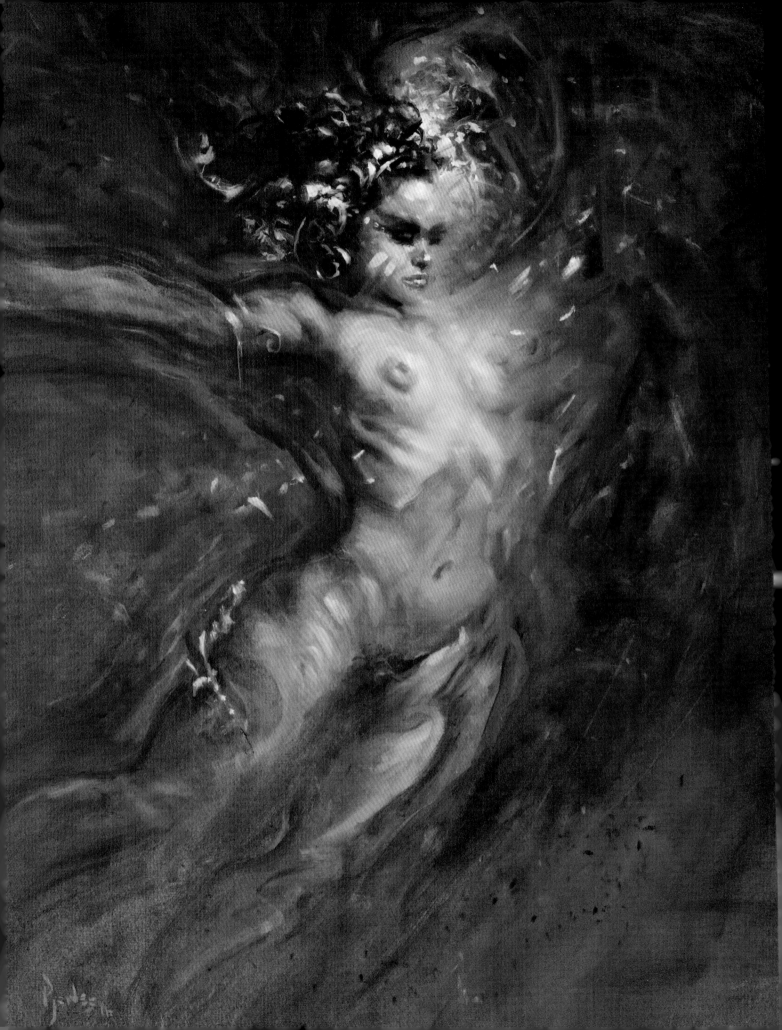

Finishing is torture... There's always some newly seen flaw. But the little glimpses of beauty between the anxiety make it worth it.

Jacob Collins (1964–)

Epilogue

At thirteen years old I had a simple plan: I would become a fantasy artist, and it would make me happy. Throughout my advertising career I fought against the powerful force of my inner teenage voice. The force was not concerned with my adult reasoning that bills needed paying, and during that raging conflict I churned out countless paintings for giant corporations to sell their wares. Exhausted and artistically drained, I sat down and talked to my inner voice: "My paintings win awards, advertising agencies sing my praises, I get paid well – so why am I miserable?' My thirteen-year-old self knew the answer and set me straight.

And so I made a pact with myself. As a grown adult I will continue to fight tooth and nail to be paid well for my work so that I can survive, but when the smoke clears I will turn to my thirteen-year-old self for the spiritual strength to paint for myself.

Just the other week I went to a gathering of seasoned illustrators in my home town of Brisbane. A mother had brought along her daughter, Madeline, an aspiring artist, for advice from the tribal elders. Madeline showed me her work and it was terrific – filled with life and lovingly treasured in her sketch book. I asked Madeline how old she was and she told me she was thirteen. A jaded artist may have crushed Madeline's dreams to dust and blown them in her face, but I saw hope for humanity. My daughter Daryl is studying Design and Fashion at Belfast University in Ireland, and my son Dean is an aspiring writer. My foolish adult self wants to warn them to get out while there is still time, to save themselves, but my inner teenage voice shouts, "Go do it kids, go set the world on fire!" Seeing the wonder in their eyes as they look to the future inspires me to do the same.

As I bring this book to a close I have various projects in the works, each seemingly more exciting than the last. So, rather than considering this an ending, I choose to call it a beginning and look forward to sharing my scribbles, paintings, and ramblings further via my online movies, books and appearances, or on social media. So, until we meet again – virtually or in reality – I wish you the best of luck with your own art adventures...

Patrick J. Jones

Left: *Singularity;* 20 x 14 inches; oil on canvas

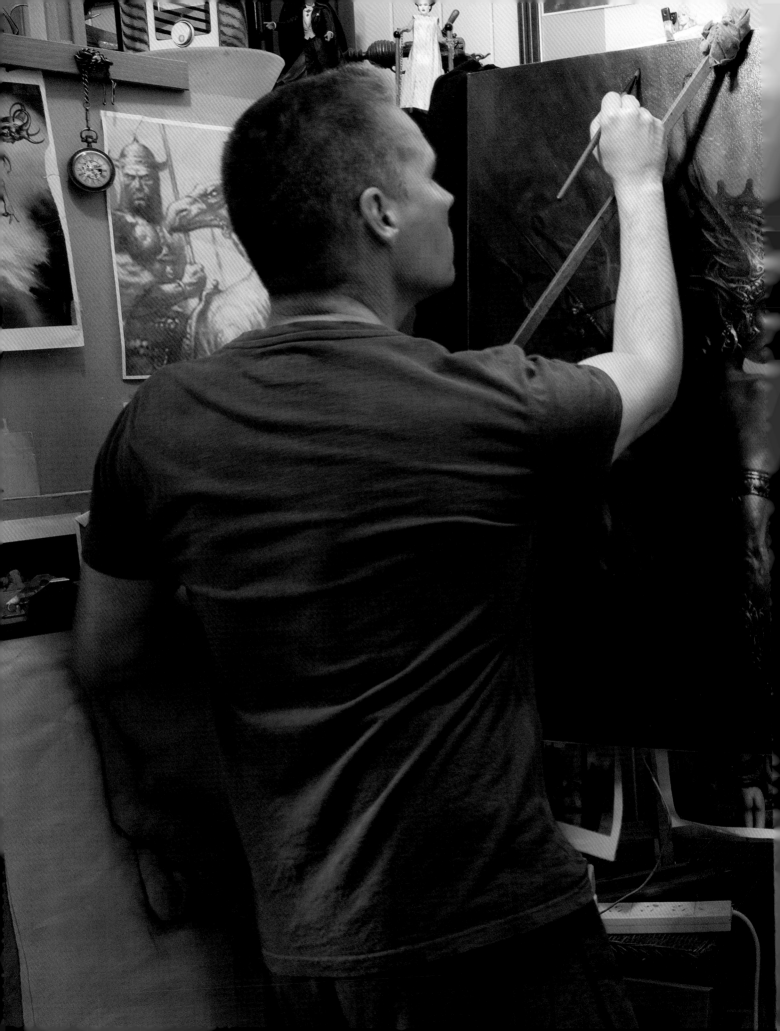

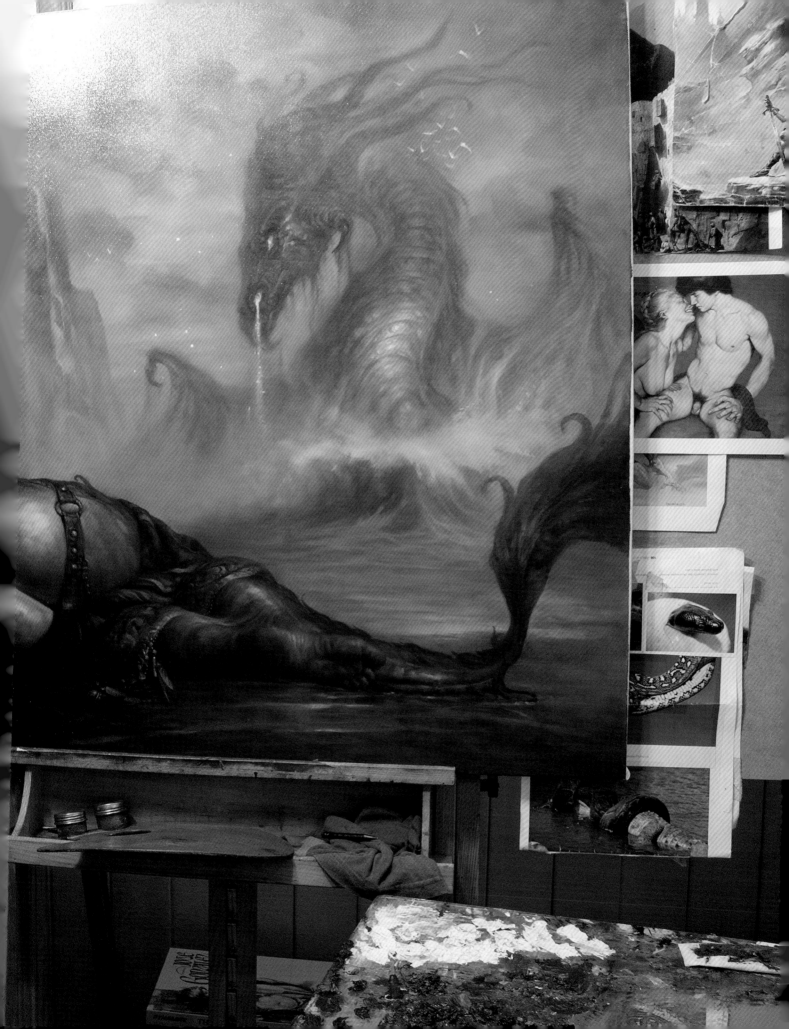

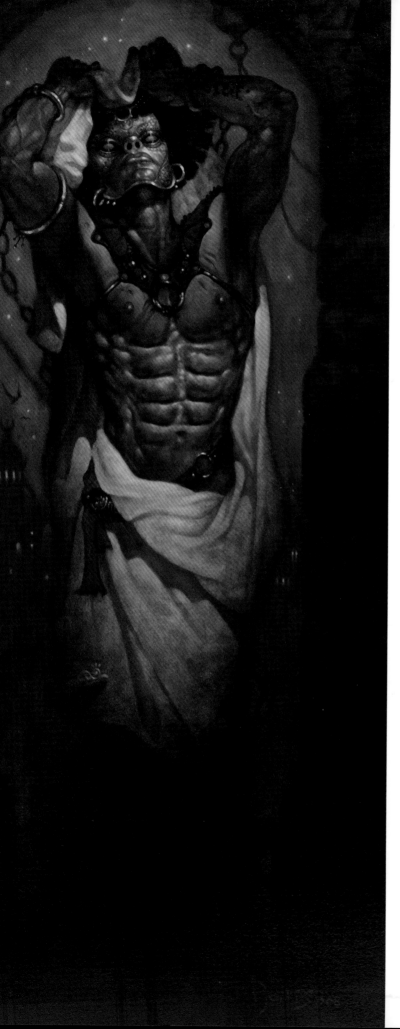

In memory of my friend
Colin Fagg (1960–2016)

Thanks...

To Donato Giancola for honouring me by writing the foreword to this, my first art book.

To Mercedes at the Leeton Model Agency for introducing me to so many great models, and for our Tuesday night life drawing sessions: www.leetonagency.com.au.

To my models: Tora Hylands, Alana Brekelmans, Kelsi White, Mary Ricci, Jason Clarke, Bryce Cleary, Sarah Jade Sliwka, Carmen Olsen, Max Oberoi, Mel Gregory, Emily Campbell, Alina Osipov, Katy Woods, Carly Rees, Nima, Amanda. Without them this would be a book filled with stick figures.

To Pat and Jeannie Wilshire for creating IX and for their friendship and constant support of both my work, and the art of the fantastic: www.illuxcon.com.

To the artists and collectors who inspire me to do better. Special thanks to Catherine Gyllerstrom, Tim Shumate, Carmen M. Wegner, Neil and Leigh Mechem, Earl Weed and Gareth Knowles for their heartfelt support during the making of this book.

To my publisher, Yak, for his faith, Skype calls, and friendship.

To my parents, Patrick and Sally, and my siblings, Donna, Sharon, Brenda, Jacqueline, and Tony. Thanks for being a gregarious family of great humour; without you I may have grown up too shy to speak.

To my childhood friends, who I see less and less of as the decades pass, but who are always in my mind.

To my kids, Dean and Daryl, for their unerring love.

To my beautiful wife, Cathy – my eternal flame and inspiration.